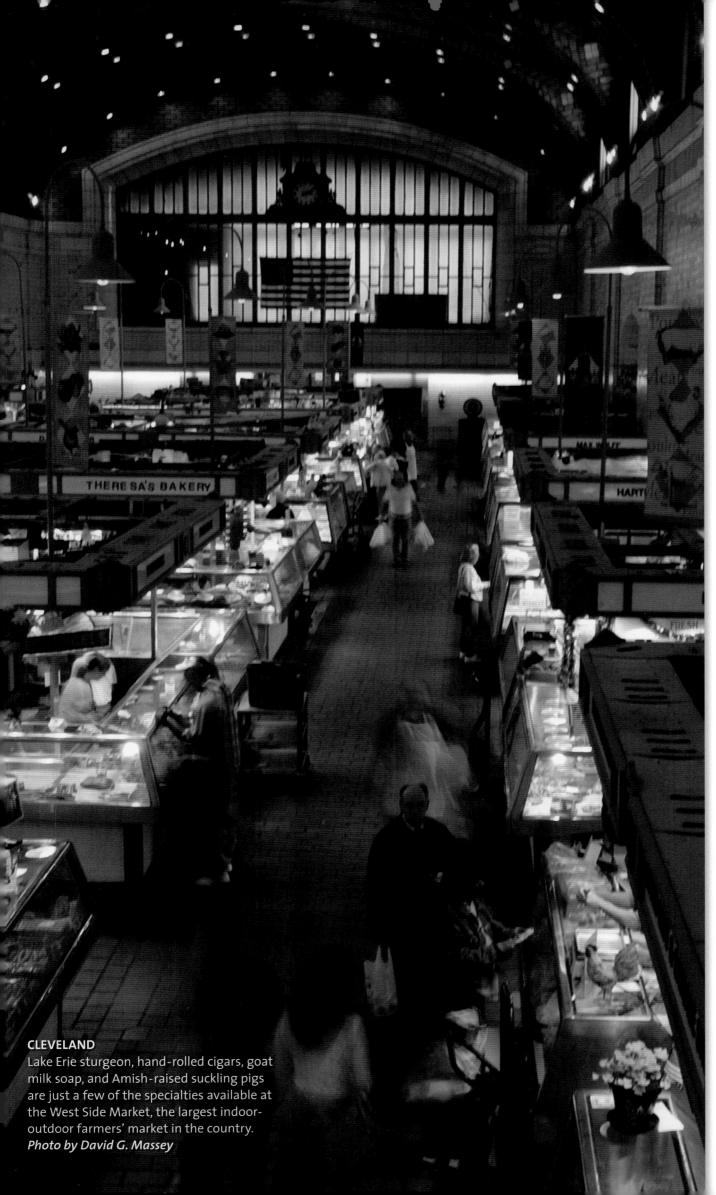

**CLEVELAND**
Lake Erie sturgeon, hand-rolled cigars, goat milk soap, and Amish-raised suckling pigs are just a few of the specialties available at the West Side Market, the largest indoor-outdoor farmers' market in the country.
*Photo by David G. Massey*

*Ohio 24/7* is the sequel to *The New York Times* bestseller *America 24/7* shot by tens of thousands of digital photographers across America over the course of a single week. We would like to thank the following sponsors, the wonderful people of Ohio, and the talented photojournalists who made this book possible.

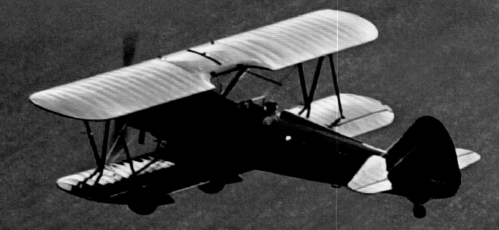

LONDON, NEW YORK, MUNICH, MELBOURNE, and DELHI

Created by Rick Smolan and David Elliot Cohen

24/7 Media, LLC
PO Box 1189
Sausalito, CA 94966-1189
www.america24-7.com

First Edition, 2004
04 05 06 07 08 10 9 8 7 6 5 4 3 2 1

Published in the United States by
DK Publishing, Inc.
375 Hudson Street
New York, NY 10014

DK Publishing, Inc. offers special discounts for bulk purchases for sales promo-
tions or premiums. Specific, large-quantity needs can be met with special edi-
tions, personalized covers, excerpts of existing guides, and corporate imprints.
For more information, contact:

Special Markets Department
DK Publishing, Inc.
375 Hudson Street
New York, NY 10014
Fax: 212-689-5254

Cataloging-in-Publication data is available
from the Library of Congress
ISBN 0-7566-0076-6

Printed in the UK by Butler & Tanner Limited

First printing, October 2004

**NORWALK**
Beneath this 1943 Boeing Stearman biplane,
north-central Ohio spreads out in a series of
rolling hills and plains checkered with corn
and soybean fields. In a few months, these
denuded acres will be carpeted once again
with well-ordered stalks and vines.
*Photo by Lawrence Hamel-Lambert*

# OHIO 24/7

## 24 Hours. 7 Days.
## Extraordinary Images of
## One Week in Ohio.

Created by Rick Smolan and David Elliot Cohen

DK
DK Publishing

# About the America 24/7 Project

A hundred years hence, historians may pose questions such as: What was America like at the beginning of the third millennium? How did life change after 9/11 and the ensuing war on terrorism? How was America affected by its corporate scandals and the high-tech boom and bust? Could Americans still express themselves freely?

To address these questions, we created *America 24/7*, the largest collaborative photography event in history. We invited Americans to tell their stories with digital pictures. We asked them to shoot a visual memoir of their lives, families, and communities.

During one week in May 2003, more than 25,000 professionals and amateurs shot more than a million pictures. These images, sent to us via the Internet, compose a panoramic yet highly intimate view of Americans in celebration and sadness; in action and contemplation; at work, home, and school. The best of these photographs, more than 6,000, are collected in 51 volumes that make up the *America 24/7* series: the landmark national volume *America 24/7*, published to critical acclaim in 2003, and the 50 state books published in 2004.

Our decision to make *America 24/7* an all-digital project was prompted by the fact that in 2003 digital camera sales overtook film camera sales. This techno-logical evolution allowed us to extend the project to a huge pool of photographers. We were thrilled by the response to our challenge and moved by the insight offered into American life. Sometimes, the amateurs outshot the pros—even the Pulitzer Prize winners.

The exuberant democracy of images visible throughout these books is a revela-tion. The message that emerges is that now, more than ever, America is a supersized idea. A dreamspace, where individuals and families from around the world are free to govern themselves, worship, read, and speak as they wish. Within its wide margins, the polyglot American nation manages to encompass an inexplicably complex yet workable whole. The pictures in this book are dedicated to that idea.

*—Rick Smolan and David Elliot Cohen*

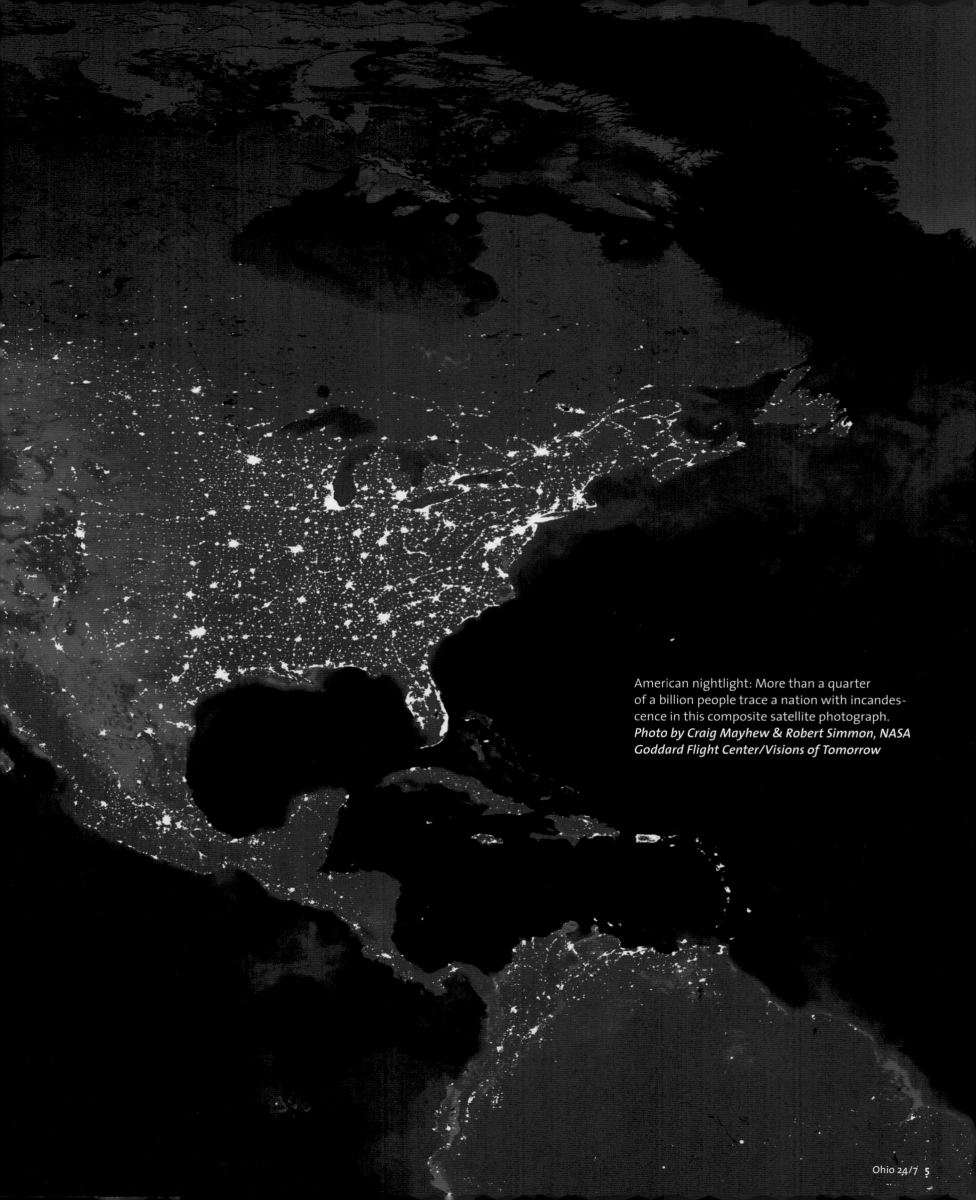

American nightlight: More than a quarter of a billion people trace a nation with incandescence in this composite satellite photograph.
*Photo by Craig Mayhew & Robert Simmon, NASA Goddard Flight Center/Visions of Tomorrow*

# The Middle of It All

*By Mike Harden*

Ohio was first called the "Promised Land" when the republic was in its infancy, and a grateful nation paid Revolutionary War veterans in virginal tracts of land west of the Alleghenies. They felled the hardwood forests and plowed the furrows, freckling the soft, billiard-table terrain with tilled fields, church spires, and silos.

As they built new lives, so was the Buckeye State's reputation—as a crucible of industrial muscle and agrarian might—built upon their backs. The mines, mills, and factories made Ohio the engine of the heartland. A virtual sea of corn made it the breadbasket of the nation. Bounded by river and lake, the land cradled the American sons who gave light (Thomas Edison) and flight (the Wright brothers) to the world.

Yet, a century after the dawning of the Industrial Revolution, the nation's Steel Belt became its Rust Belt as the business of blast furnacing shifted to the Far East and elsewhere. Depressed prices, soaring production costs, and monolithic agribusiness drove family farmers from landed legacies to city jobs.

The changing face of the U.S. job market forced Ohio to reinvent and rediscover itself. Forsaking brawn for brain and trading on its central location, it became a shipping and business logistics hub for the eastern part of the country. Airborne Express headquartered in Wilmington; Victoria's Secret warehouses sprawled outside Columbus. From Crazy Glue to Grupo Bimbo's taco chips, foreign brands love Ohio. The fields of central Ohio that once produced corn began measuring productivity in Honda automobiles.

**ATHENS**
Patched together from many small, family farms, the countryside around Athens rolls gently into the foothills of the Appalachians.
*Photo by Larry Nighswander, Ohio University*

In the deep reaches of Appalachian Ohio, when the coal played out, when mine tipples crumbled and thriving villages took on the look of ghost towns, bed-and-breakfasts sprang up to court blue-chip tourists. Interlopers from Columbus and Cincinnati arrived in SUVs to drink in the autumn foliage going saffron, sorrel, and crimson. River towns—that once beckoned runaway slaves to freedom and factories to the easy convenience of the Ohio's shipping lanes—reinvented themselves as havens of craft and antique stores, courting the latte and biscotti set.

The central feature of Ohio today is its ongoing struggle for economic regeneration. As Ohioans confront that hurdle, they move about their labors and leisure as seemingly unruffled as a Norman Rockwell tableau. Valued by marketers as a microcosmic mirror of the nation's tastes and sensibilities, Ohio routinely plays the guinea pig when it comes to test-marketing everything from candy bars to candidates. The population is sufficiently comfortable with its role and its place in the heart of the heartland that it can chuckle, along with the cosmopolitan Babylonians of either coast, about the state with too many vowels and cows and all-you-can-eat buffets.

Ohioans can be as quiet as the clop-clop of an Amish buggy on two-lane blacktop, yet as crazy as 100,000 football-frenzied Buckeye fans at a home game. They pray for salvation at coliseums as much as at country clapboard churches, taking pennants as seriously as penance. At the end of the day, they sleep content with the knowledge that they are in the middle of it all.

---

*For 21 years, Columbus native* MIKE HARDEN *has been writing his nationally syndicated column "In Essence" for* The Columbus Dispatch.

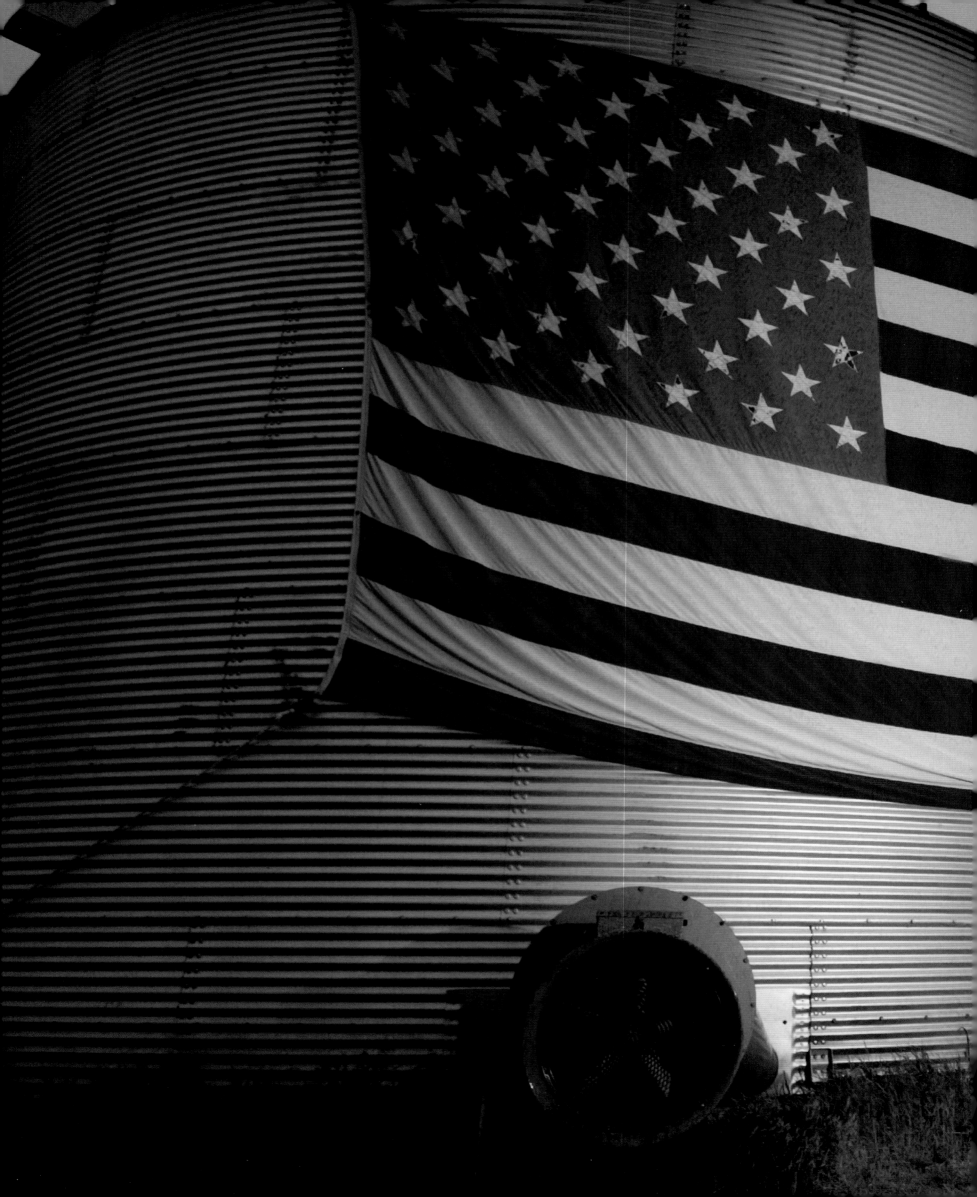

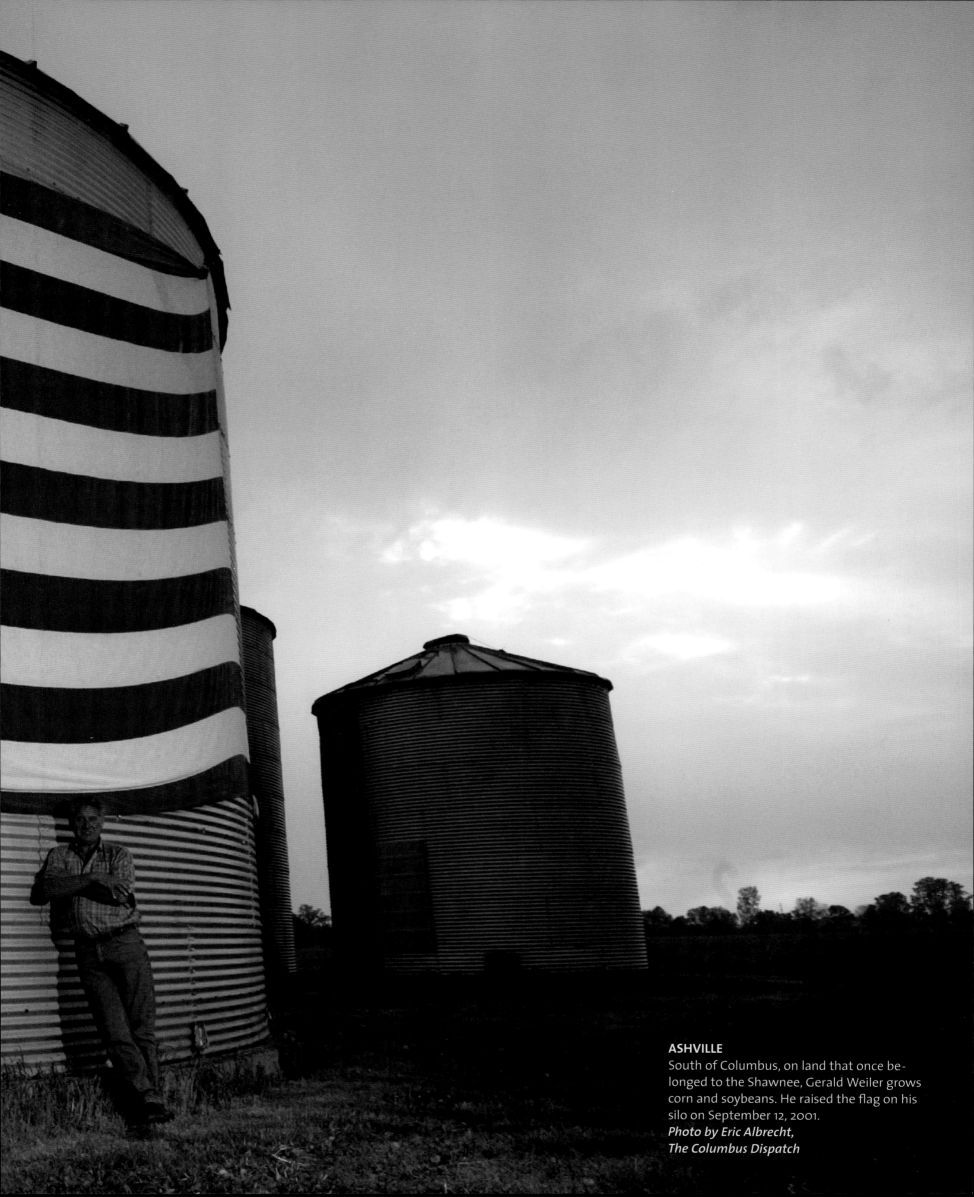

**ASHVILLE**
South of Columbus, on land that once belonged to the Shawnee, Gerald Weiler grows corn and soybeans. He raised the flag on his silo on September 12, 2001.
*Photo by Eric Albrecht,*
*The Columbus Dispatch*

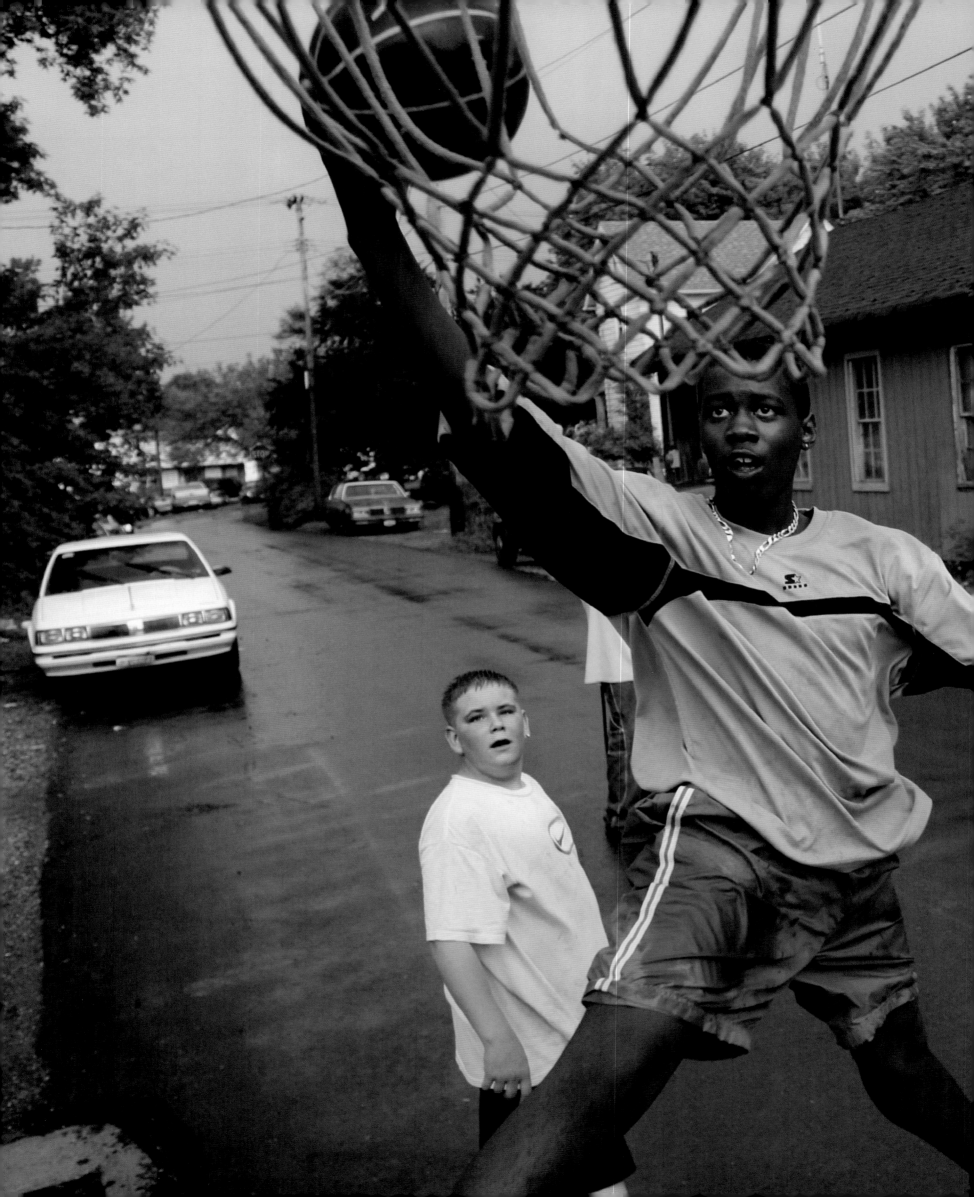

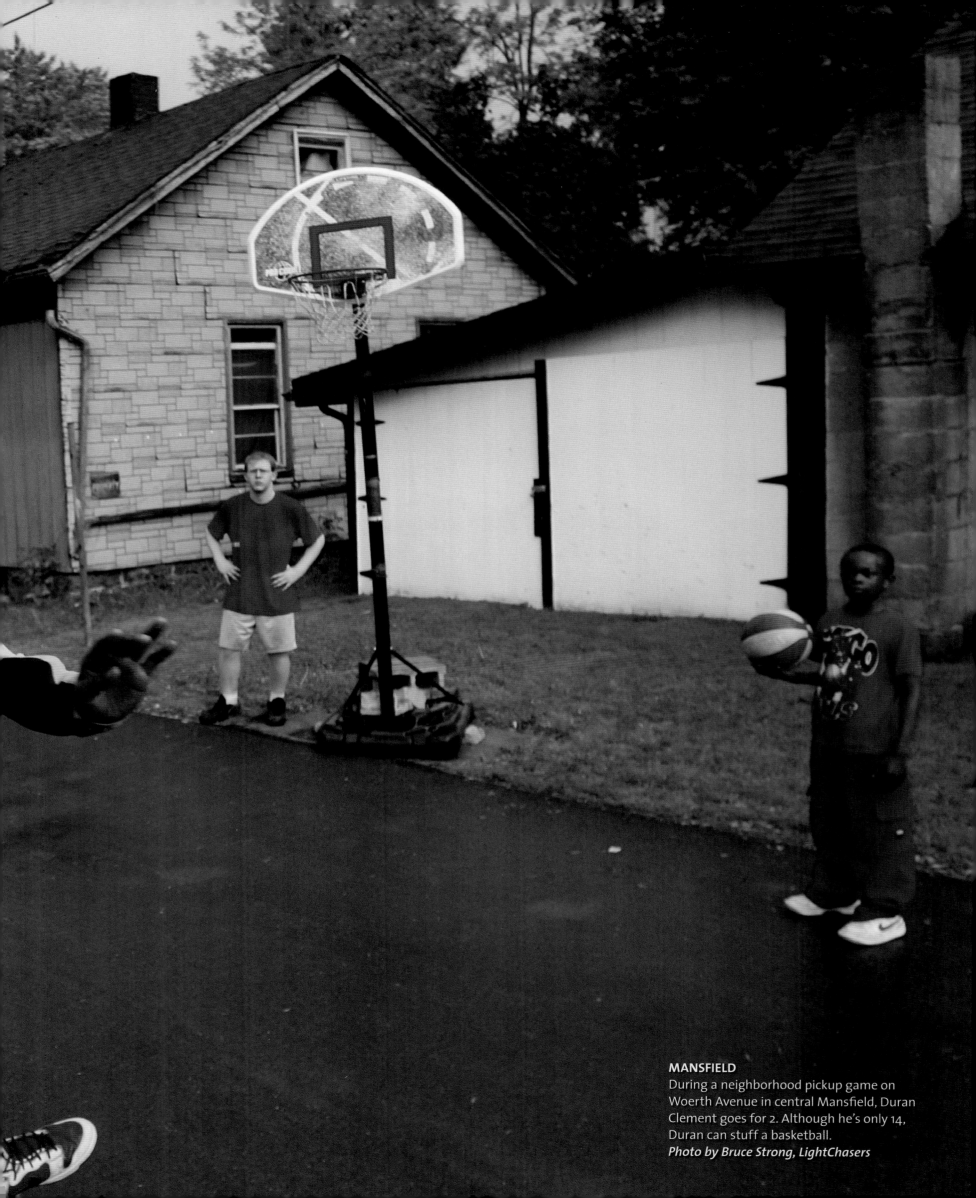

**MANSFIELD**
During a neighborhood pickup game on Woerth Avenue in central Mansfield, Duran Clement goes for 2. Although he's only 14, Duran can stuff a basketball.
*Photo by Bruce Strong, LightChasers*

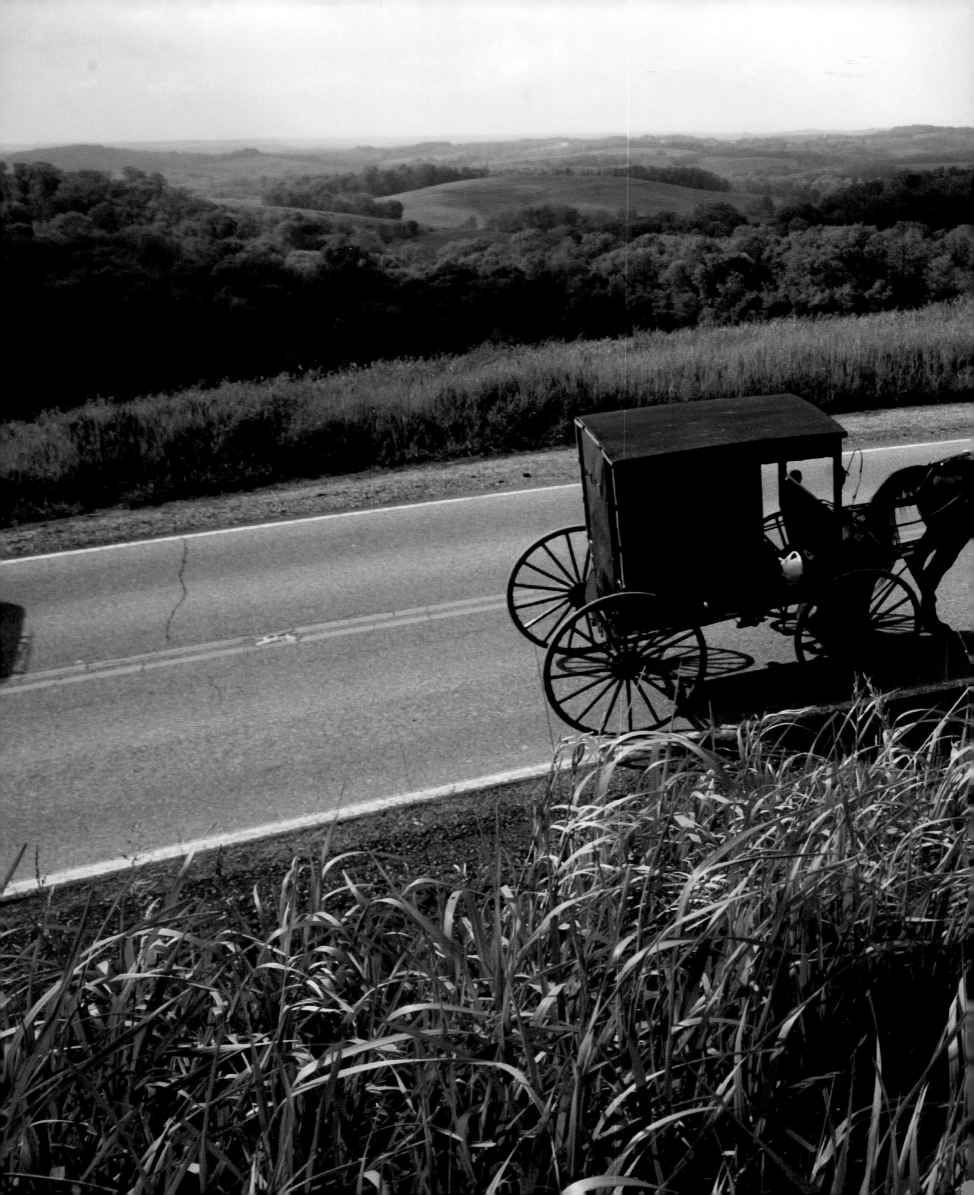

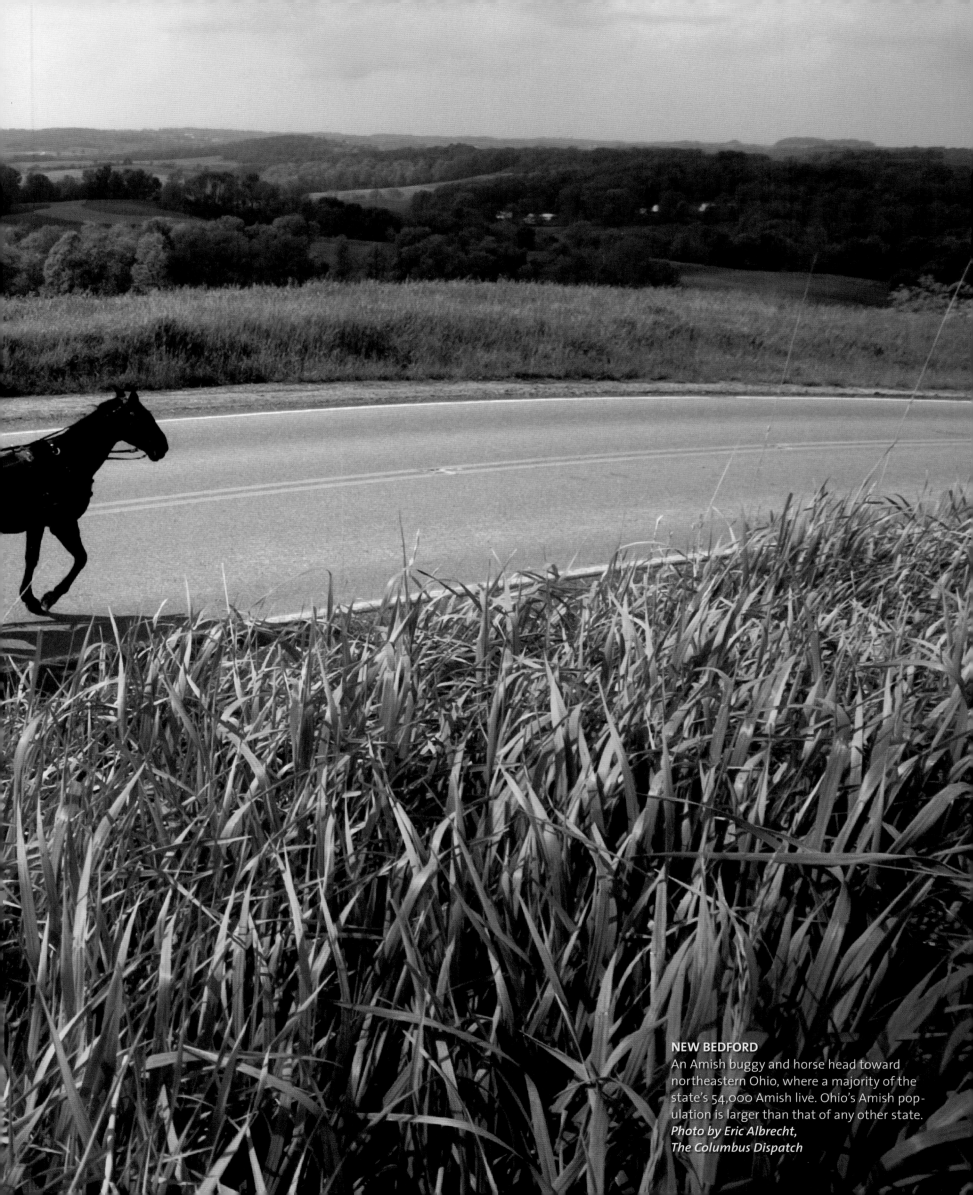

**NEW BEDFORD**
An Amish buggy and horse head toward
northeastern Ohio, where a majority of the
state's 54,000 Amish live. Ohio's Amish pop-
ulation is larger than that of any other state.
*Photo by Eric Albrecht,*
*The Columbus Dispatch*

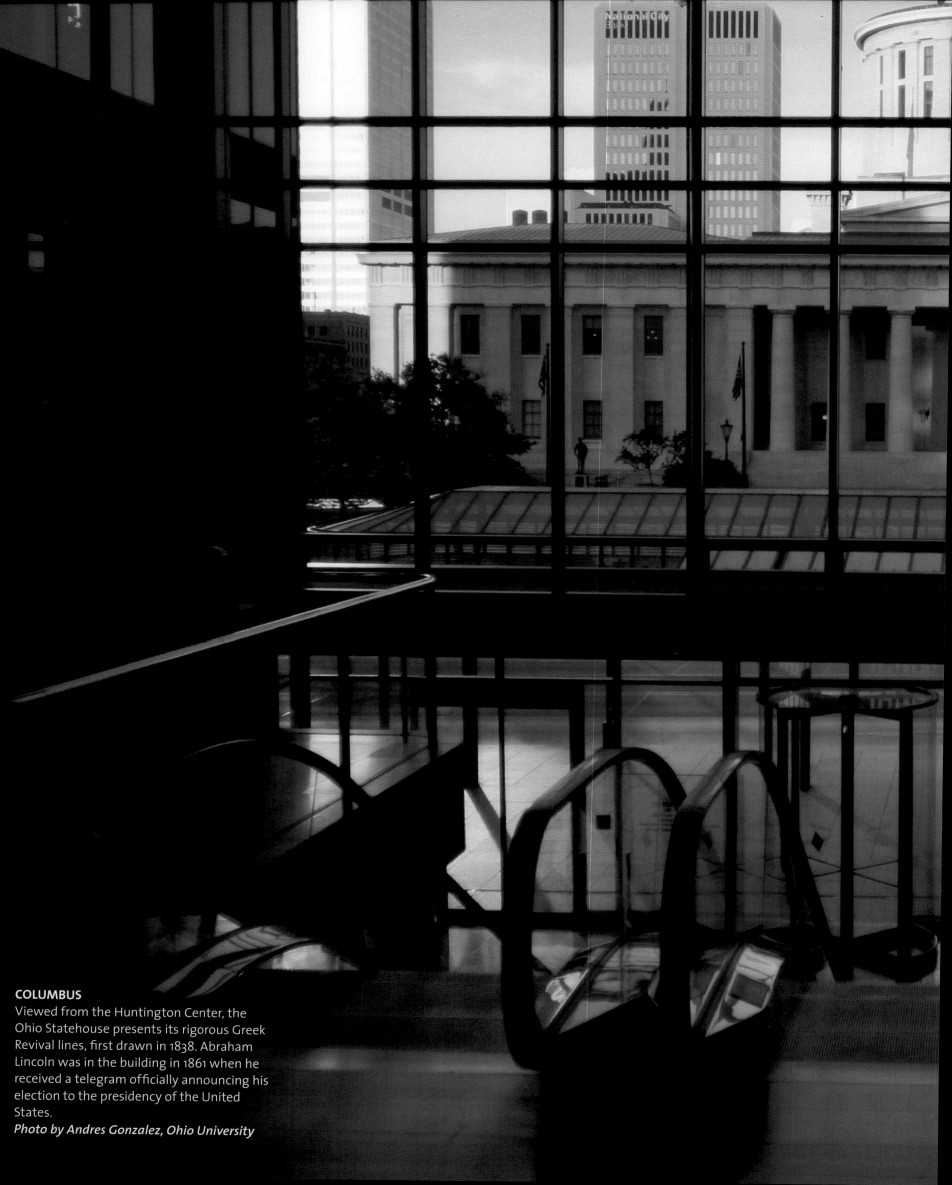

**COLUMBUS**
Viewed from the Huntington Center, the Ohio Statehouse presents its rigorous Greek Revival lines, first drawn in 1838. Abraham Lincoln was in the building in 1861 when he received a telegram officially announcing his election to the presidency of the United States.
*Photo by Andres Gonzalez, Ohio University*

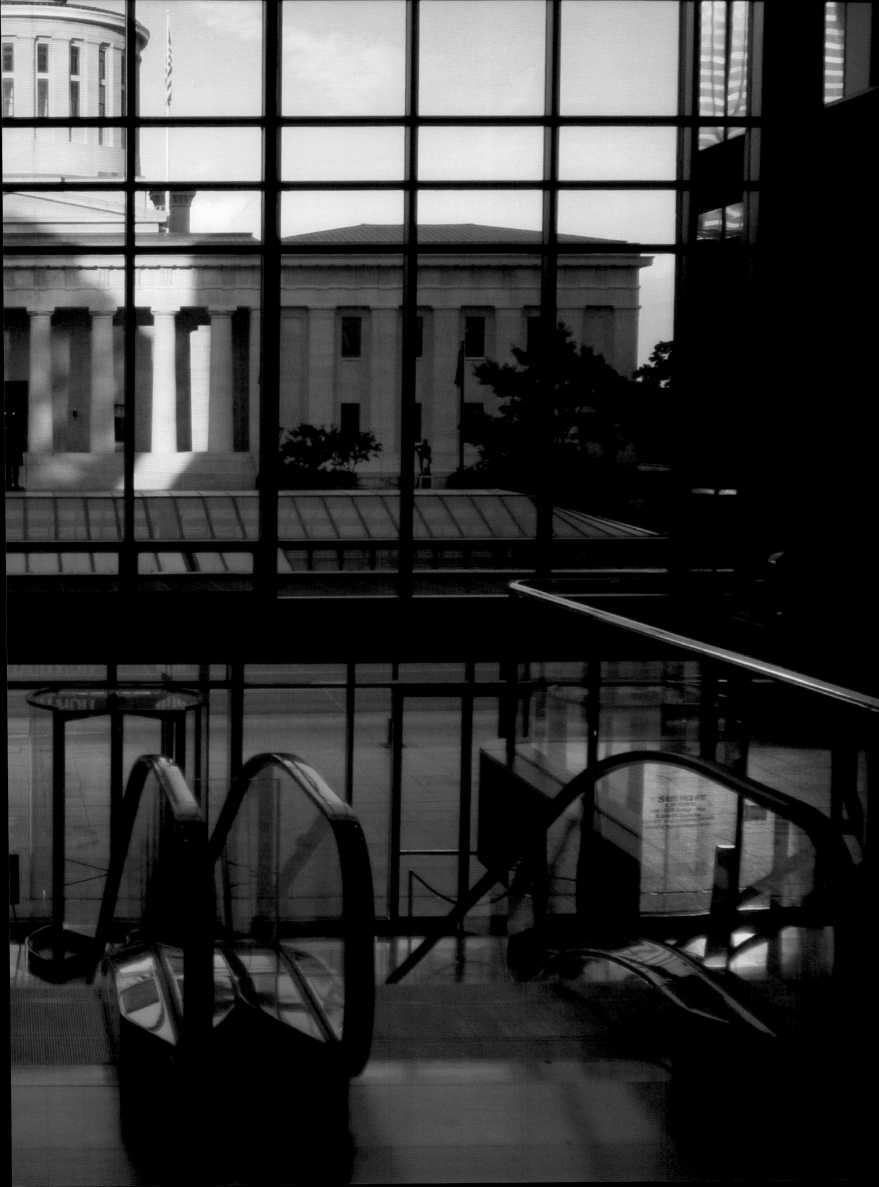

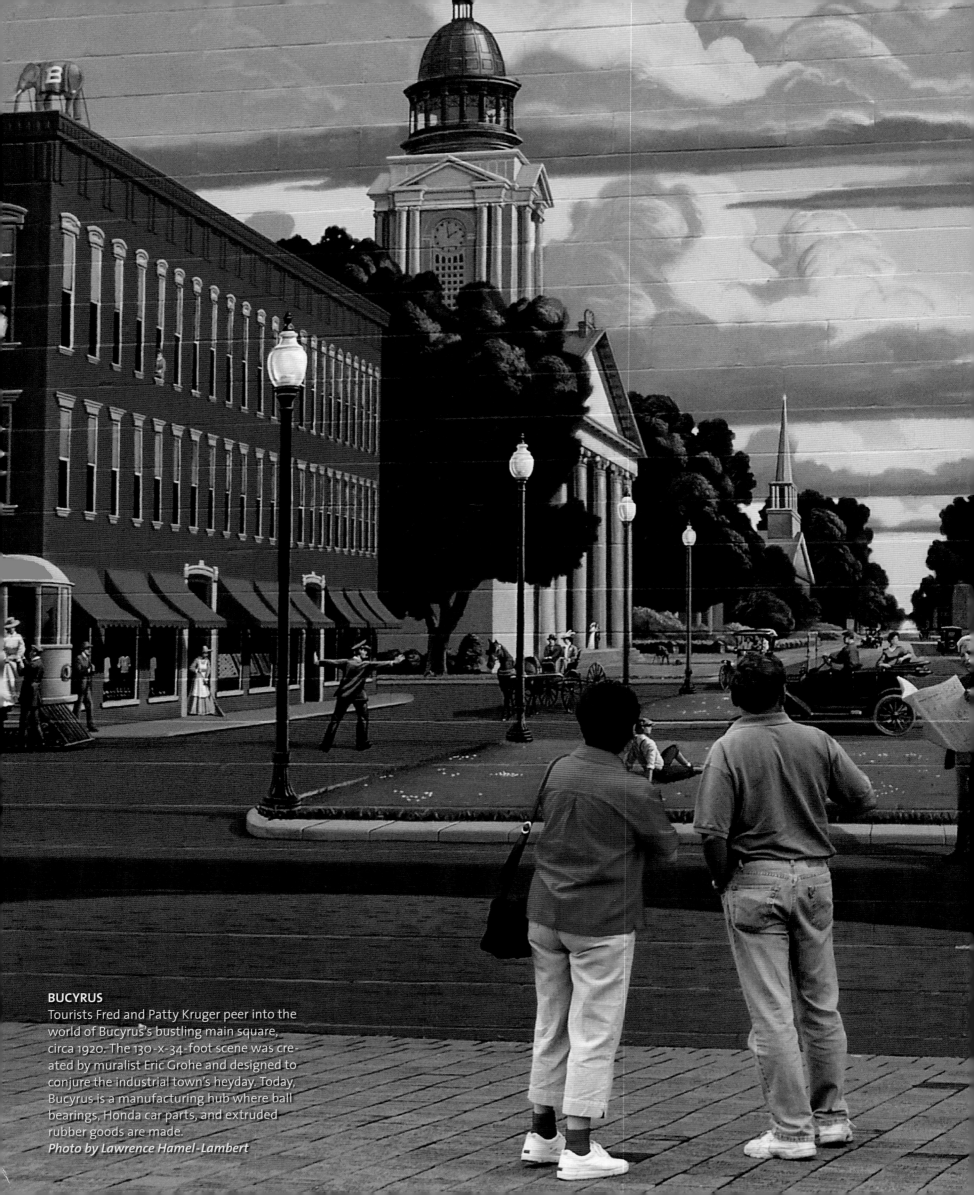

**BUCYRUS**
Tourists Fred and Patty Kruger peer into the world of Bucyrus's bustling main square, circa 1920. The 130-x-34-foot scene was created by muralist Eric Grohe and designed to conjure the industrial town's heyday. Today, Bucyrus is a manufacturing hub where ball bearings, Honda car parts, and extruded rubber goods are made.
*Photo by Lawrence Hamel-Lambert*

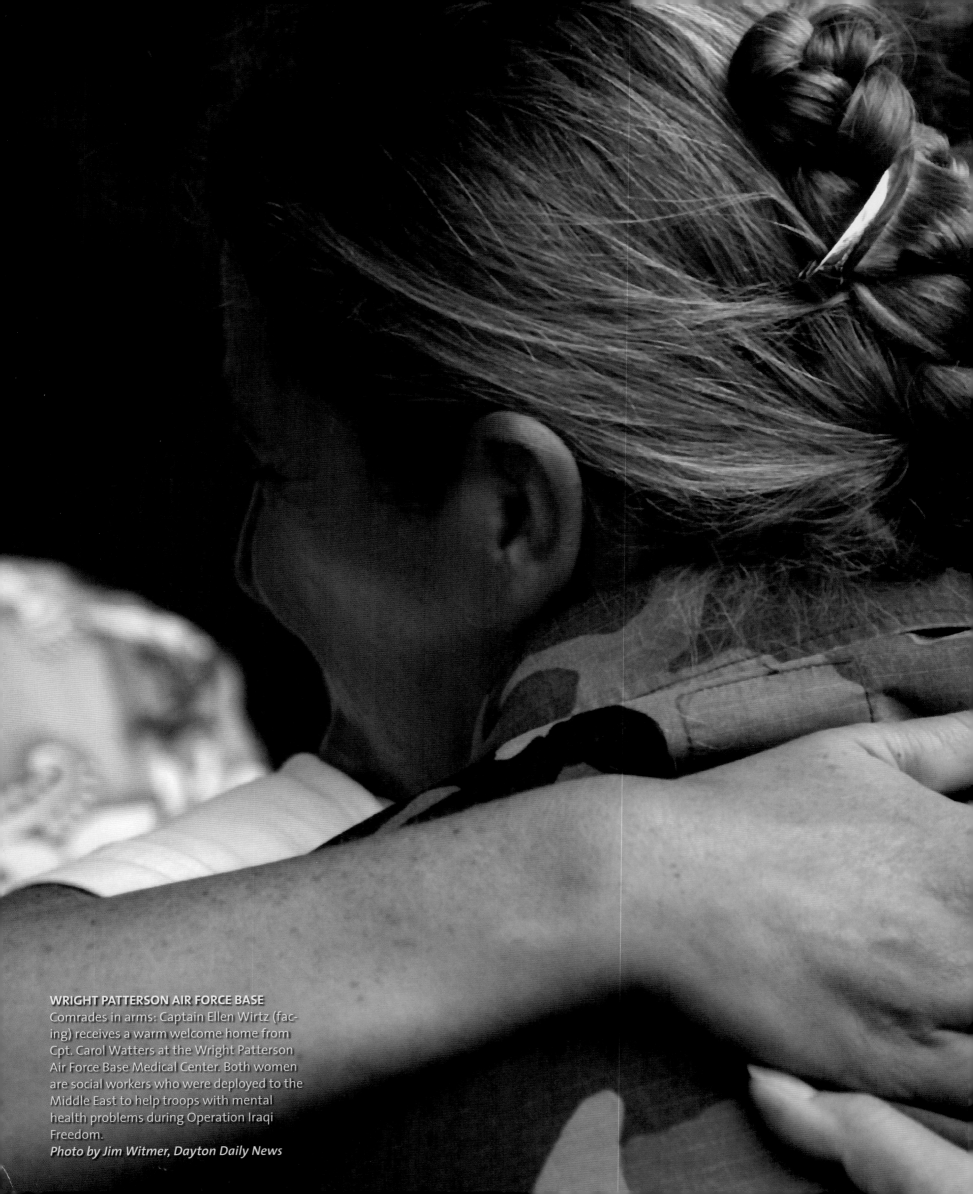

**WRIGHT PATTERSON AIR FORCE BASE**
Comrades in arms: Captain Ellen Wirtz (facing) receives a warm welcome home from Cpt. Carol Watters at the Wright Patterson Air Force Base Medical Center. Both women are social workers who were deployed to the Middle East to help troops with mental health problems during Operation Iraqi Freedom.
*Photo by Jim Witmer, Dayton Daily News*

Hearth & Home

**BUCYRUS**

Bridget Kohls lives directly across the street from her grandpa, Ed Fox. Sometimes, he takes her to the hairdresser, and afterwards they stop by the Dairy Scoop for a vanilla cone as big as her head. When she can't finish it, she asks grandpa for a little help. "She calls me her best friend," says Fox.
*Photo by Bruce Strong, LightChasers*

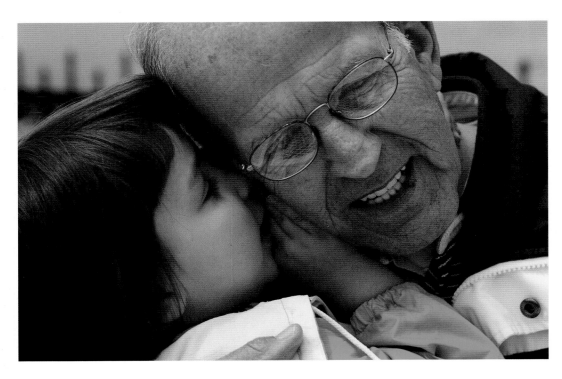

**CIRCLEVILLE**

Jackie Griffey gets a smooch from Chad Jewell before their first prom. The two attend the Brooks-Yates School, part of a center that helps children and adults who have mental or physical challenges.

*Photo by Tim Revell, The Columbus Dispatch*

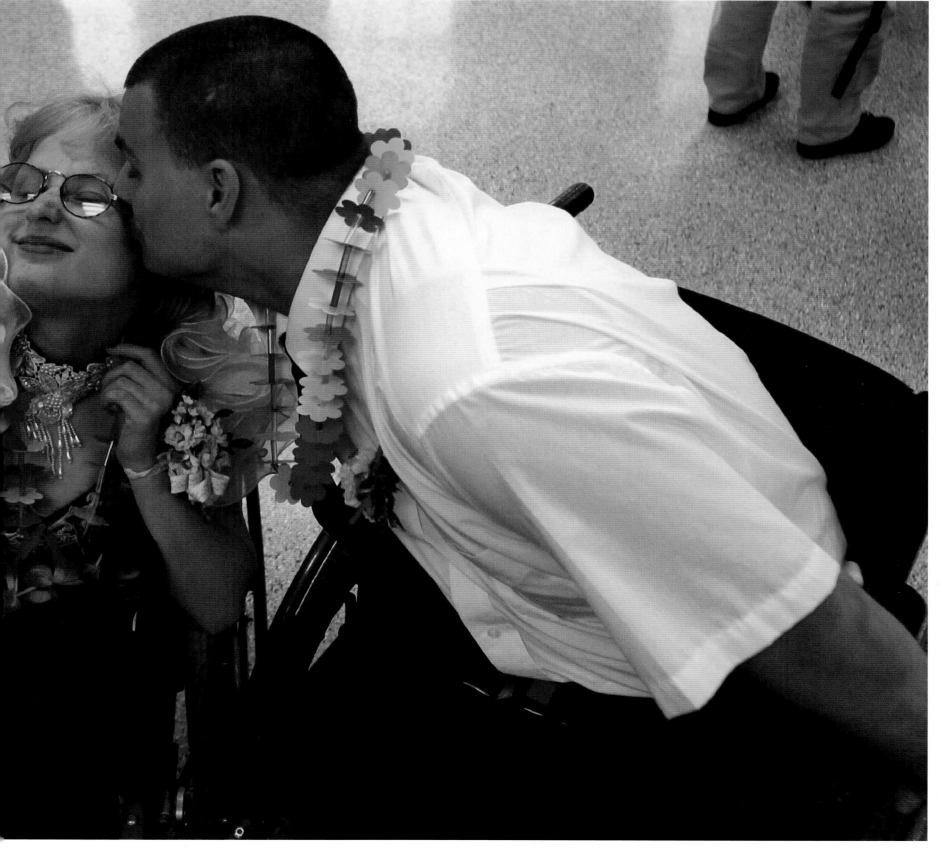

**TROY**

Every other Tuesday, a group of buddies from the neighborhood migrate to Jeff Layman's (white hat) porch for a night of euchre, beer, and cigars. Women aren't excluded per se, but the atmosphere is fairly macho, says photographer and porch regular Jim Witmer. On this night, the men made room for 2-year-old Rachel, who came with dad Gerime Blankenship (right).

*Photo by Jim Witmer, Dayton Daily News*

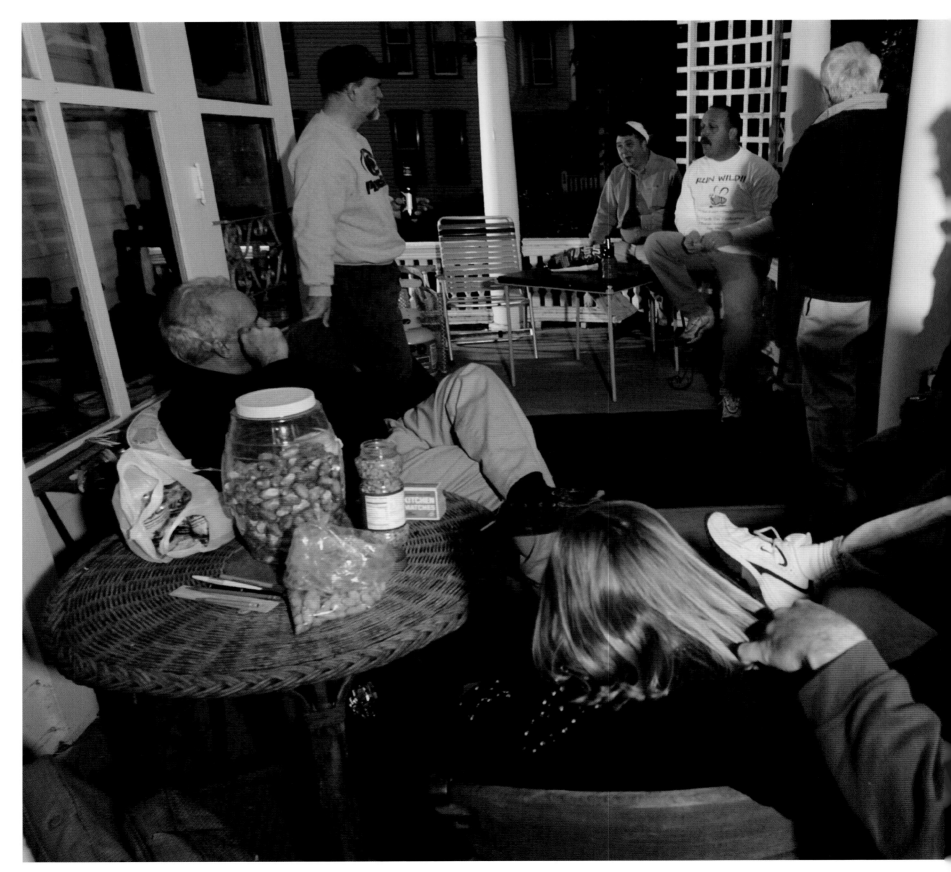

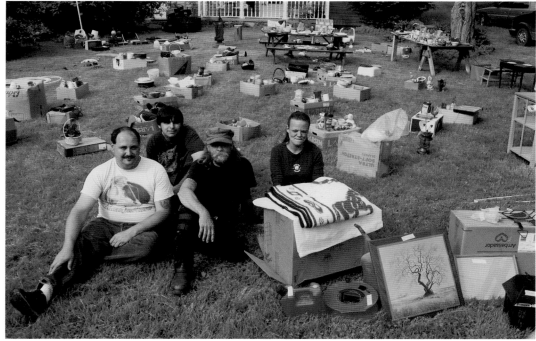

Twice a year, Jeff McGee (center) has a yard sale that lasts for three days. The inventory includes everything from car parts to a bottle of holy water. According to McGee, the best customers are retired people who spend all week prowling local garage and yard sales.
*Photo by Larry Nighswander, Ohio University*

## CINCINNATI

Noah Detrich dreams with the fishes. Before he was born, his parents decorated his room with a Noah's Ark seascape and bought him plushy toys, including a giant fish and a little shark. "After the decor, and the fact that he was born during a storm lasting forty days and nights, we had to call him Noah," says dad Allan.

*Photo by Allan E. Detrich*

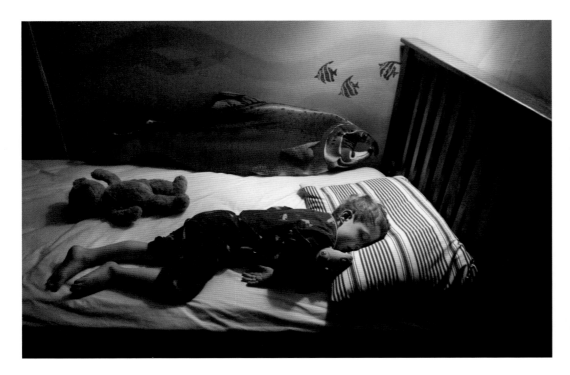

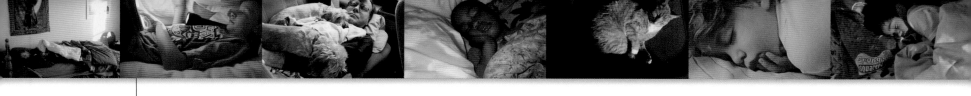

**MASON**

Burrowed into her own amber world, Kelsey
Barrett lets *Ramona's World*, by Beverly Cleary,
take her away.
***Photo by Jim Barrett***

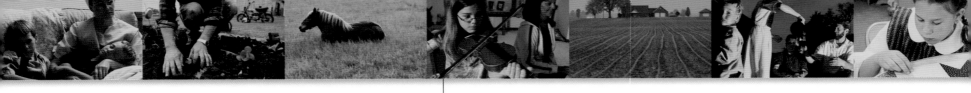

## BEAVERCREEK

Born without a right arm, Jaclyn Barker can still play "Les Bouffons"—thanks to a prosthesis created by engineering students at Cedarville University. A professor (and member of Jaclyn's church congregation) assigned his mechanical engineering class the task of designing a new limb for Jaclyn. This model, with a magnesium cam and bow holding mechanism, earned the highest marks.

*Photo by Jim Witmer, Dayton Daily News*

**BAY VILLAGE**

Homework done, sixth-grader Molly Kasperek focuses on coronet practice for the year-end Bay Village Middle School band concert. She doesn't mind the extra hours—she wants to get into the high school band for the travel. Last year, the band went to Disneyland.
*Photo by Larry Kasperek,*
*Fuchs & Kasperek Photography*

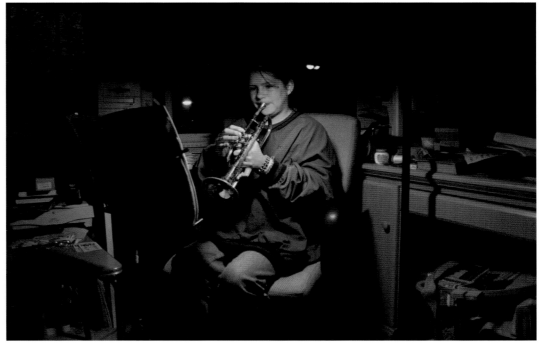

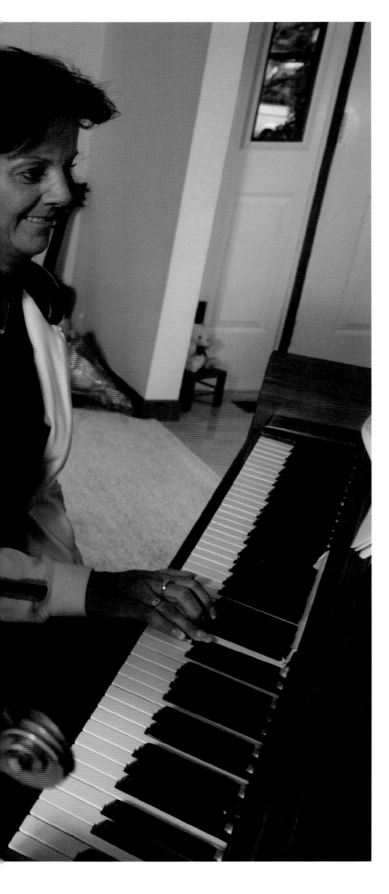

**GERMANTOWN**

Joy Couch quizzes her quadruplets Jacob, Molly, Amy, and Isaac with arithmetic flashcards in the stairwell of their home as baby Sarah waits for breast-feeding. Math lessons in the Couch household can occur almost anywhere. All the kids are homeschooled, which allows their teacher/mom to incorporate lessons into everyday activities.
*Photos by Jim Witmer, Dayton Daily News*

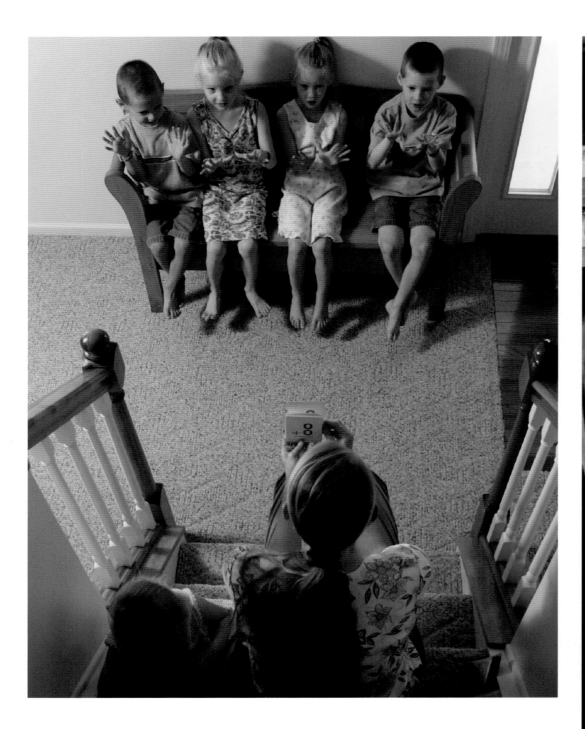

## GERMANTOWN

Couch's six kids require time management. Here, she showers some affection on 8-year-old Emily as "the quads" concentrate on schoolwork. Mom and dad made the decision to teach their children at home because, "we don't want to miss a minute of their growing-up years."

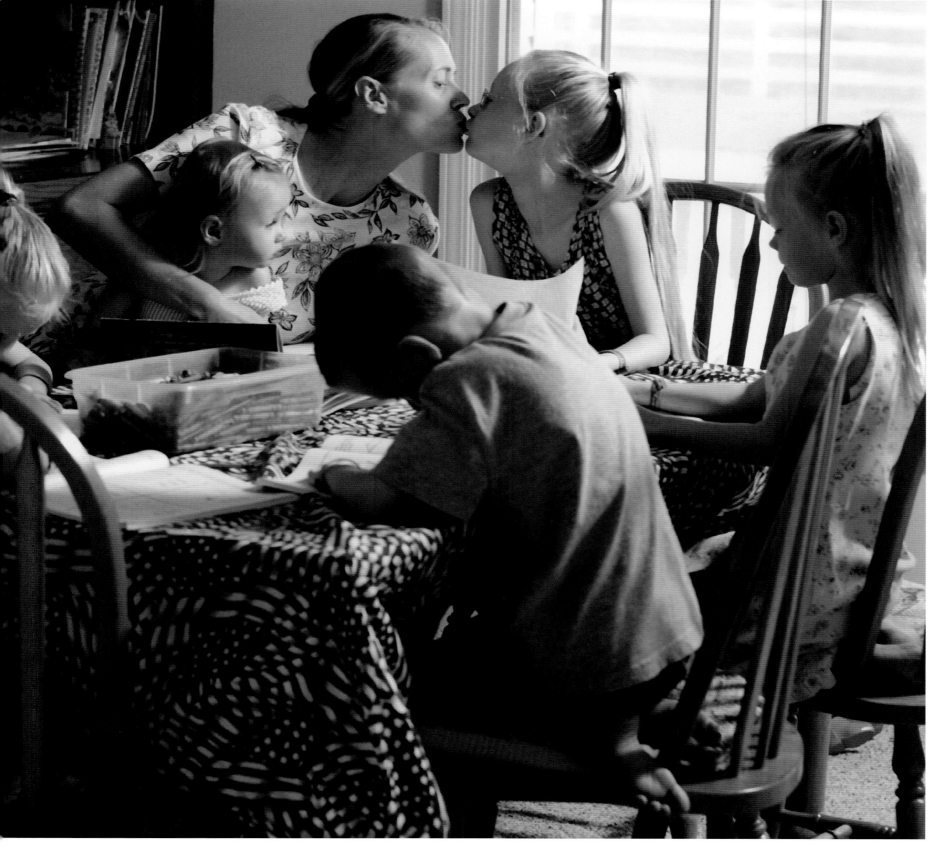

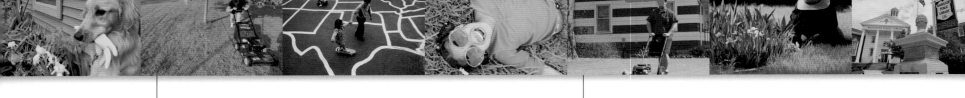

**ATHENS**

Grass pollen kicks up in May, making tasks like mowing the lawn an itchy, sneezy affair. Debbie Clary, though, is largely oblivious to the cloud of hayfever-inducing particles around her—she's one of the lucky Athens residents who's blissfully allergy-free.

*Photo by Robert Caplin*

**DAYTON**

The stars and stripes on Jeff Brashear's home are a tribute to New York City's firefighters. The Dayton press operator painted his mural a week after Sept. 11. "I was pretty touched by the sacrifices the firefighters made," he says. "They had a lot of heart."

*Photo by Jim Witmer, Dayton Daily News*

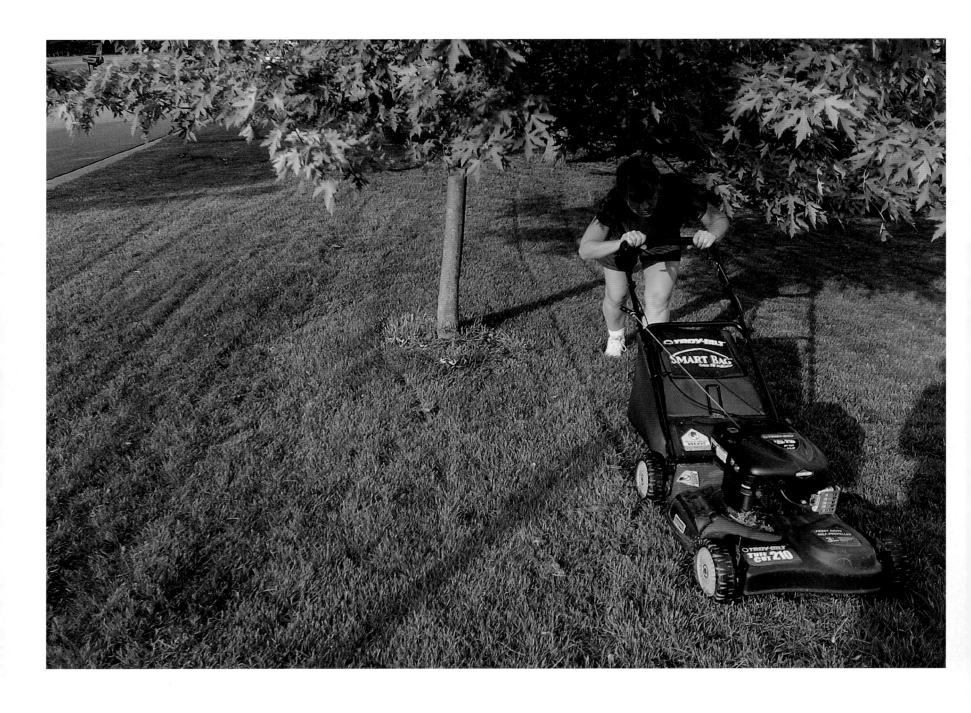

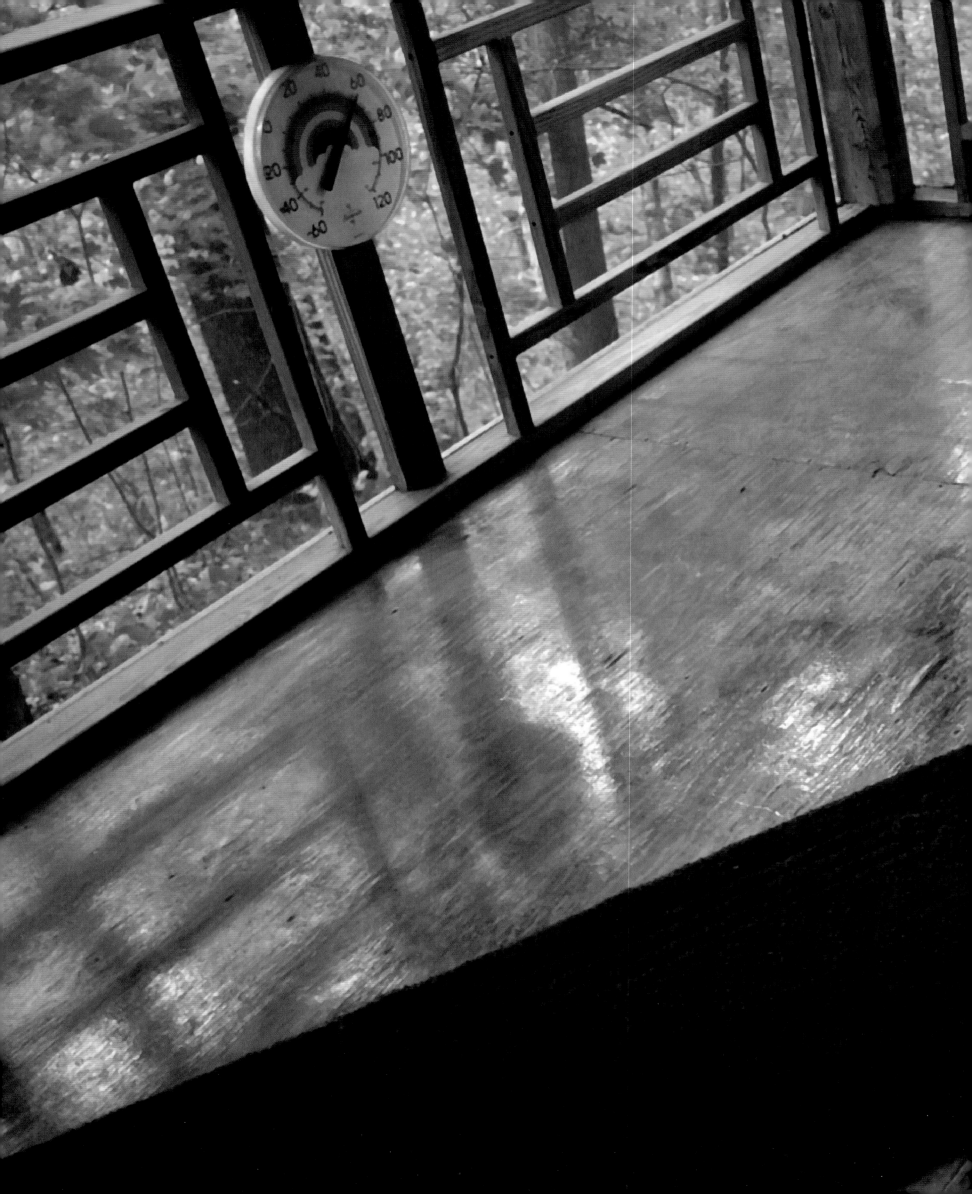

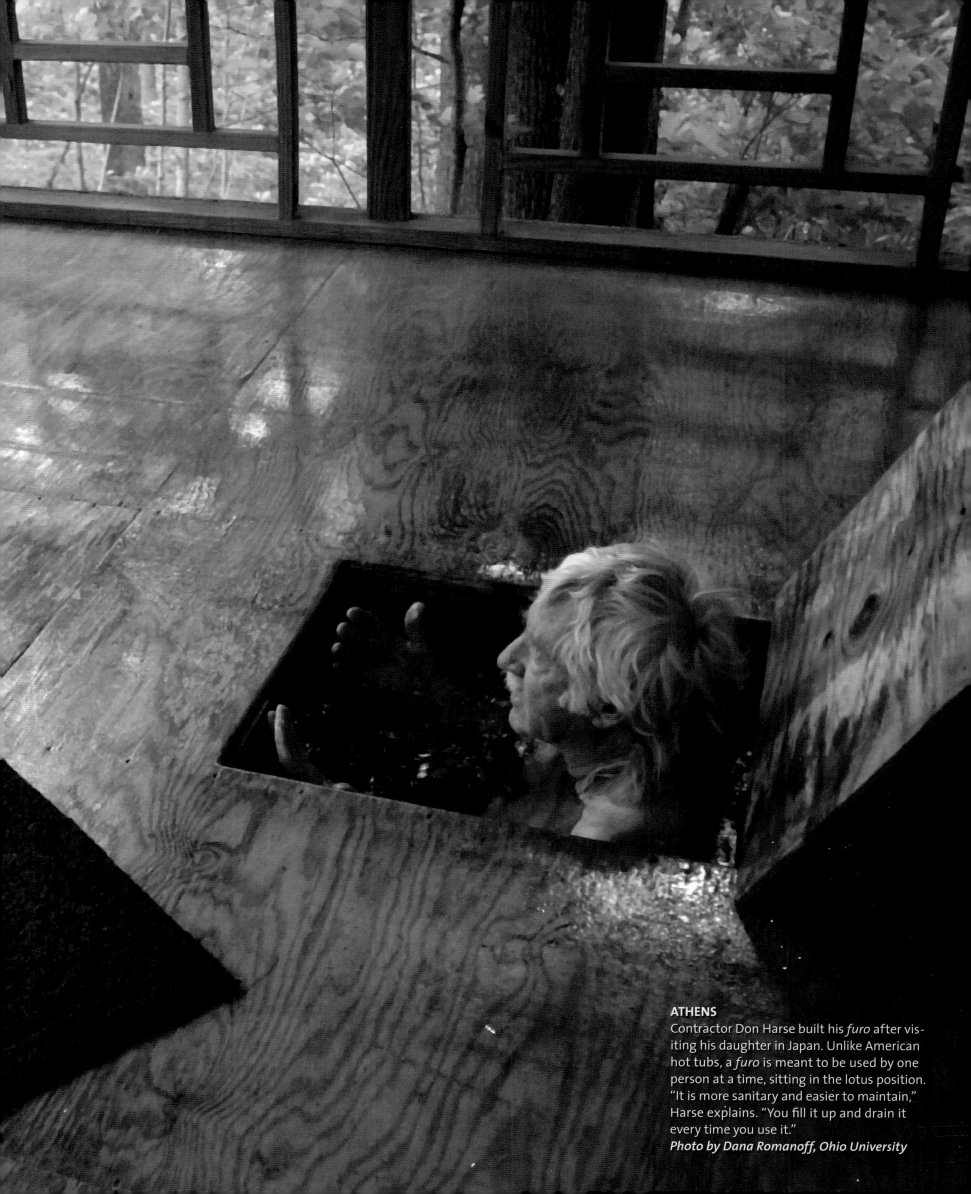

**ATHENS**
Contractor Don Harse built his *furo* after visiting his daughter in Japan. Unlike American hot tubs, *a furo* is meant to be used by one person at a time, sitting in the lotus position. "It is more sanitary and easier to maintain," Harse explains. "You fill it up and drain it every time you use it."
*Photo by Dana Romanoff, Ohio University*

Bride Nimo Jama (seated in back) wears a stan-
dard gown, but the rest of her wedding is tradi-
tionally Somali. Jama does not attend the cere-
mony, which is conducted by her groom, her
father, and male relatives. The women attend
a reception where they dance and sing blessings
to the bride, until the groom shows up after
midnight to claim his new wife.
*Photo by Denise McGill, www.denisemcgill.com*

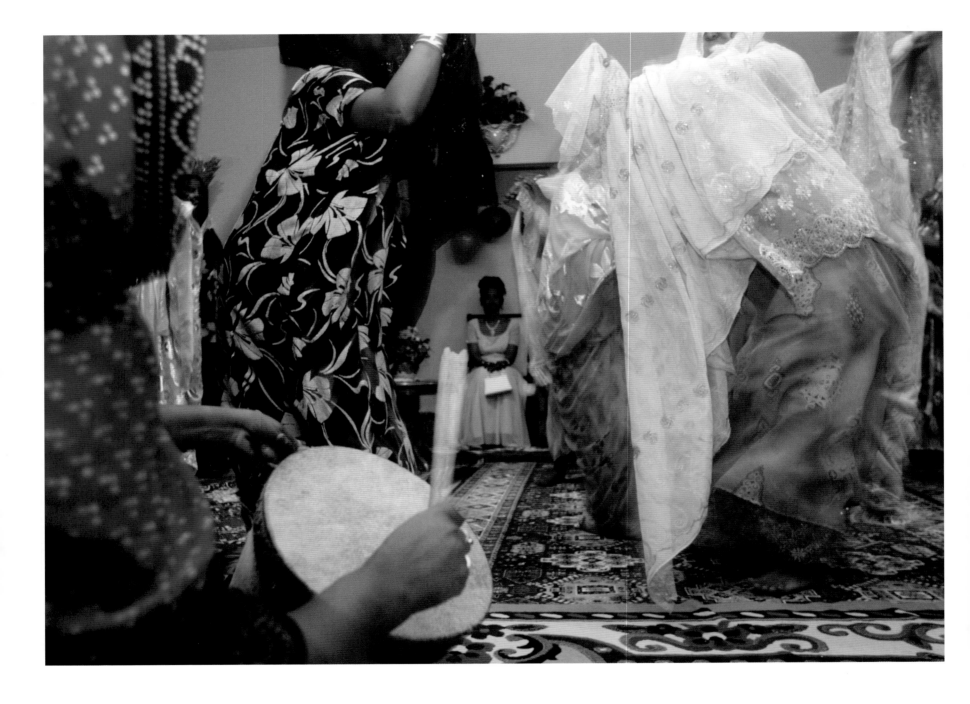

**AKRON**
With the first and most important segment of her big day behind her, Megan Moon prepares for round two—her wedding reception at Todaro's Party Center.
*Photo by Carolyn Drake*

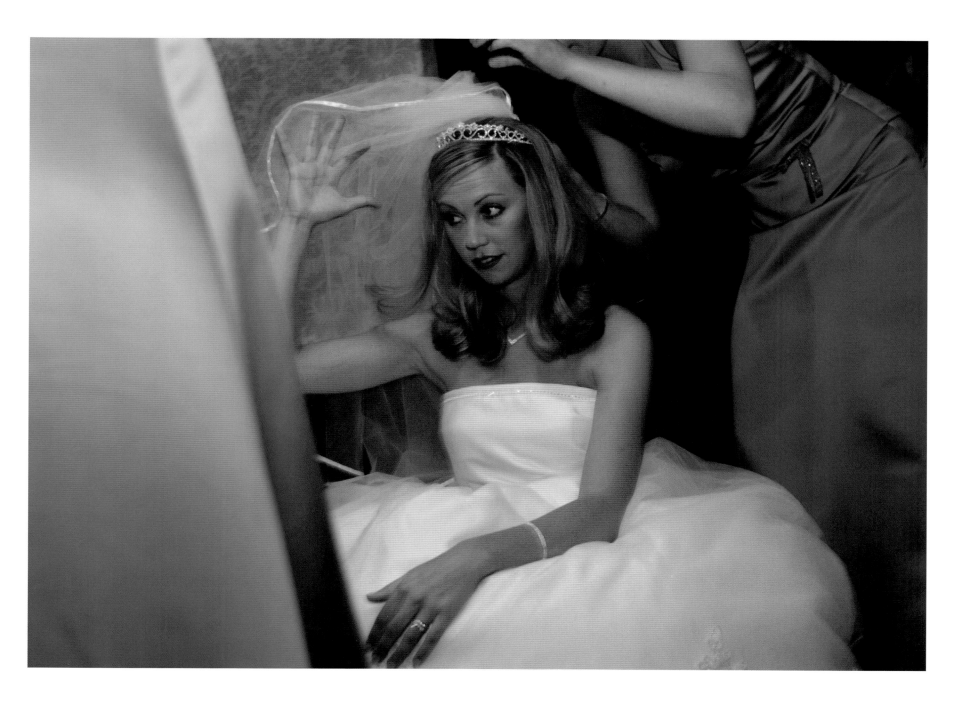

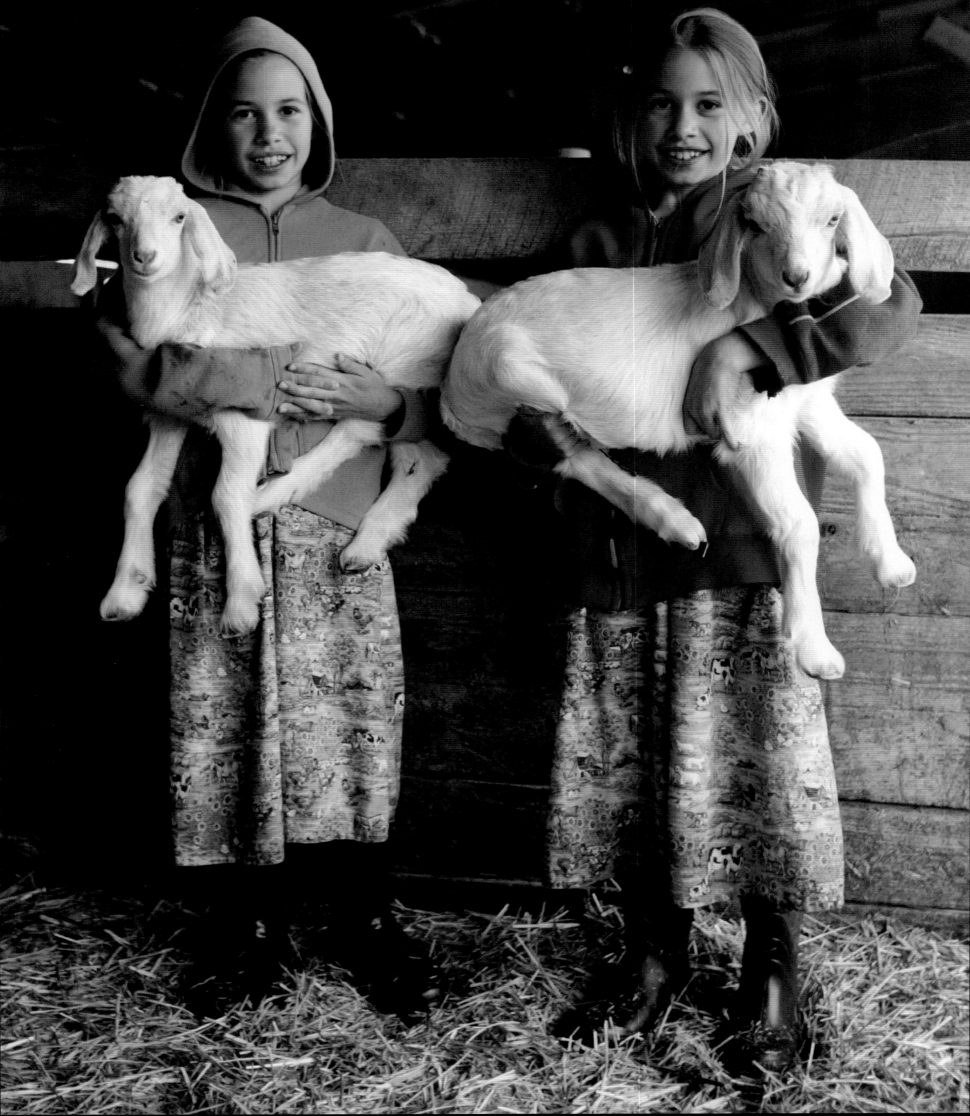

**LOGAN**

Twins Joanna and Meloday Fisher have seven siblings and four goats, including Willy and Billy. Playing with the goats by butting heads with them is one thing, drinking their milk another. Joanna tried goat's milk—twice. "It was kind of gross."

*Photo by Eric Albrecht,*
*The Columbus Dispatch*

**TROY**

Lucas Hershberger and his grandpa Norris Young haul in a Jersey cow for milking on the family dairy farm. Young has been grooming 10-year-old Lucas and his two brothers to take over the business, which has been in the family for close to a century.

*Photo by Jim Witmer,*
*Dayton Daily News*

**LOGAN**

Farm girl Meloday Fisher and farm goat Blossom engage in a six-legged struggle. Meloday is trying to persuade Blossom to get to work and eat a patch of weeds.

*Photo by Eric Albrecht,*
*The Columbus Dispatch*

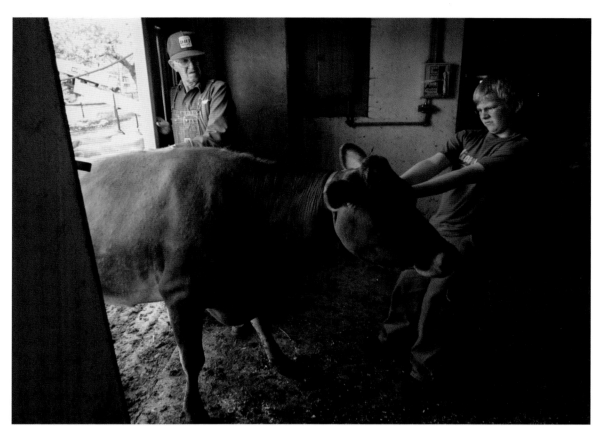

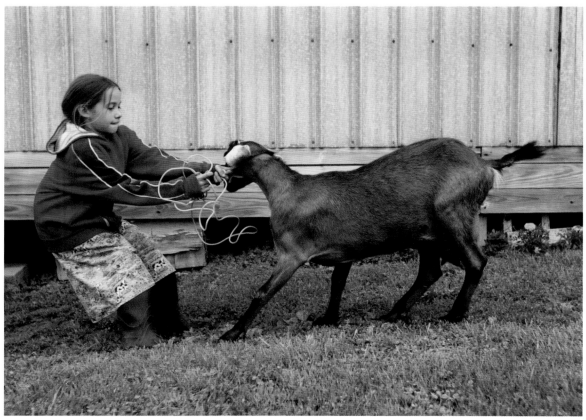

**MANSFIELD**
Spencer Johnson holds tiny Rachel, one of the family cat's five new kittens. Spencer, a seventh-grader, loves animals and often brings home stray dogs as well as the occasional snake or frog.
*Photos by Bruce Strong, LightChasers*

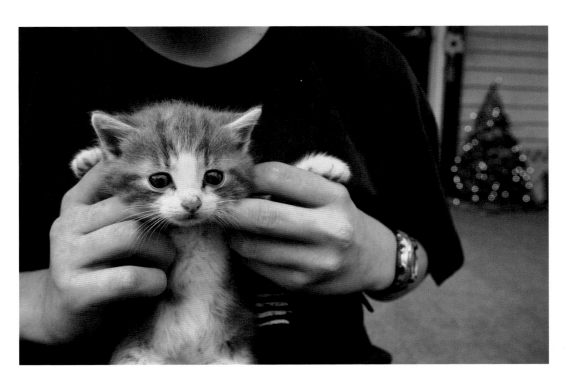

**MANSFIELD**

Michael Lee's family tends toward macho pets. Sid, a rottweiler-bulldog puppy, and Sunshine the python generally ignore each other—but the family never leaves the two animals alone together.

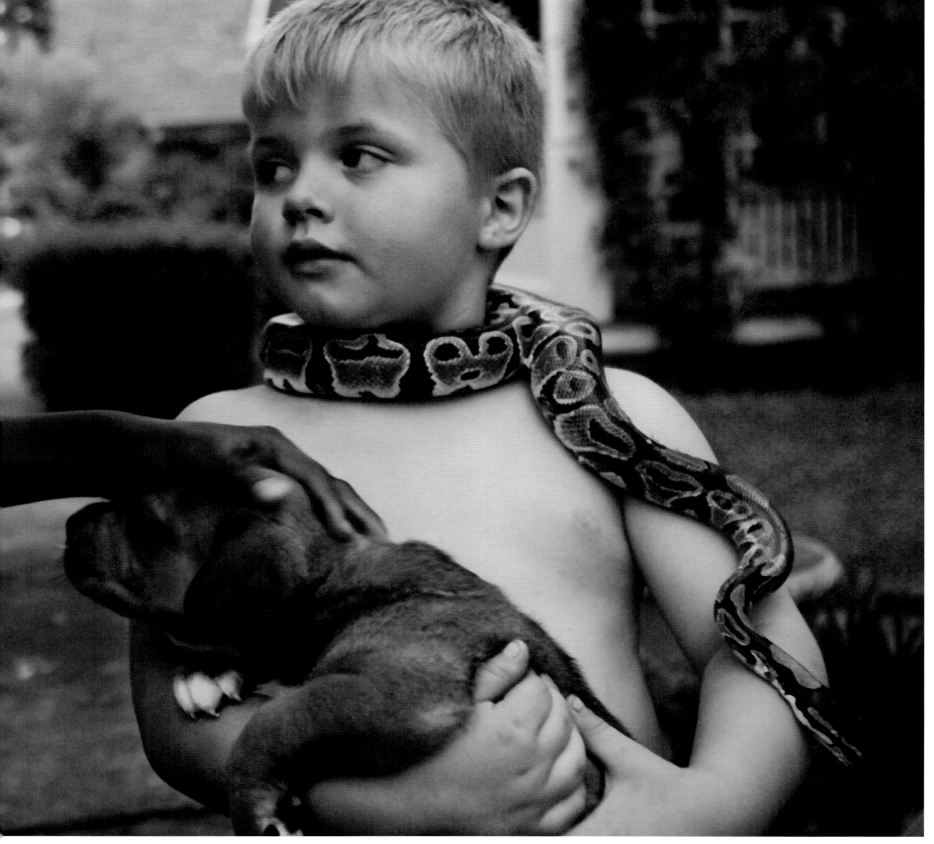

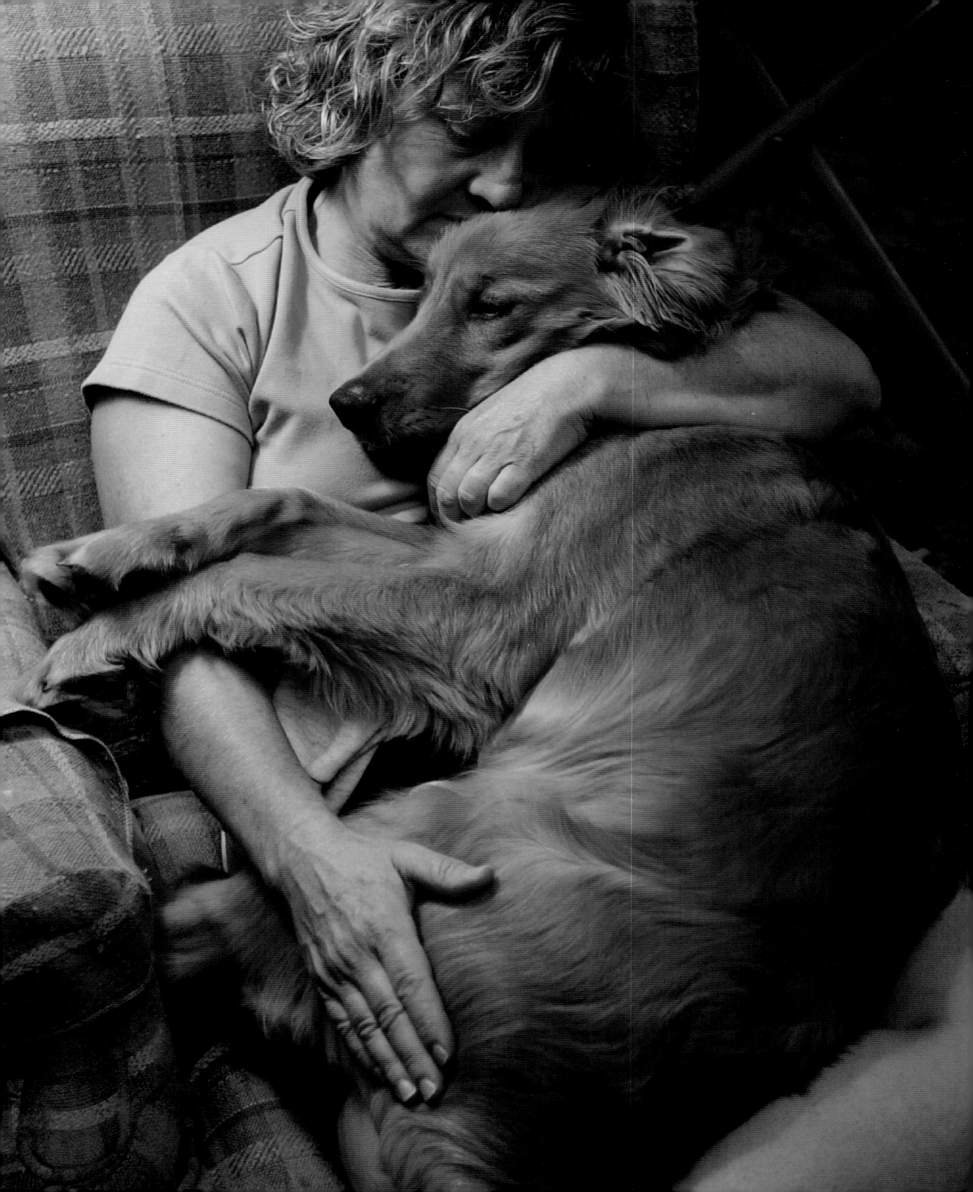

**CINCINNATI**

Melanie Reddy snuggles her baby, 6-month-old golden retriever Oliver. According to husband Pat, Melanie spoils the dog: "Ollie's supposed to stay off the furniture, but my wife always lets him crawl on the coach to take a nap with her."
*Photos by Patrick Reddy, Cincinnati Enquirer*

**HAMILTON**

Certified therapy dog Kippie pulls a moment of affection from Dorothy Wagner, a resident of an assisted living facility. With his tricks and cuddly nature, the little schipperke spends his time visiting patients in nursing homes and children's hospitals. "He loves people and could care less about other dogs," says owner and trainer Kim LeCompte.

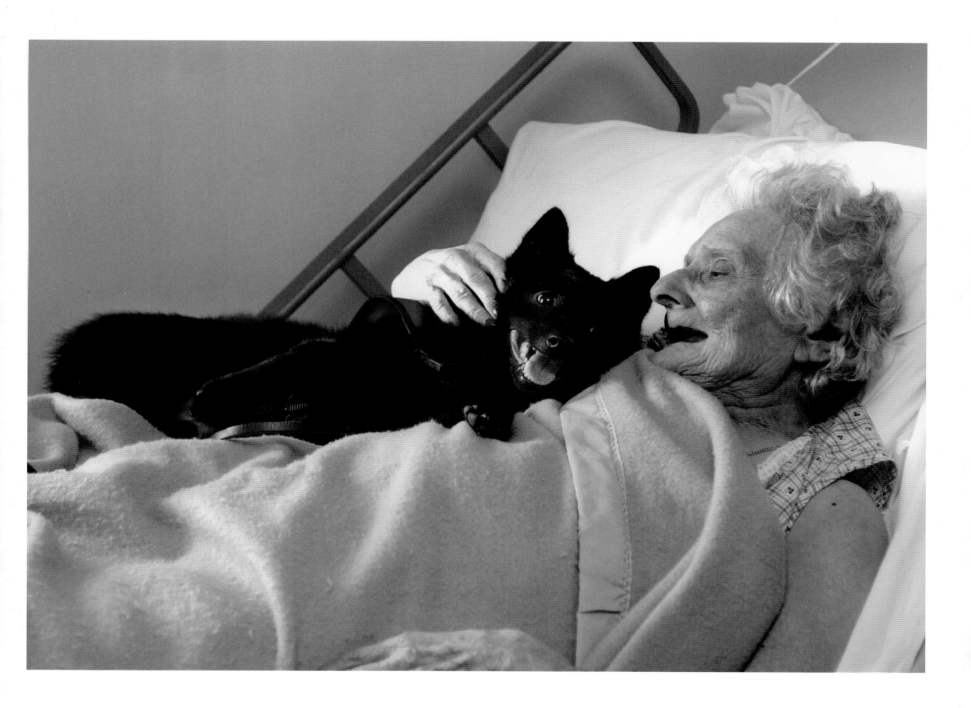

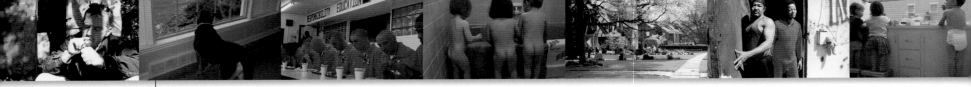

**BAY VILLAGE**
Brownie, a shepherd mix, watches from the living room window every day as Molly and Matthew Kasperek leave for school. The faithful dog knows exactly when the kids are due home and waits by the window for their return.
*Photo by Larry Kasperek,*
*Fuchs & Kasperek Photography*

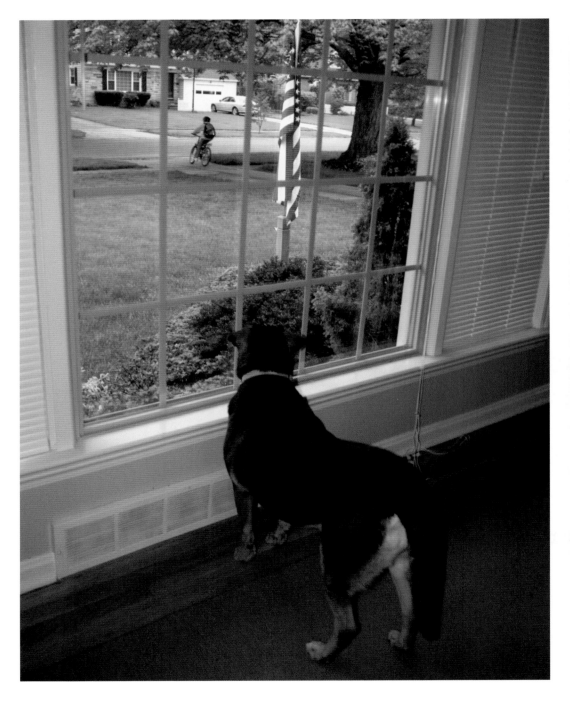

## COLUMBUS

Every night more than 100 men sleep at the Open Shelter. Although there are a half-dozen shelters in Columbus, The Open Shelter is the only one that accepts men regardless of their condition. Since the local government cut funding several years ago, the shelter's future remains uncertain.

*Photo by Doral Chenoweth,*
*The Columbus Dispatch*

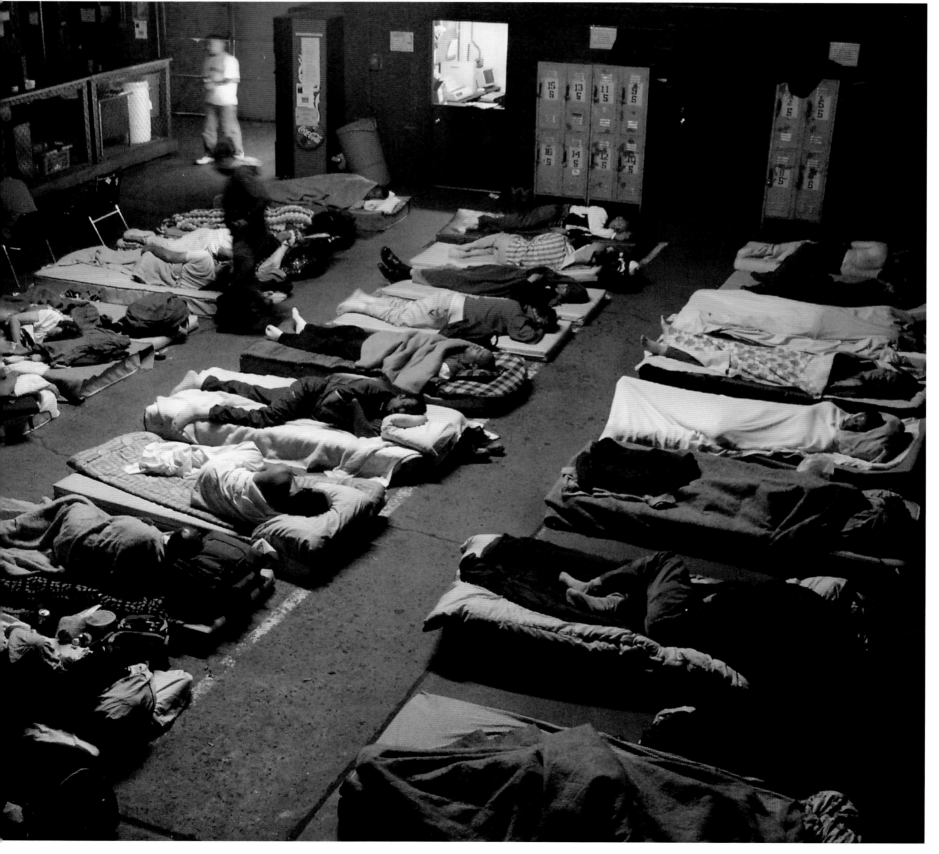

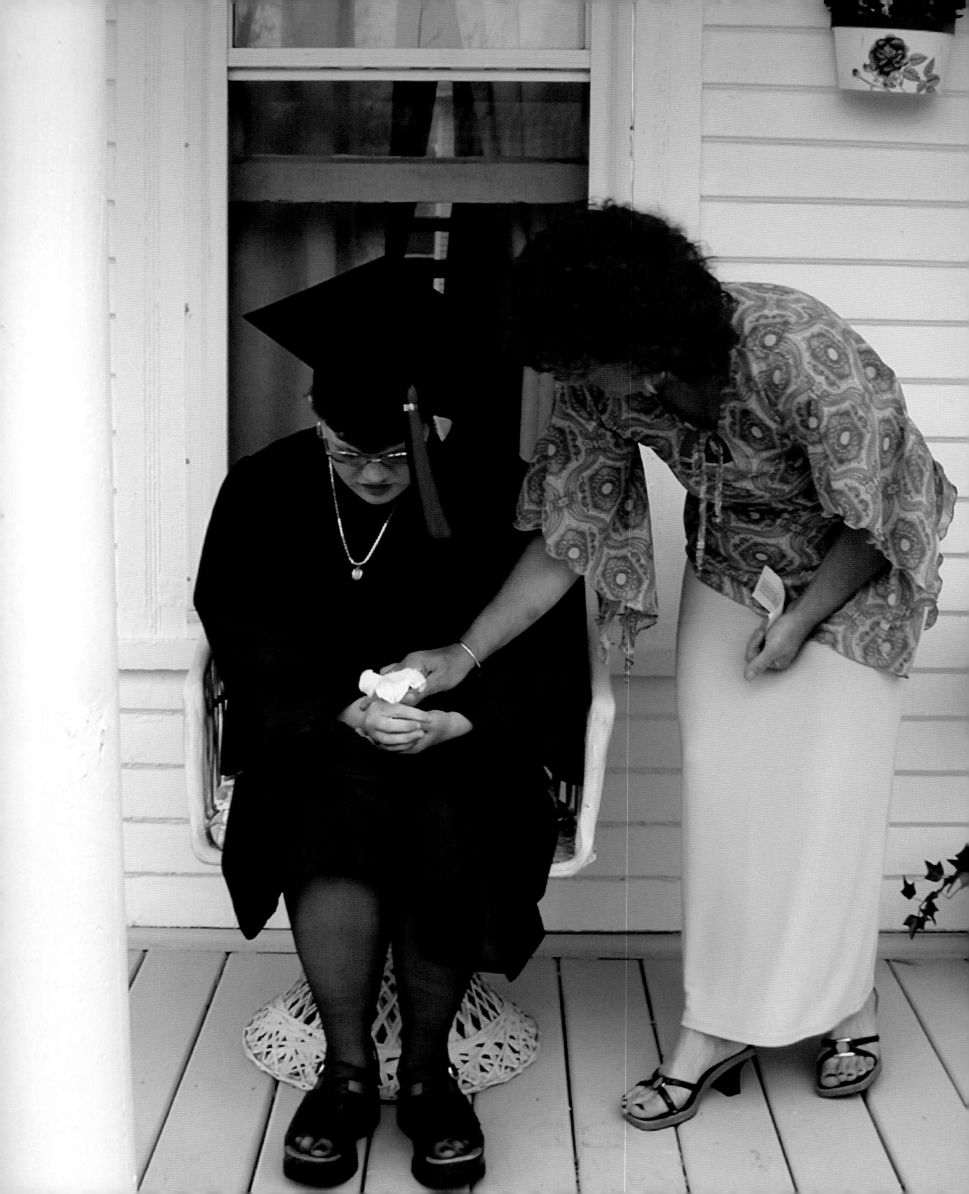

**ALBANY**

Soon-to-be high school graduate Renee Queen, 18, didn't get an easy start in life. Starting when she was 8, she bounced from one foster family to another until she landed with the Queens three years ago. "I could see her good qualities," says Becky Queen. "All Renee needed was lots of love and a consistent routine."

*Photo by Dana Romanoff, Ohio University*

**SEVILLE**

Rachel Ware, who says she lives "in the middle of nowhere," prepares for her day at Cloverleaf High School. She gets up at 6 a.m. in her basement bedroom, showers, washes her hair, straightens it, and then applies makeup: cover-up, bronzer, eyeliner, mascara, a little blush, and "if I'm feeling saucy," eye shadow. Eschewing lipstick, she prefers ChapStick or gels.

*Photo by Shirley Ware, Medina Gazette*

The year 2003 marked a turning point in the history of photography: It was the first year that digital cameras outsold film cameras. To celebrate this unprecedented sea change, the *America 24/7* project invited amateur photographers—along with students and professionals—to shoot and, via the Internet, submit digital images. Think of it as audience participation. Their visions of community are interspersed with the professional frames throughout this book. On the following four pages, however, we present a gallery produced exclusively by amateur photographers.

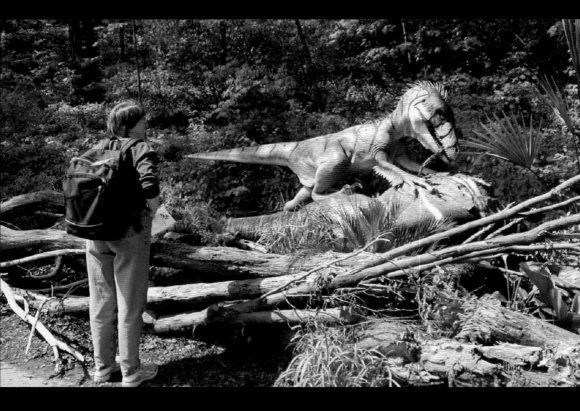

**CLEVELAND** It's a dinosaur-eat-dinosaur world out there at the Cleveland Metroparks Zoo. A domineering deinonychus shows a brachiosaurus who's boss. *Photo by Dave Hoffman*

**CLEVELAND** Eric Mundson and his girlfriend Brady Dindia just moved into their first place together: an airy downtown loft. Mundson said he couldn't believe it was theirs, and then fell silent. Dindia picked up her camera. *Photo by Brady Dindia*

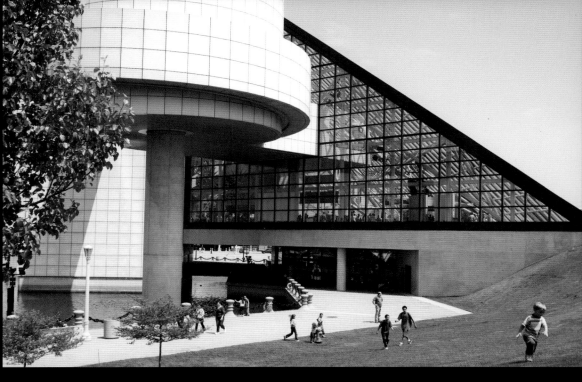

**CLEVELAND** Architect I.M. Pei didn't know much about rock 'n' roll when he was asked to design the Rock and Roll Hall of Fame and Museum. But he learned, and the place rocks. *Photo by Bonson Yee*

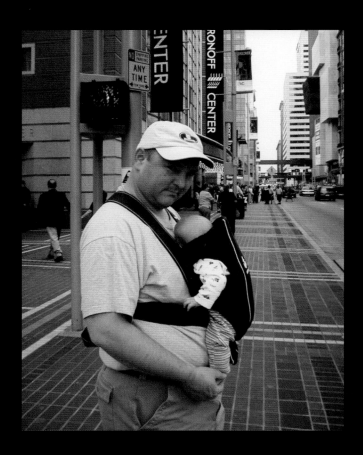

**CINCINNATI** Downtown, Larry Bohman soaks up some street life with baby Elijah. The Bohmans say they actively sought out city life. They made a decision to forgo green space in order to live right in the mix of things. *Photo by Lisa Bohman*

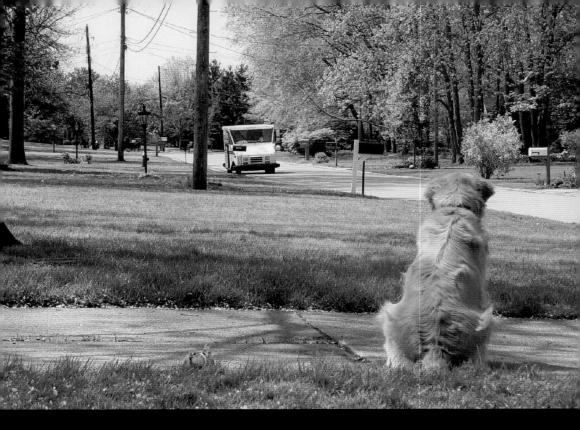

**BRECKSVILLE** Rocky and the mailman are such good buddies that when the carrier had surgery, Rocky's owner gave him a picture of the retriever to cheer him up. *Photo by Jason Kossman*

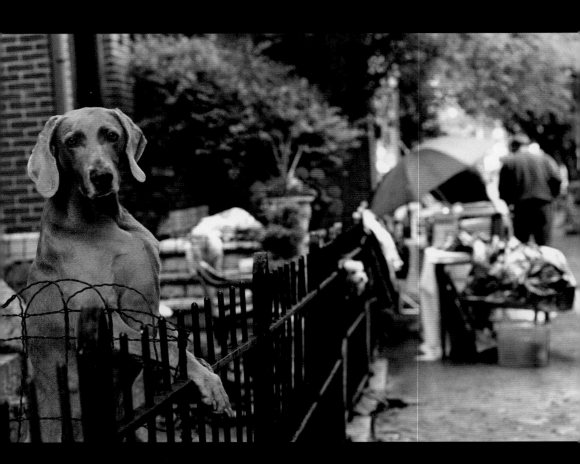

**COLUMBUS** South of downtown, a weimaraner oversees the annual yard sale put on by the historic German Village District. There's also a *Biergarten*. *Photo by Chris Pezzutti*

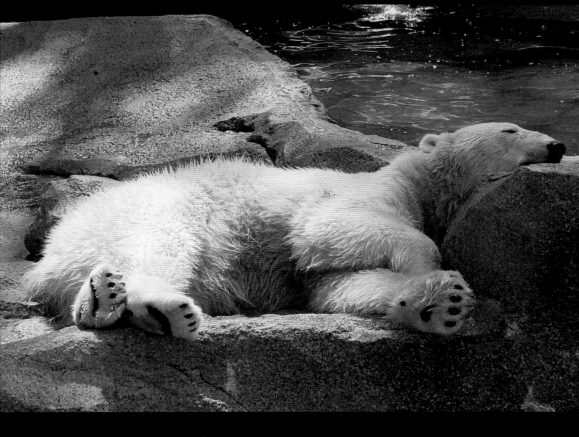

**CINCINNATI** With the Cincinnati Zoo's new 21,000-square-foot "Lords of the Arctic" polar bear habitat, there is plenty for 7-year-old Rizzo to do, or not. *Photo by John DeMarco*

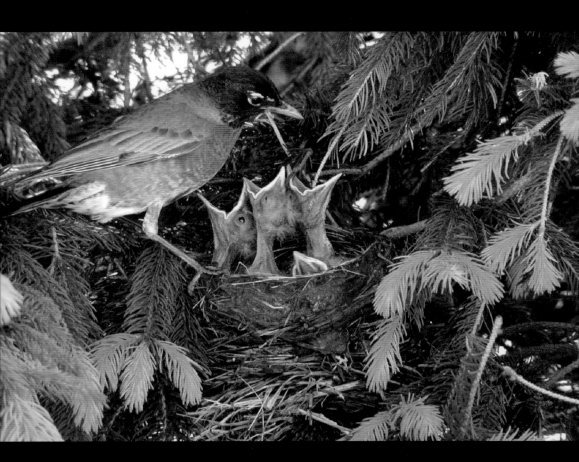

**DAYTON** Perhaps because the state bird is not the robin (it's the cardinal), robin chicks are especially hungry for attention. *Photo by Carl Keller*

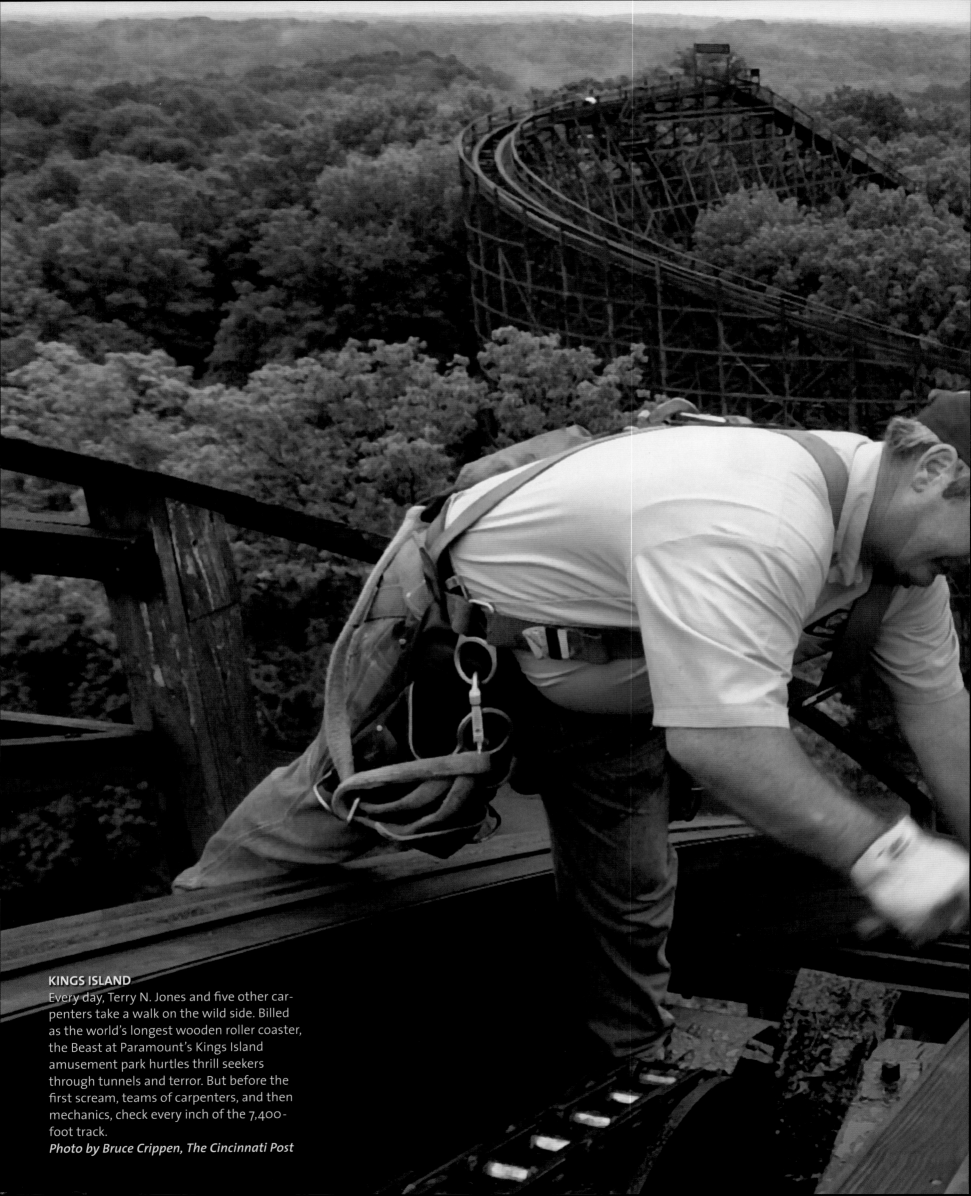

**KINGS ISLAND**
Every day, Terry N. Jones and five other carpenters take a walk on the wild side. Billed as the world's longest wooden roller coaster, the Beast at Paramount's Kings Island amusement park hurtles thrill seekers through tunnels and terror. But before the first scream, teams of carpenters, and then mechanics, check every inch of the 7,400-foot track.
*Photo by Bruce Crippen, The Cincinnati Post*

Hard At Work

**COSHOCTON**

Mass-produced rolls of flags await shipment at the Annin & Company factory, the country's oldest and largest manufacturer of flags. After 9/11, demand for American flags doubled, forcing Annin's four plants to work around the clock to fill their backlog of orders.

*Photos by Lawrence Hamel-Lambert*

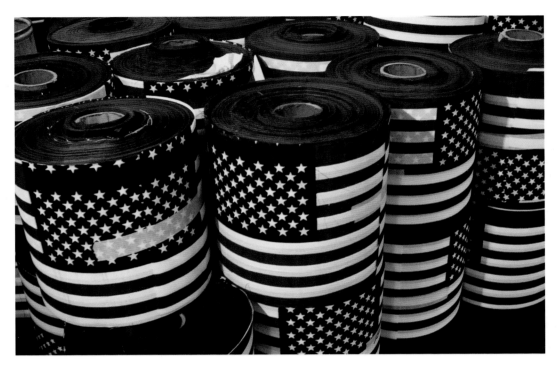

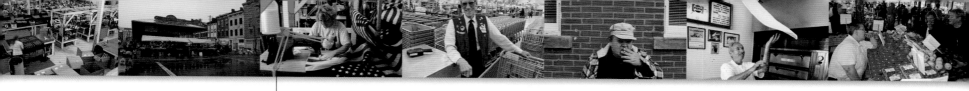

**COSHOCTON**

Jodi Bradford steadies a swath of stars and stripes through a Juki industrial sewing machine. During the spring rush, the seamstress produces 600 to 1,200 flags each day at Annin to meet consumer demand for Memorial Day and Fourth of July decorations.

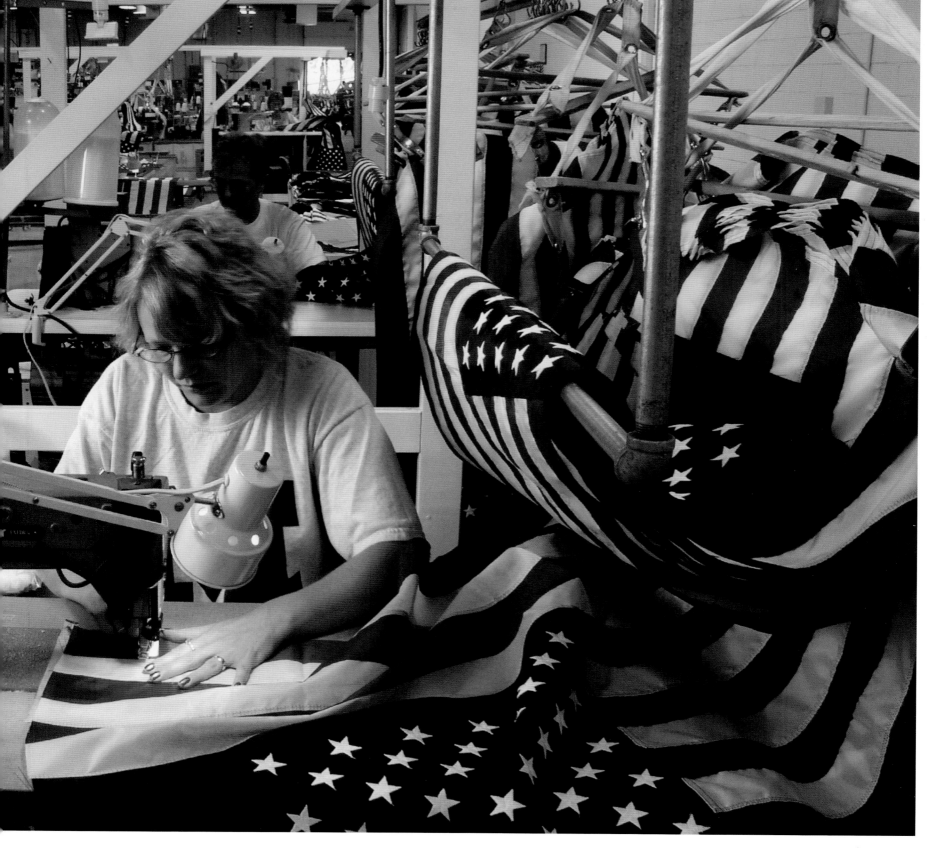

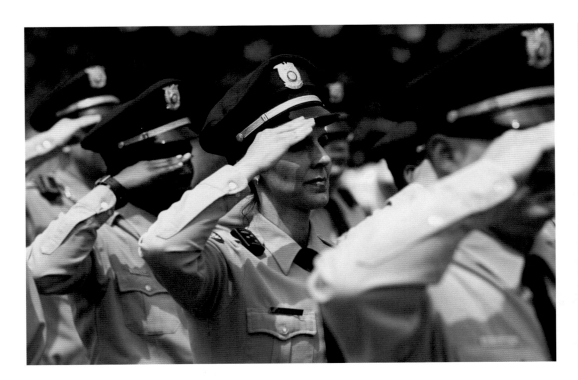

**DAYTON**
In front of headquarters, Dayton Police Officer Becky Rose, a 17-year veteran, salutes her fallen comrades. Every May, on National Peace Officer's Memorial Day, police departments across the country honor cops who have been killed in the line of duty. Dayton's police force has lost 24 officers since its inception in 1873.
*Photo by Skip Peterson, Dayton Daily News*

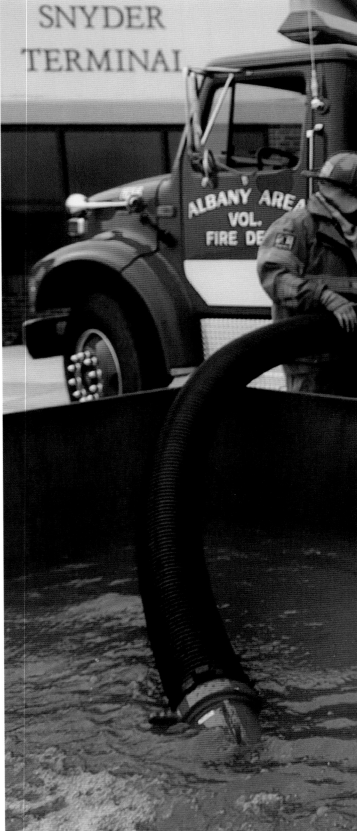

**ALBANY**

Athens County tests its first responders with a mock airplane crash at Ohio University Airport. Firefighters transfer water from hydrants to this temporary basin where a pumper truck refills before rushing to the simulated impact site.

*Photo by Robert Caplin*

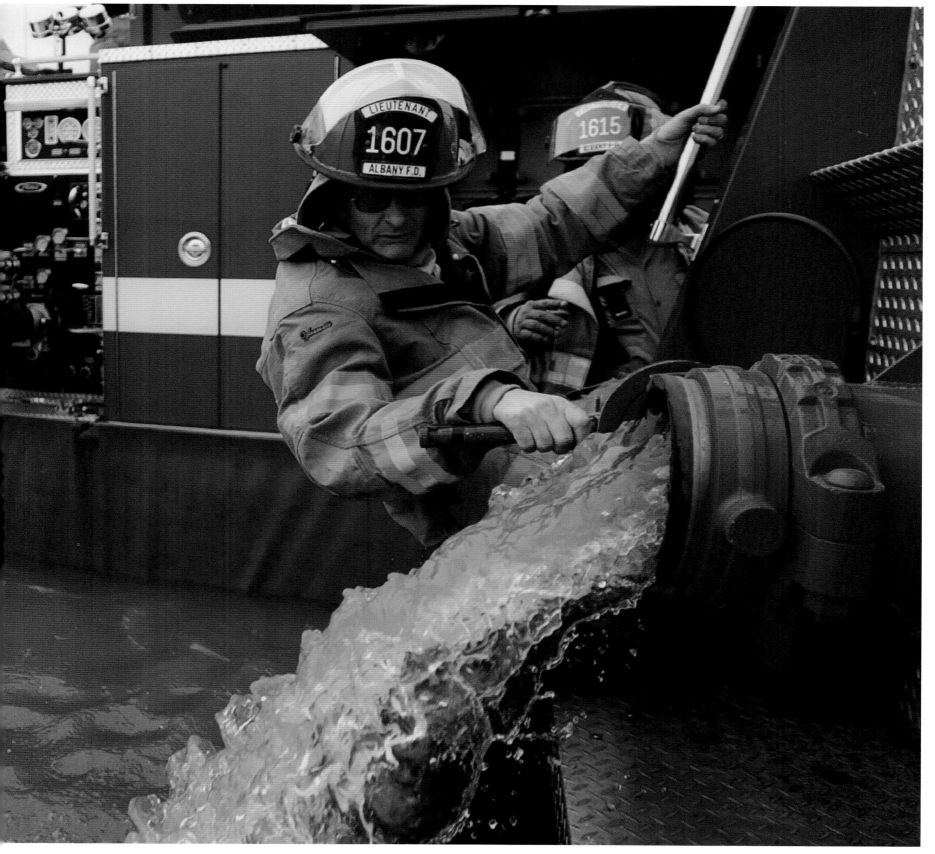

**CLEVELAND**

Steel worker John Polinsky watches the basic oxygen furnace at ISG Cleveland Inc., a supplier of cast steel for automotive, appliance, and construction companies. Typical of the struggling steel industry, the plant's workforce has been reduced from 3,100 in 2001 to its present roster of 1,300.

*Photo by Dale Omori*

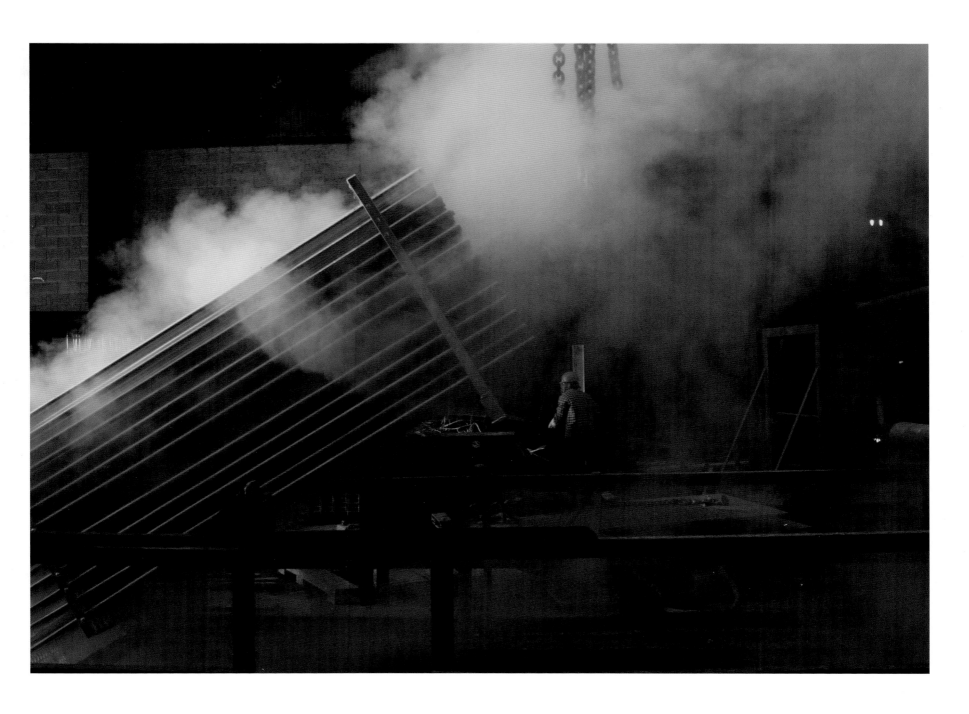

**CANTON**

A newly galvanized rack of heating pipes lets off a little steam at Gregory Industries. Started in 1916, the company specializes in applying a zinc coating to finished steel products—everything from small bolts to 17-ton beams. The 275,000-square-foot plant is run by a fifth-generation Gregory.

*Photo by Bruce Strong, LightChasers*

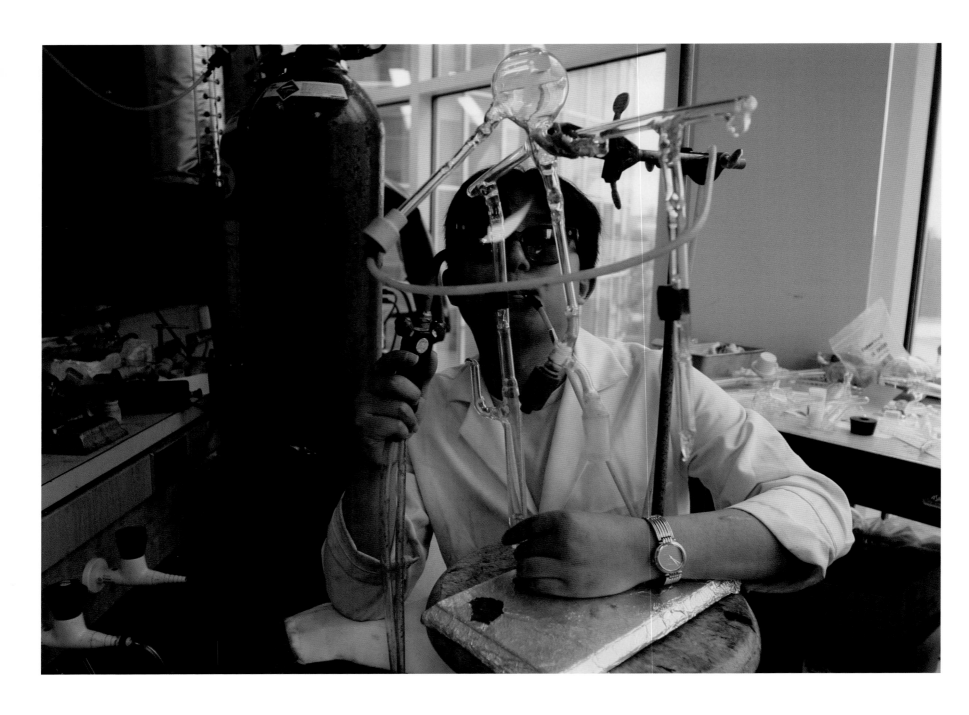

**AKRON**
Graduate student Xiaoliang Zheng fuses glass tubes before an experiment on polymer brush structures—chains of molecules that form a new material used in optical technology. "It is really hard to explain what I do," says Zheng. No kidding.
*Photo by Carolyn Drake*

**TIFFIN**

Aiden Scully learned the art of crystal glass cutting from the best: Waterford's legendary Edward J. Flavin. After working in Ireland and England, Scully, a master crystal glass cutter and designer, came to the Crystal Traditions studio showroom as an artist in residence. The company, which evolved from the Tiffin Glass factory, is dedicated to keeping Ohio's glass-making heritage alive.

*Photo by Bruce Strong, LightChasers*

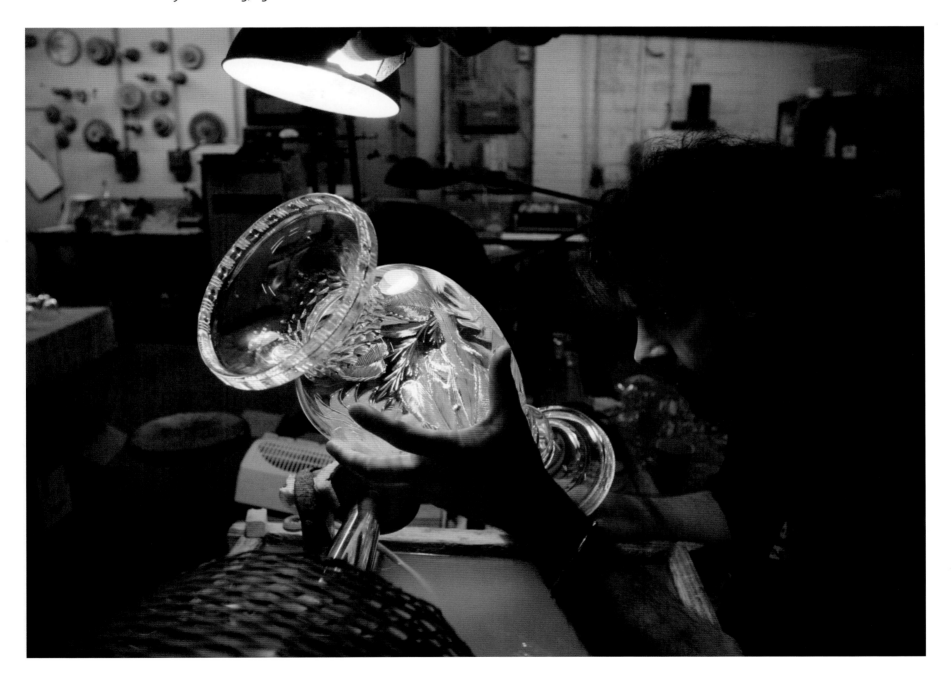

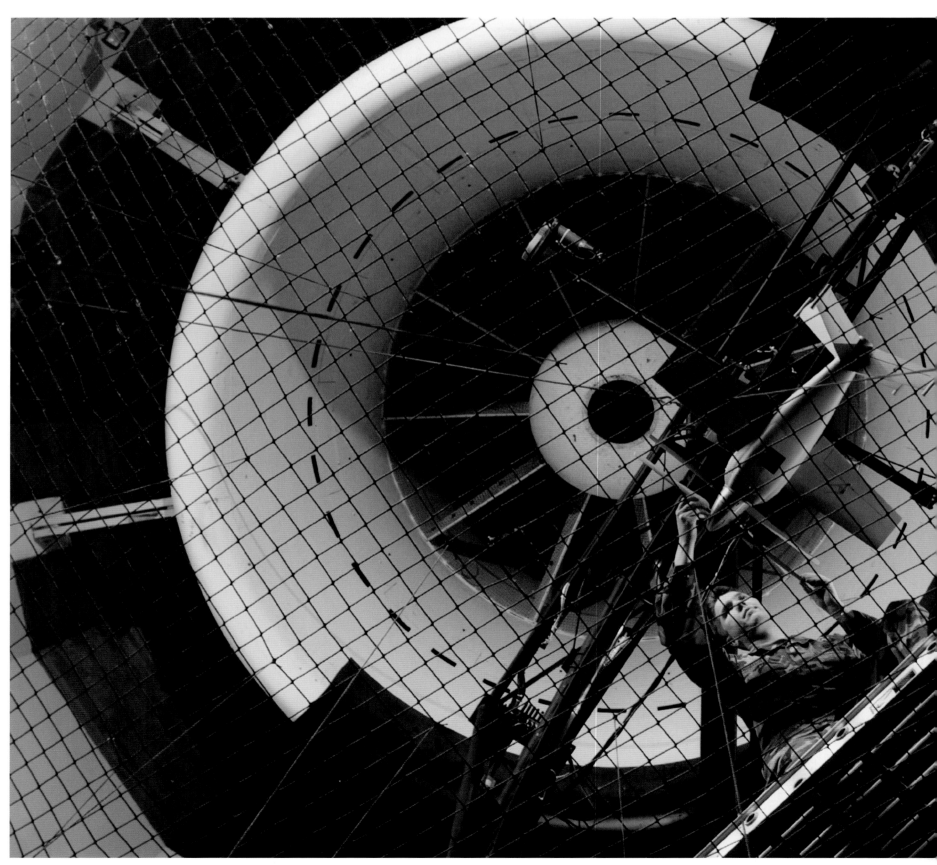

**WRIGHT PATTERSON AIR FORCE BASE**
Lieutenant Art Morse manipulates the position of a Skytote unmanned aircraft model. The aerospace engineer uses a vertical wind tunnel to test the impact of different airflow speeds on the plane's lift and drag. The experimental pilotless aircraft is being developed to deliver and retrieve cargo in war zones.
*Photo by Jim Witmer, Dayton Daily News*

**DAYTON**

In 1916, Henry Ford's original Model T traveled on Dayton Wire Wheels. The distinctive wheels now sparkle on everything from vintage sports cars to low riders. At the factory, Lisa Collier hand laces spokes on about 35 wheels a day. "Sometimes I'll notice a guy's wheel and know I laced it because I see my sticker," says Collier.

*Photo by Skip Peterson, Dayton Daily News*

**MORAINE**

Romana Lovins installs a torque converter on an SUV engine at the GM Truck and Bus Group assembly plant. She begins her shift at 5:20 a.m. and works four 10-hour days a week in a plant that produces 1,240 SUVs every day. "These days, I'm lucky to have a good job with great benefits," says the 10-year GM veteran.

*Photo by Skip Peterson, Dayton Daily News*

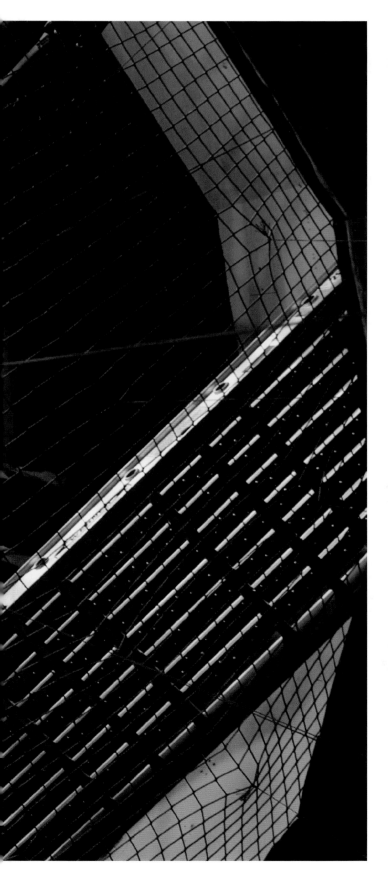

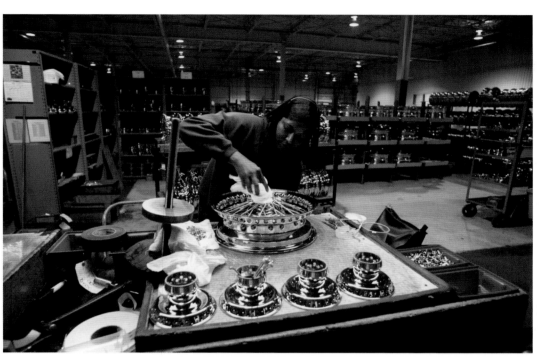

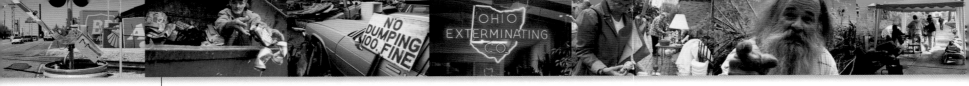

**ATHENS**

The dumpsters behind the fraternity houses at Ohio University are a gold mine for can collector William Hutchenson. On a weekend morning, he scavenges up to 200 beer cans from this bin near the Sigma Alpha Epsilon fraternity.
*Photo by Robert Caplin*

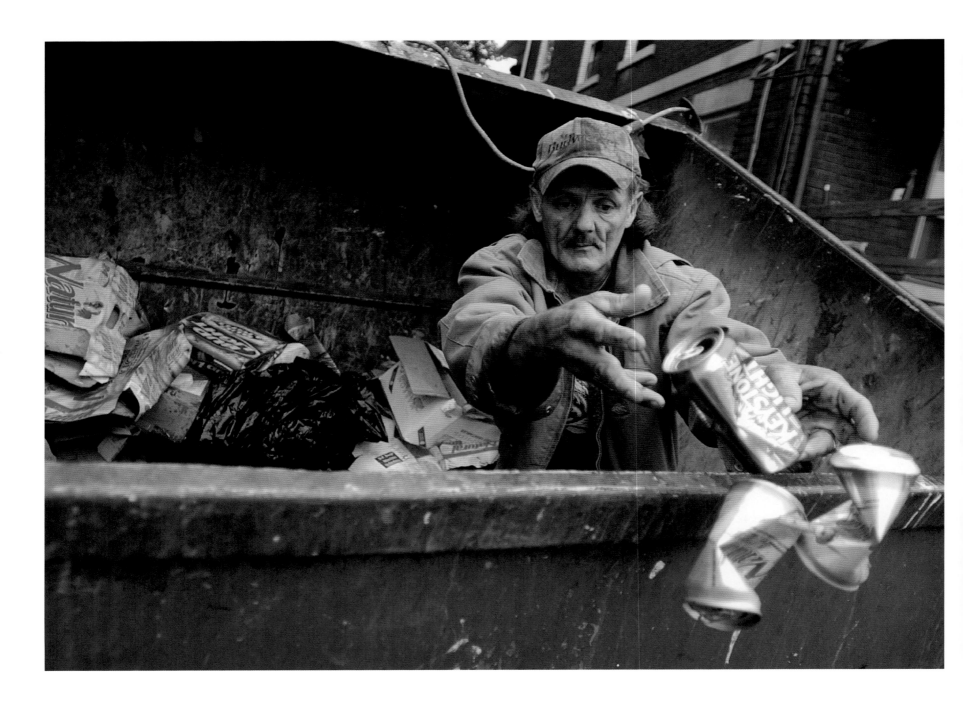

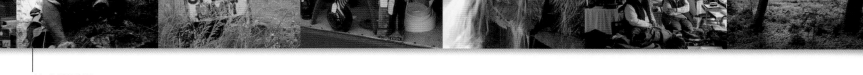

**McARTHUR**

"There is real history right here. I can feel in these bottles a piece of other people's lives," says carpenter Wayne McComis, digging for old bottles on the banks of Raccoon Creek. Weather permitting, McComis gets out and digs nearly every day.
*Photo by Andres Gonzalez, Ohio University*

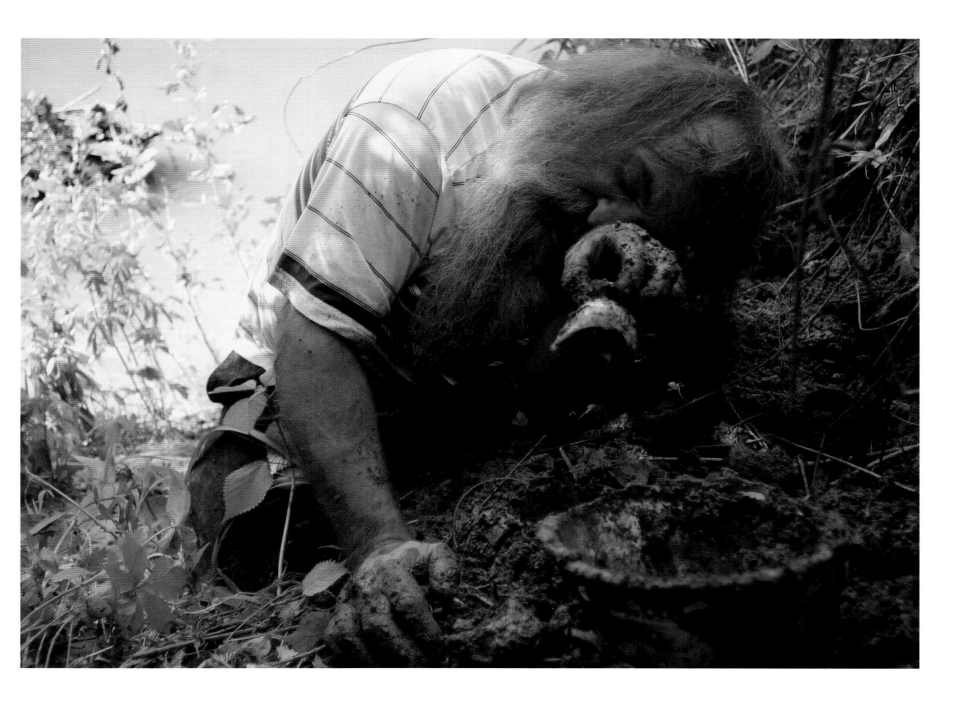

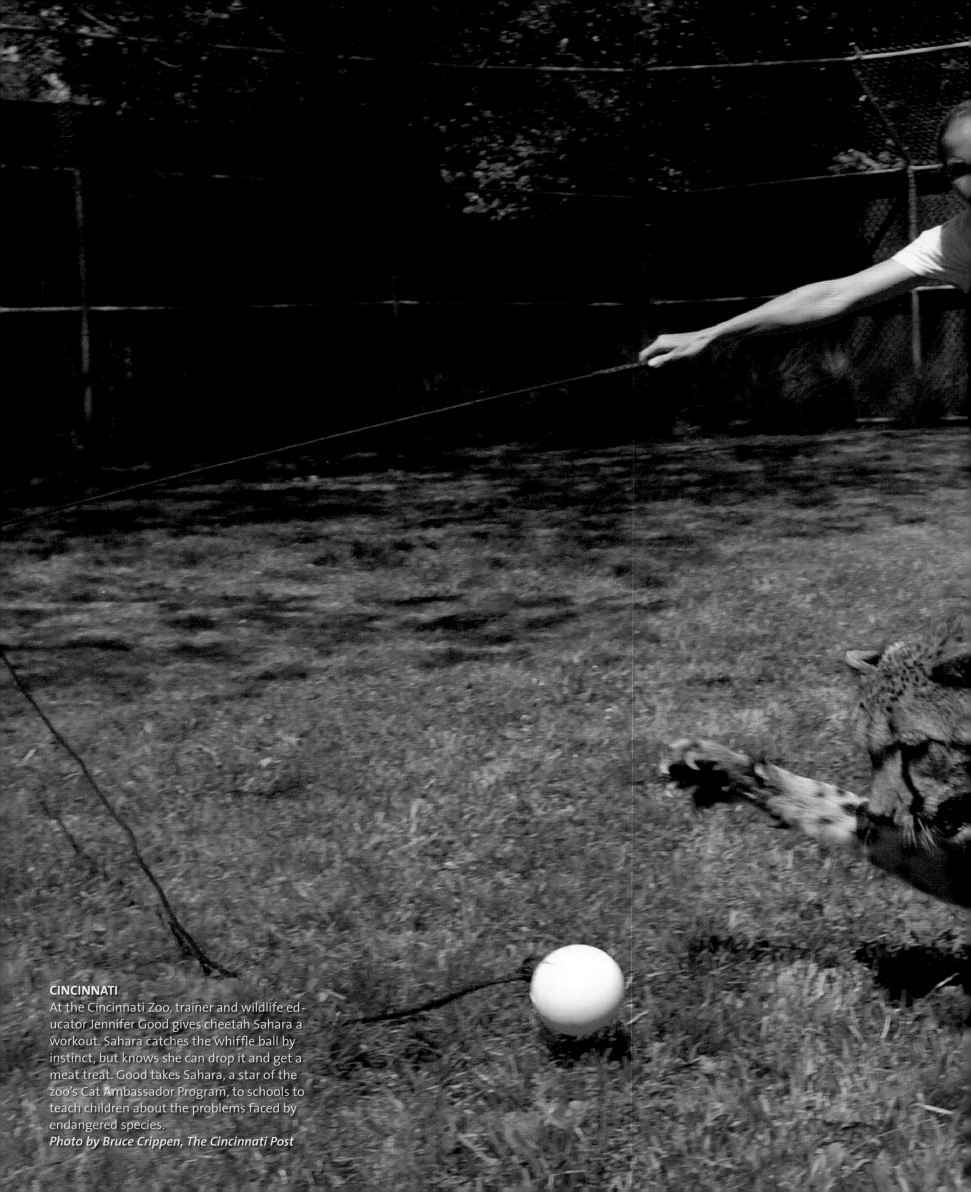

**CINCINNATI**
At the Cincinnati Zoo, trainer and wildlife educator Jennifer Good gives cheetah Sahara a workout. Sahara catches the whiffle ball by instinct, but knows she can drop it and get a meat treat. Good takes Sahara, a star of the zoo's Cat Ambassador Program, to schools to teach children about the problems faced by endangered species.
*Photo by Bruce Crippen, The Cincinnati Post*

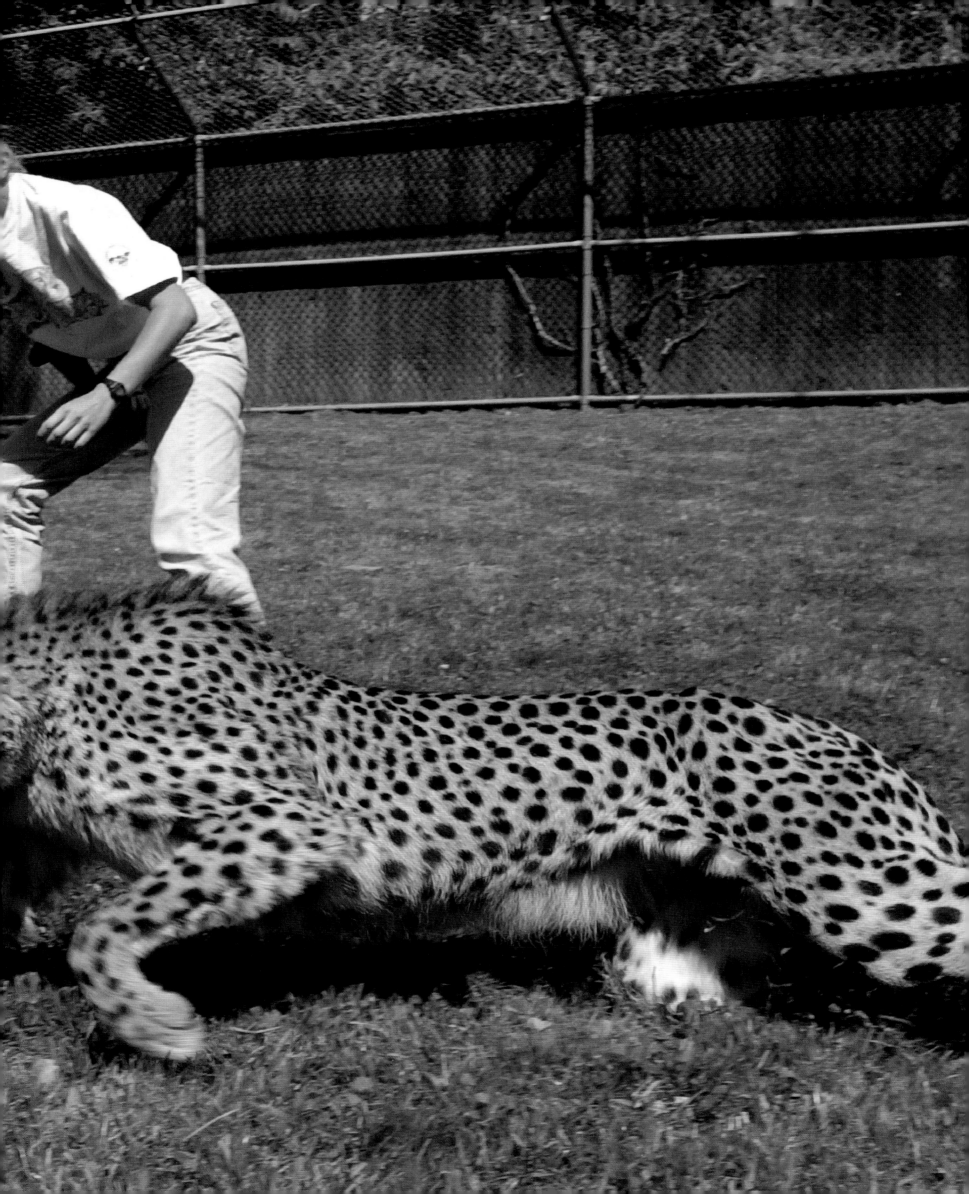

At Lee Middleton Original Dolls, Inc., the largest doll factory in America, Ruth Fleming stuffs polyester fill into the body of a life-size, vinyl toddler. One of 60 employees at the 34,000-square-foot facility, Fleming does a variety of jobs. Her favorite? Painting eyes and mouths using a stencil, followed by air brushing blush on the cheeks.
*Photos by Uma Sanghvi*

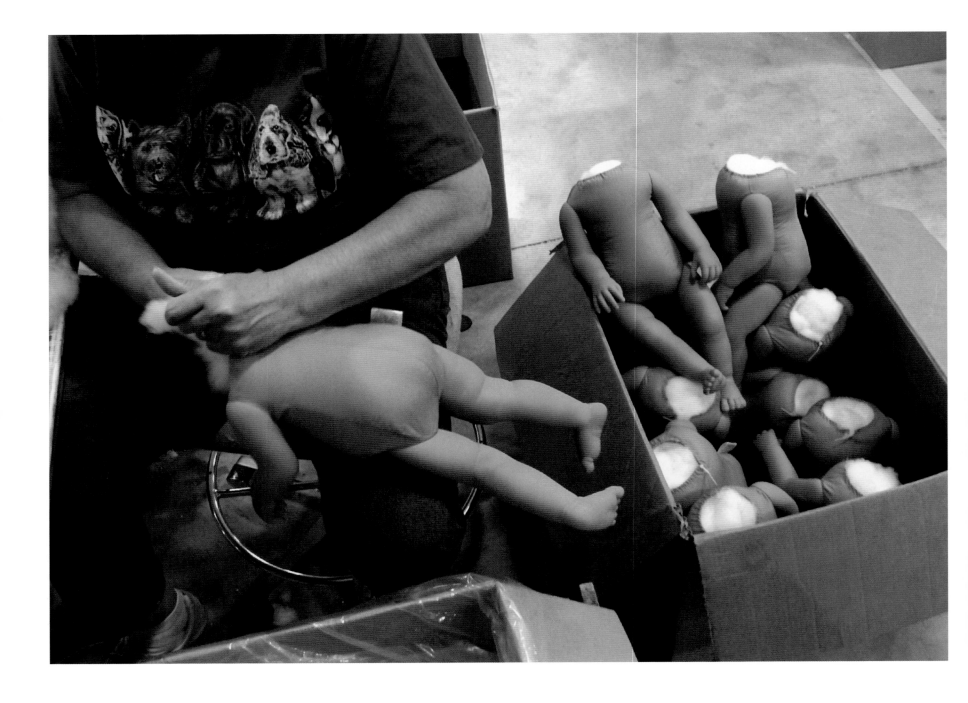

**BELPRE**

No, they're not triplets. They're Lee Middleton doll heads waiting to get eyelashes. Prized by collectors for their lifelike appearance, the vinyl dolls have been produced since 1978—and are priced between $180 and $350.

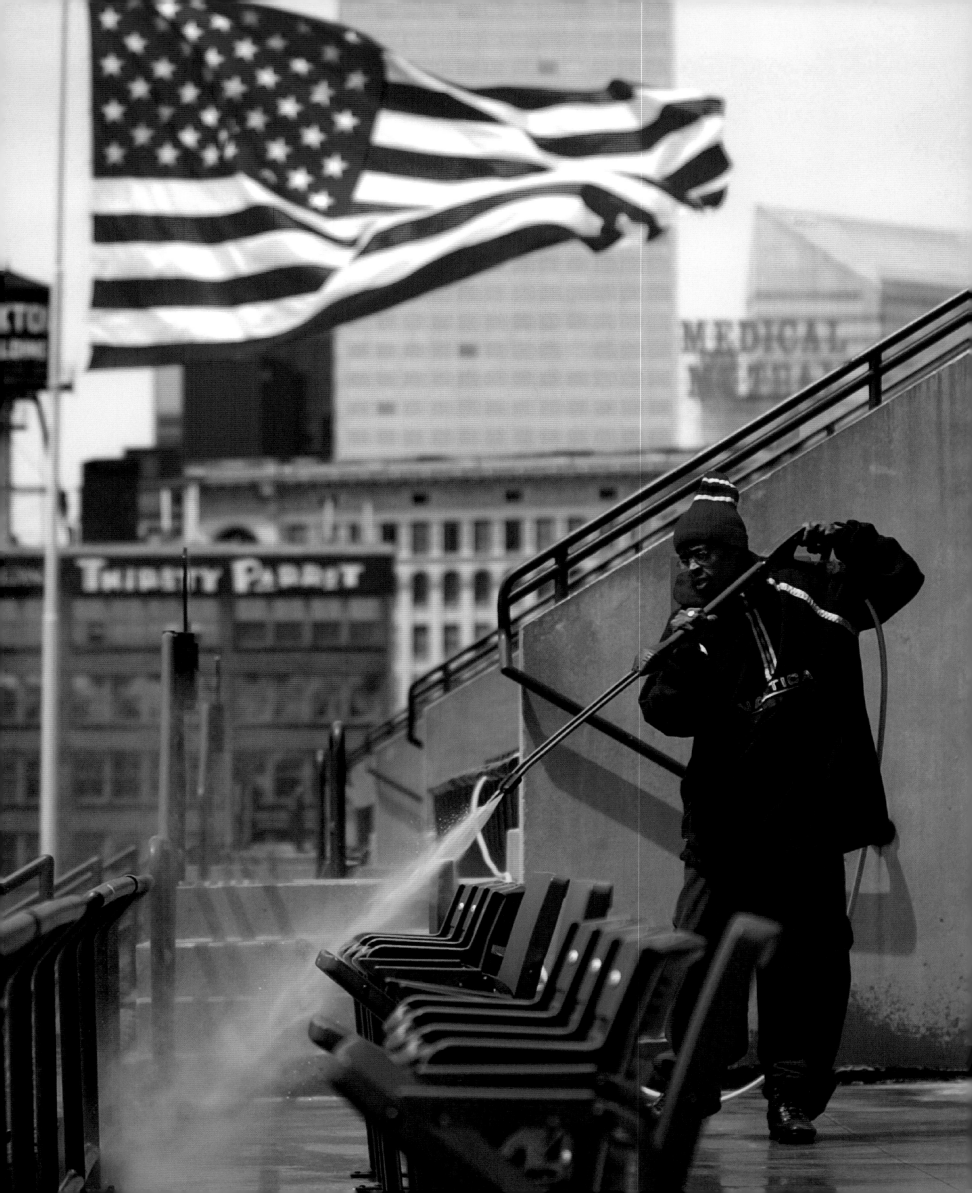

**CLEVELAND**

Greg Harper rinses the postgame scuzz off Jacobs Field's 43,000 seats. Peanut shells and popcorn and beer spills are no match for his 168-PSI spray gun. After the stadium dries, Cleveland Indians fans will fill the seats for a game against the Seattle Mariners.

*Photo by David G. Massey*

**CANTON**

Sign installer Daniel King stands atop a 30-foot ladder while he and partner Bryan Chaddock snap a chalk line to create a grid for muralist Scott Hagan. Using the grid as a guide, Hagan will paint his 20-by-20-foot Ohio Bicentennial logo on this wall at the Football Hall of Fame. Statehood came to Ohio on March 1, 1803.

*Photo by Bruce Strong, LightChasers*

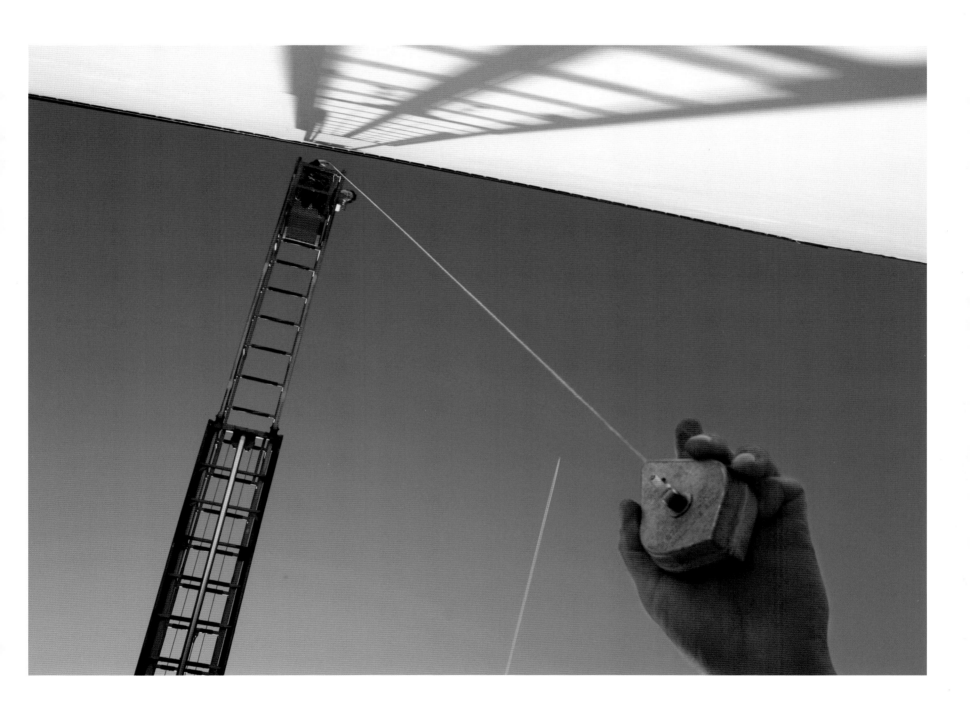

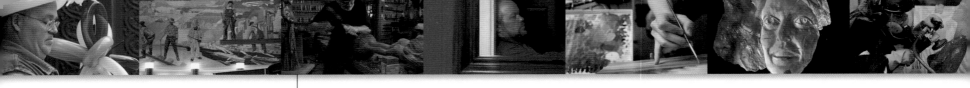

**ATHENS**

An accident led David Hostetler to a career in art. After suffering a shrapnel wound during a WWII Army training exercise, he took up sketching during his recovery. Since then, he's created sculptures for mogul Donald Trump and has shown his work in 25 museums worldwide. His hardwood and bronze pieces explore the female form.
*Photo by Terry E. Eiler, Ohio University*

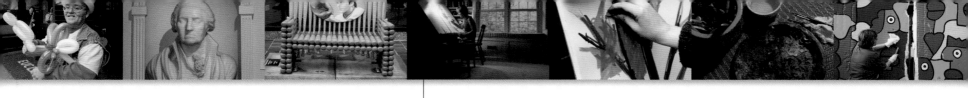

**MILFORD**

"It's a passion," says Kathy Crowther of painting. She gets up at 5:30 a.m., has breakfast with her banker husband, and hits the easel by 6.
*Photo by Bruce Crippen, The Cincinnati Post*

**CLEVELAND**
Architecture and design buffs from as far away as Japan order ornamental plaster from the Fischer & Jirouch Company. That's because the business, established in 1902, makes each cornice, frieze, mantel, and ceiling medallion (pictured) by hand.
*Photo by Albert P. Fuchs,*
*Fuchs & Kasperek Photography*

**CINCINNATI**
Andy Eschenbach worked as an apprentice for a year to become a tattoo artist. At Designs by Dana, customers can choose from his original creations or off-the-shelf images like the long-horn skull he traces on Bryan Chaddock's back. "With this work, art becomes a living thing," Eschenbach says.
*Photo by Patrick Reddy, Cincinnati Enquirer*

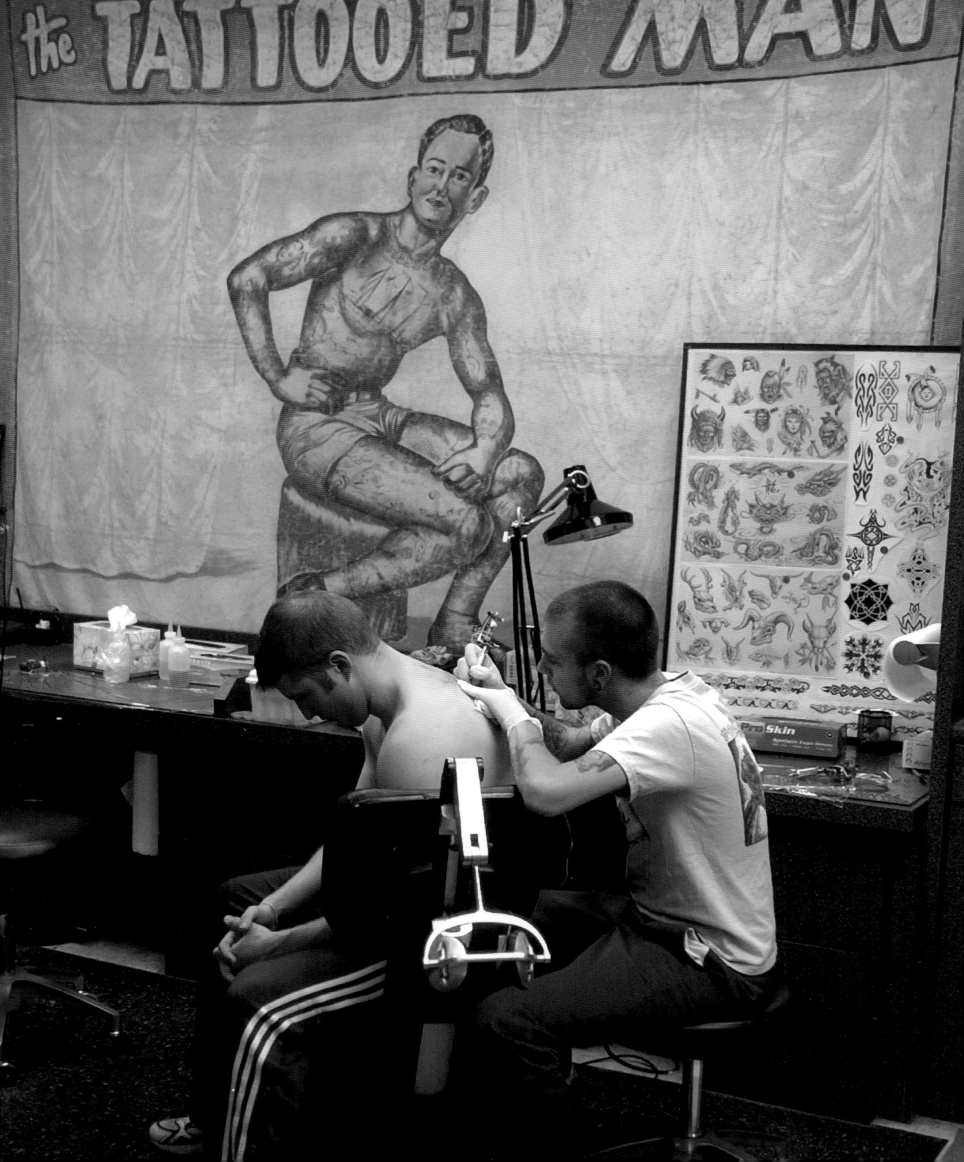

**COLUMBUS**
While trying to get a full-time teaching job, Danie
Rettig plants seedlings for Oakland Nursery. Here,
she's set to trowel scaevola zig zag and scaevola
blue wonder into planters outside stores along
East Broad Street.
*Photo by Eric Albrecht, The Columbus Dispatch*

Ron Hollmeyer sprays the chemical Sevin on his Jonathan apple trees to reduce the yield and increase the size of the fruit. His 45-acre apple and pear orchard has been in the family since 1916, when grandfather William Hollmeyer bought the property. Nowadays, Ron wholesales some produce, but sells most of it at the family farm's open-air market.

*Photo by Patrick Reddy, Cincinnati Enquirer*

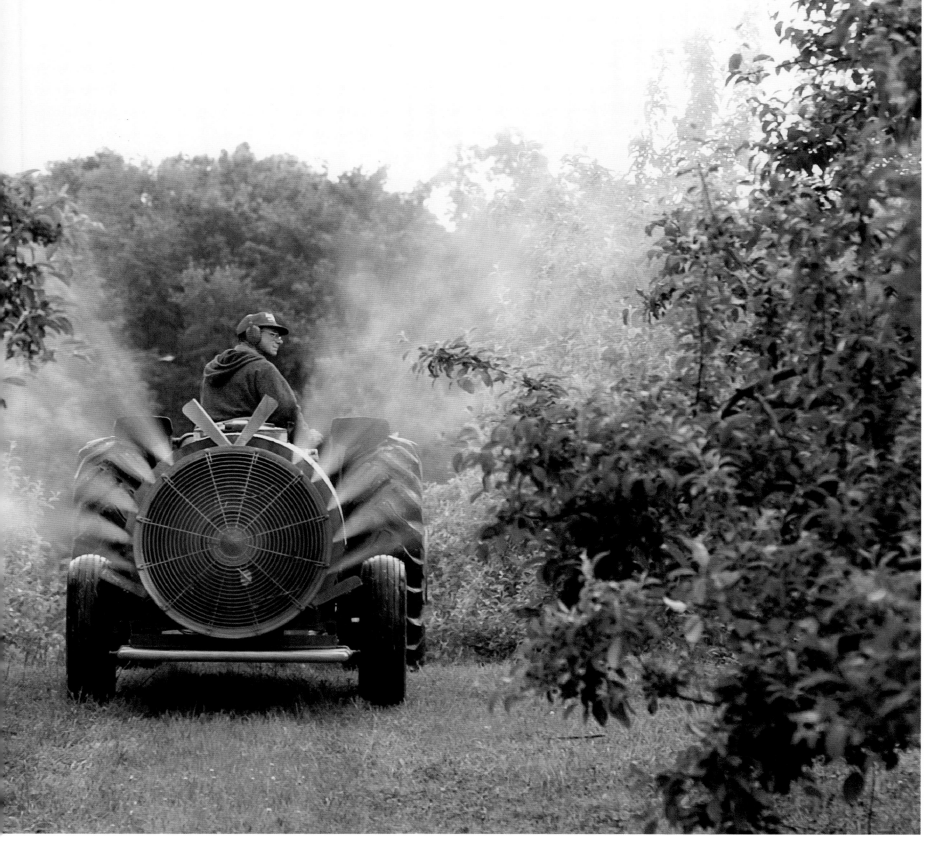

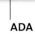

## ADA

The world's football capital is Ada (pop. 5,582). The NFL, colleges, and youth leagues all use the cowhide models manufactured by people like Pam Clark, Barbara Ulrey, and Micki Adams at the Wilson Sporting Goods Company. It takes three to five days for the plant's hide cutters, stitchers, bladder inserters, and lacers to produce a Super Bowl–quality football.
***Photo by Bill Reinke, Dayton Daily News***

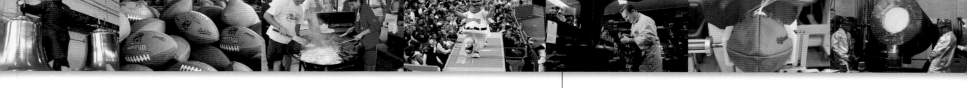

## COLUMBUS

Joe Nagy, 80, began repairing shoes on Parsons Avenue in 1948 and still does—despite the ubiquitous Nike, Skechers, and Teva. He closes the shop on Wednesdays to go grocery shopping and for reunions with the 8th Air Force. Nagy was a radio operator and gunner during World War II.
*Photo by Eric Albrecht, The Columbus Dispatch*

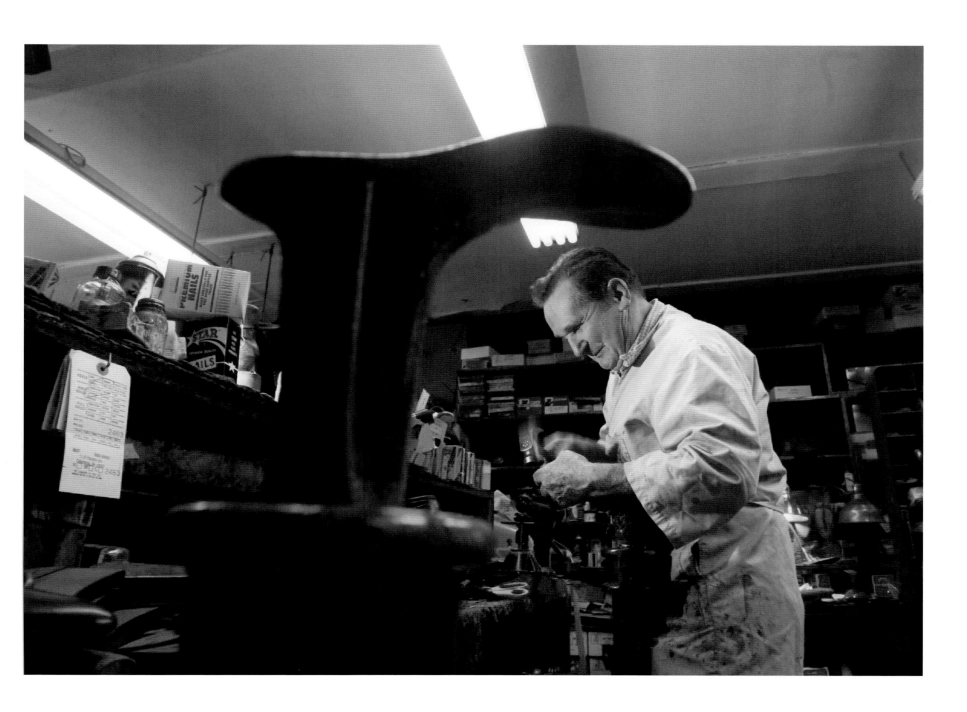

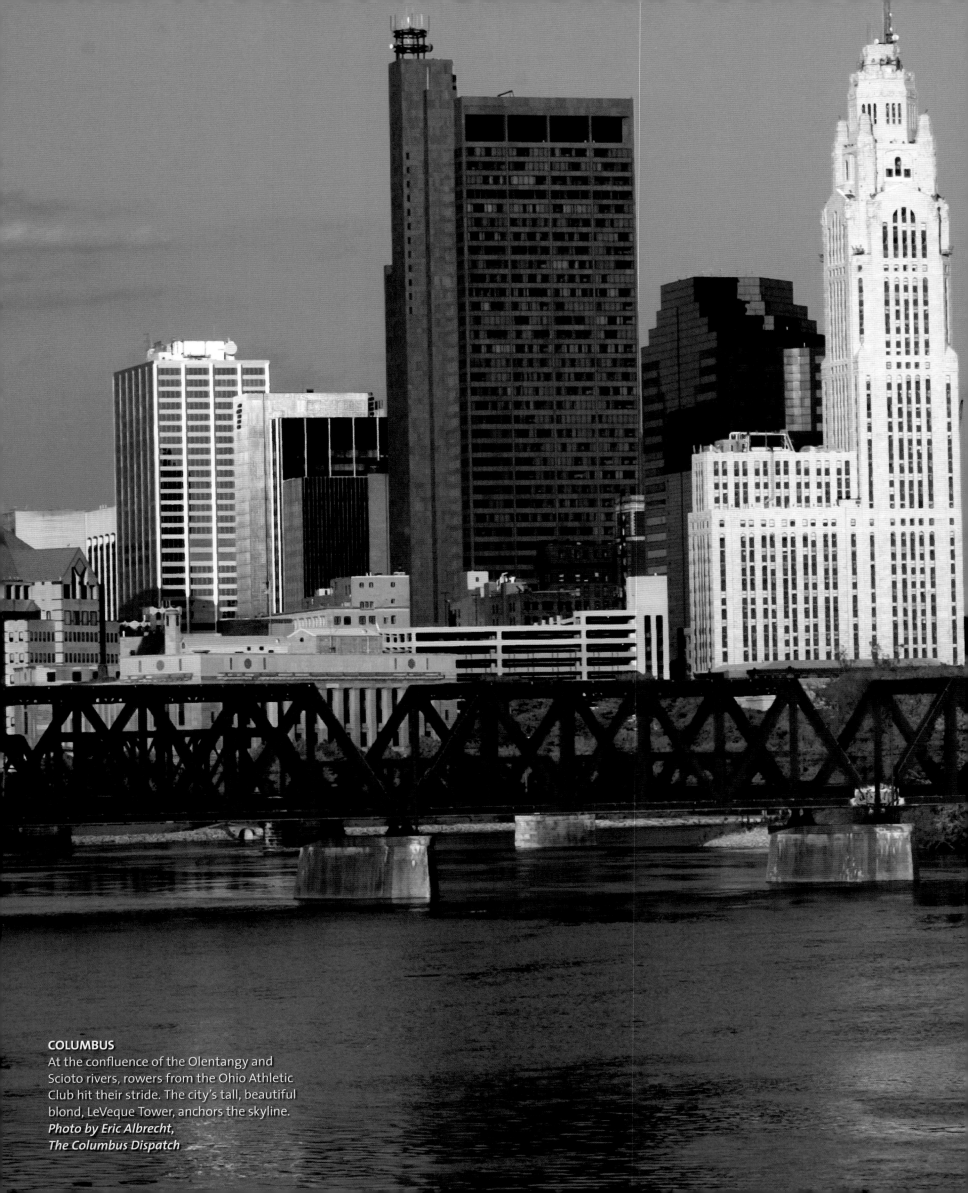

**COLUMBUS**
At the confluence of the Olentangy and
Scioto rivers, rowers from the Ohio Athletic
Club hit their stride. The city's tall, beautiful
blond, LeVeque Tower, anchors the skyline.
*Photo by Eric Albrecht,*
*The Columbus Dispatch*

COLUMBUS
Between classes at Ohio State University, Japanese studies major Amanda Carlton listens to techno music and exhales.
*Photos by Eric Albrecht, The Columbus Dispatch*

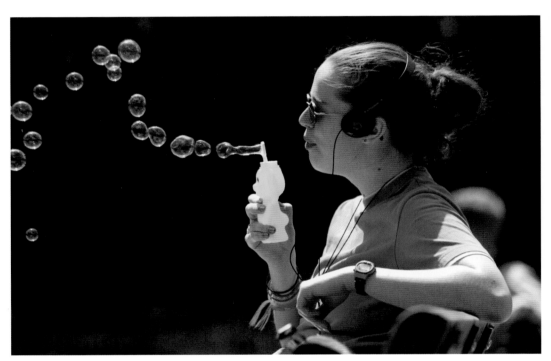

**DUBLIN**

Late one afternoon in golf-crazed central Ohio, Honda sales associate Cornelius Hayes practices chip shots at the Golf Centre driving range. He's preparing for a weekend game with coworkers.

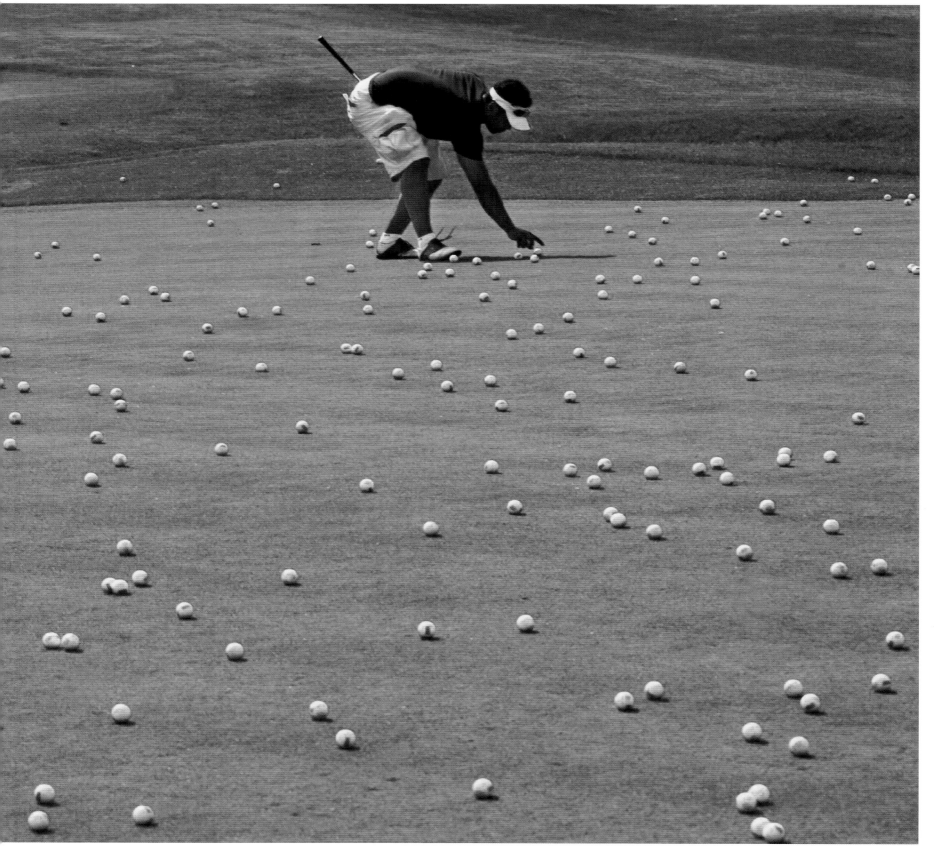

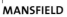

**MANSFIELD**
Chekiah Logan, 9, or "Hot Sauce" as he is known in neighborhood basketball circles, plans to be an NBA star right out of high school just like LeBron James. His older sister Charteri is not so sure.
*Photo by Bruce Strong, LightChasers*

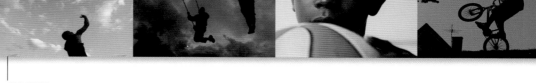

**ATHENS**

Ohio University ceramics major Seth Pringle shoots a few baskets on campus. Pringle says he tries to play every now and then to help with the pressures of school.

*Photo by Stan Alost, Ohio University*

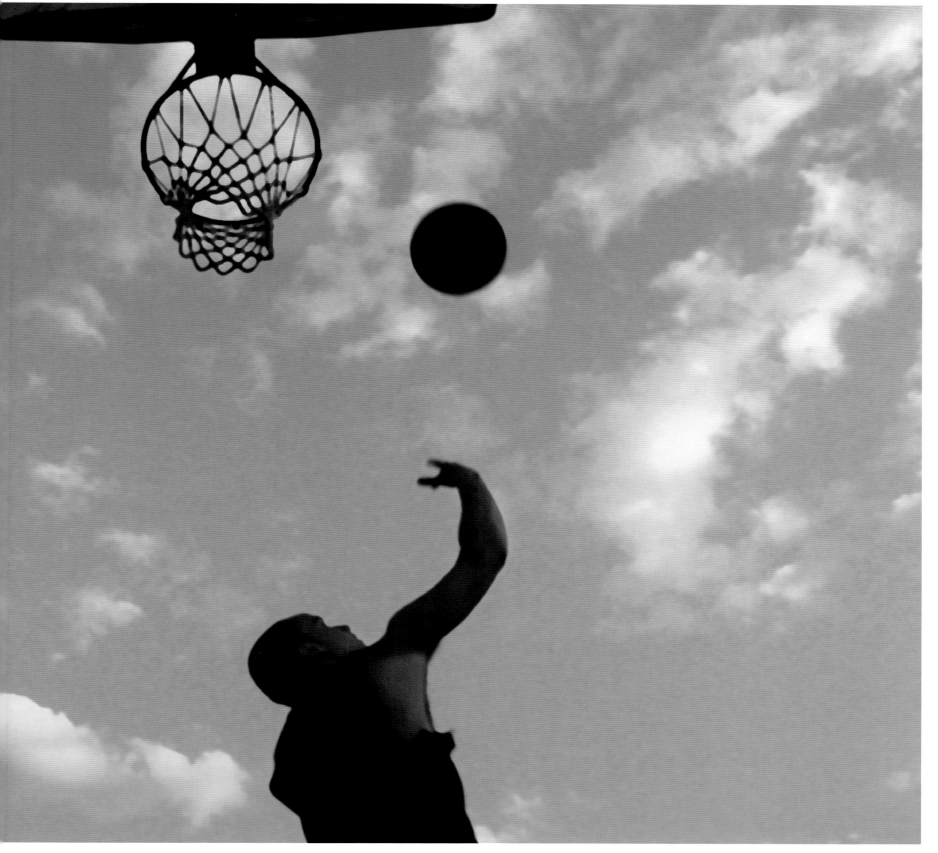

**STEWART**
Fans watch amateur drivers gun their stock cars around Skyline Speedway's 3/8-mile dirt oval during a Short Track Auto Racing Stars league race. The drivers double as mechanics and are often sponsored by local businesses. Although most race for the love of the sport, a Friday-night winner can walk away with as much as $3,000.
*Photo by Marcy Nighswander*

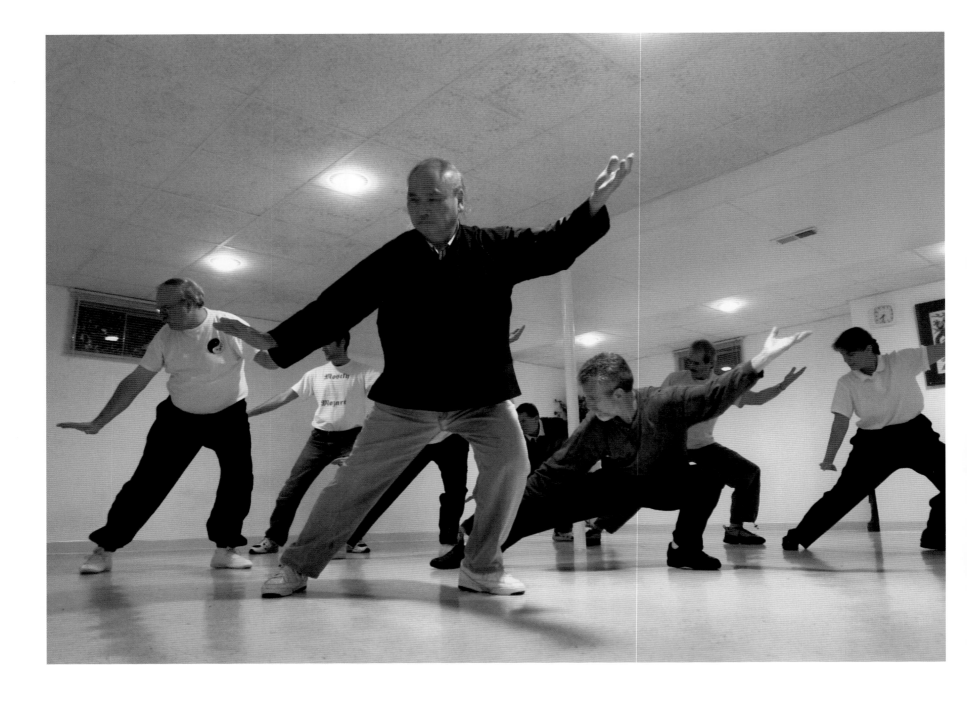

**CINCINNATI**
Hong Kong–born tai chi master Mok Lau, 78, leads a class in his studio. Among the principles of tai chi are coordinating the upper and lower parts of the body and finding stillness within movement. This posture, one of 36 in tai chi, is called Diagonal Flying.
*Photo by Bruce Crippen, The Cincinnati Post*

**OBERLIN**
A lengthy career of dancing under a Russian impresario and with the Ballet Russe in New York taught Lois Gremore of Gremore Dance Studio about discipline. "The Russians don't suffer fools gladly," she says. "You work hard or you get out."
*Photo by Monique Ganucheau*

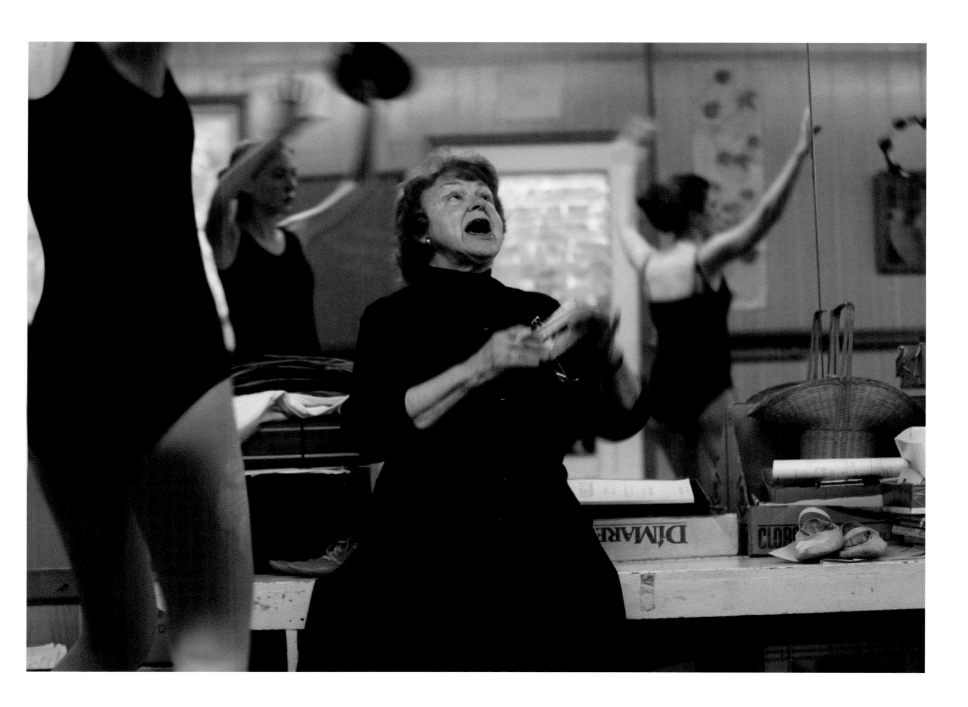

**MANSFIELD**
Richmond Carousel Park boasts having the first wooden carousel built in America since 1932. Completed in 1991, it cost $1.2 million. It's worth every penny to Kylie and Allie Malone as they take a whirl with mom and grandpa.
*Photo by Bruce Strong, LightChasers*

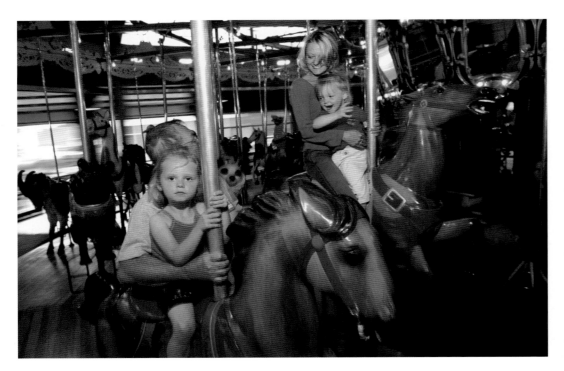

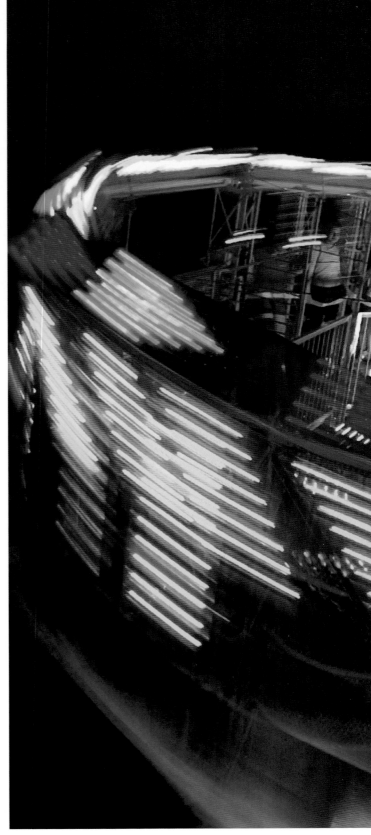

**CINCINNATI**

At the Our Lady of Victory Church's parish festival, a Round Up spins fairgoers to the wall. All summer long, fundraising festivals—with rides, games, and ubiquitous bingo—pop up all over Cincinnati's heavily Catholic west side. Parishes have to coordinate schedules carefully so the weekend events don't conflict.

*Photo by Patrick Reddy, Cincinnati Enquirer*

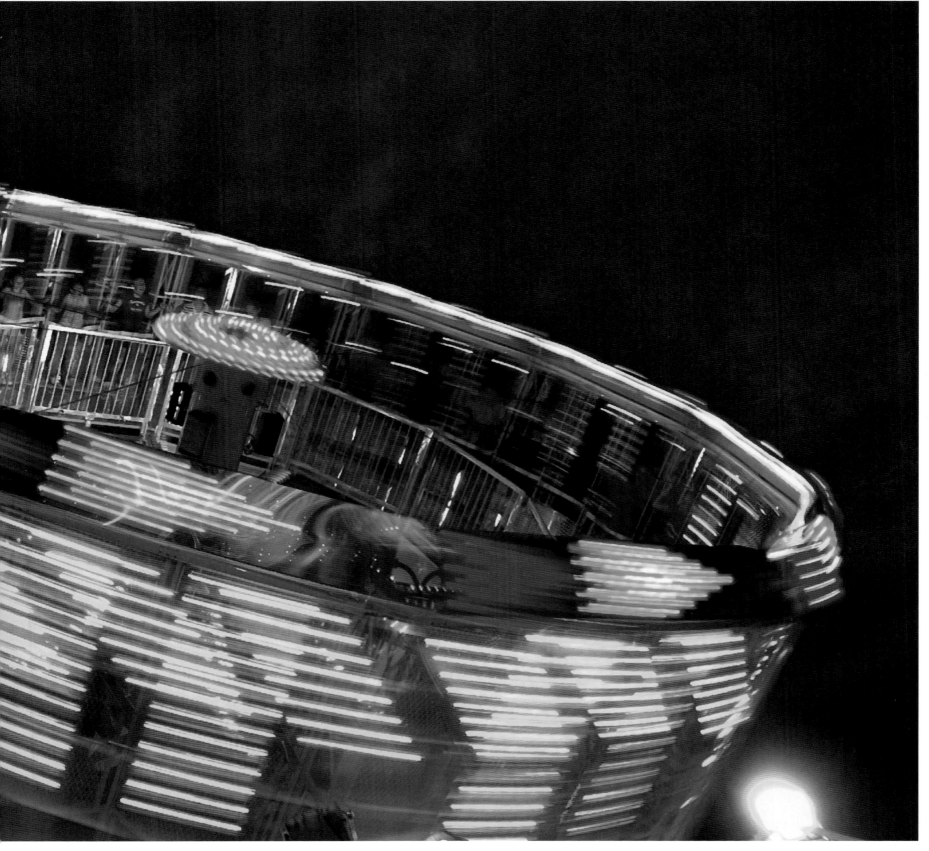

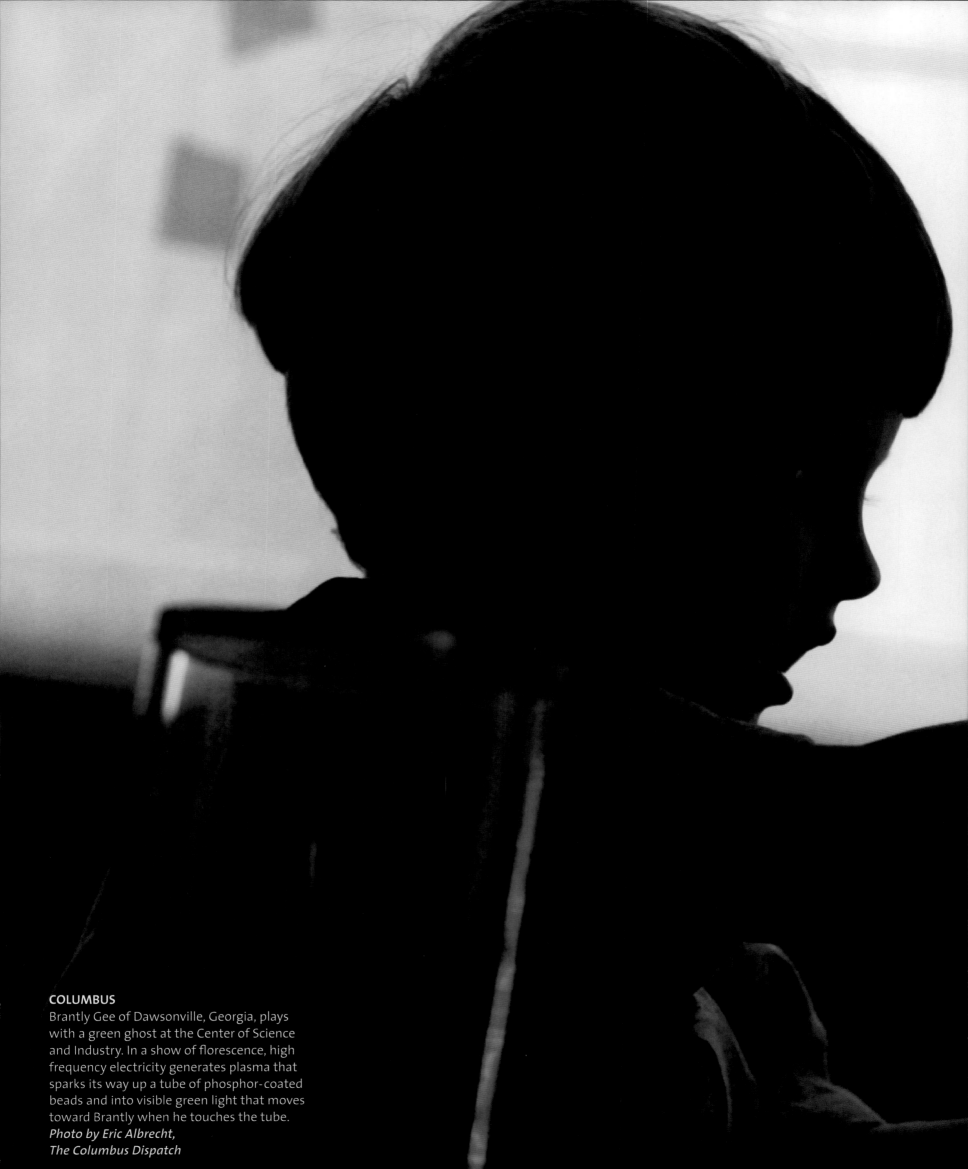

**COLUMBUS**
Brantly Gee of Dawsonville, Georgia, plays with a green ghost at the Center of Science and Industry. In a show of florescence, high frequency electricity generates plasma that sparks its way up a tube of phosphor-coated beads and into visible green light that moves toward Brantly when he touches the tube.
*Photo by Eric Albrecht,*
*The Columbus Dispatch*

## CLEVELAND

Cleveland has had its share of severe urban problems, but it also has 15 public parks—called reservations—to help offset the grit with green. Jim Wallace gets away from it all at Rocky River Reservation. "This is my church," he says.
*Photo by Dale Omori*

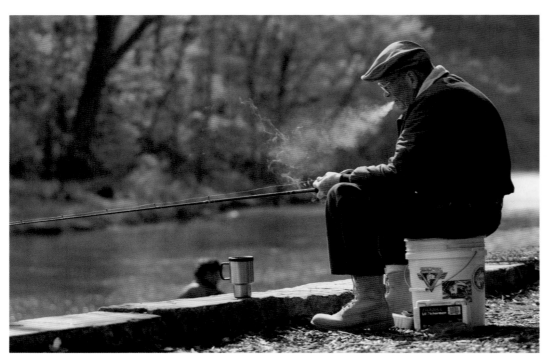

**BARBERTON**

It's not the fish that keep Jeffery Keesher coming back to Lake Anna almost every night—he's never caught a thing, he admits. The auto parts assembly line worker comes on warm evenings to cast, reel, and unwind.
*Photo by Carolyn Drake*

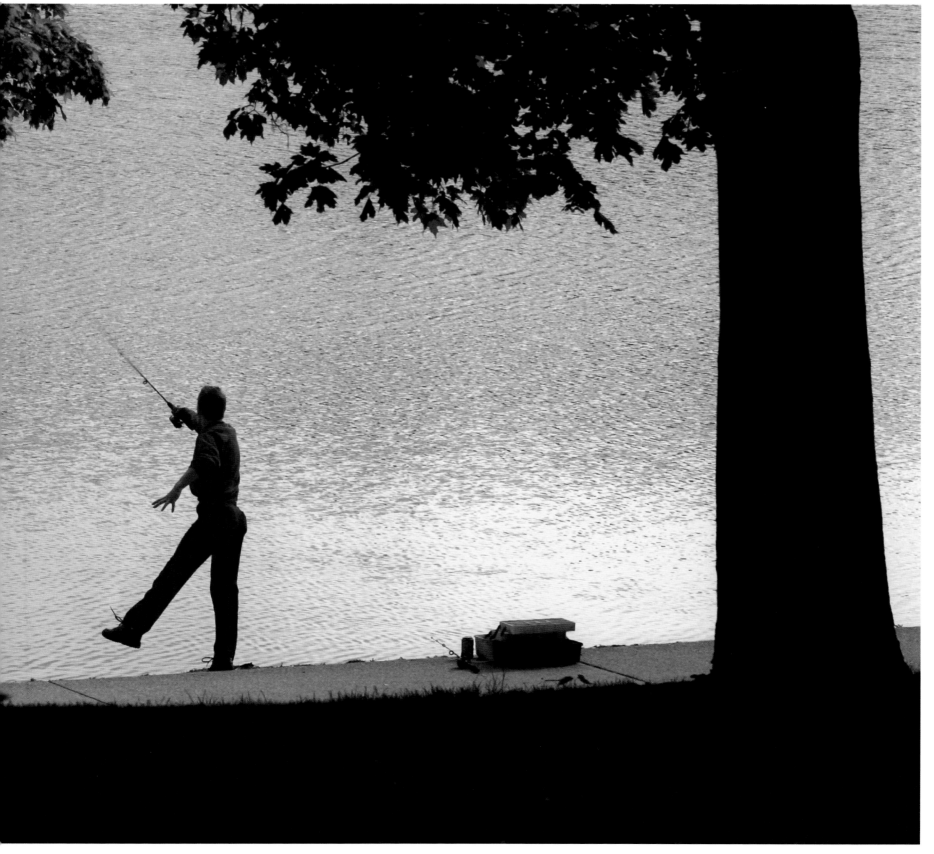

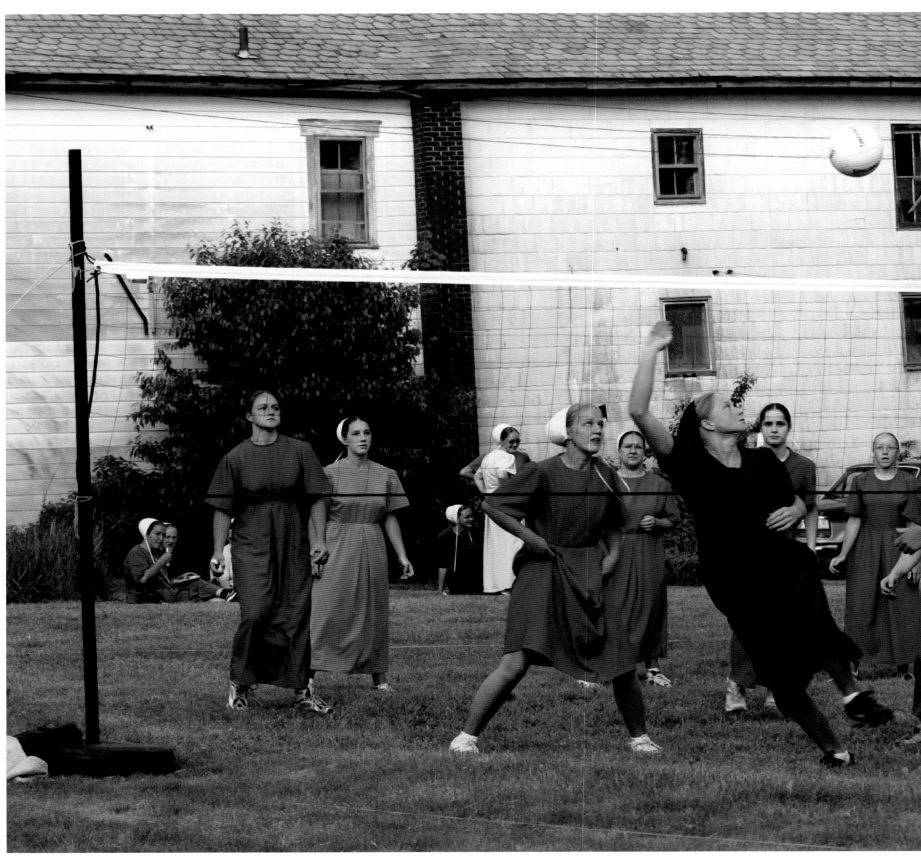

**NEW BEDFORD**
During the New Bedford Days festival, young Amish women work up their appetites. A feast, including barbecued chicken and homemade ice cream, follows. And a yard sale after that.
*Photo by Eric Albrecht, The Columbus Dispatch*

**CLAYTON**

Arcanum High School seniors Leann Sando and Amy Graham celebrate their softball triumph over National Trail High School, 2–1. The win means Arcanum advances in the Division III state tournament.

*Photo by Ron Alvey*

**TOLEDO**

Team mascot Muddy the Mud Hen throws a ball into the crowd during a Toledo Mud Hens game. In 1896, the team took its name from the strange birds that frequented the marshland near its playing field. The Mud Hens are better known as a Detroit Tigers AAA affiliate—and Corporal Klinger's obsession on the TV series *M*A*S*H*.
***Photos by Allan E. Detrich***

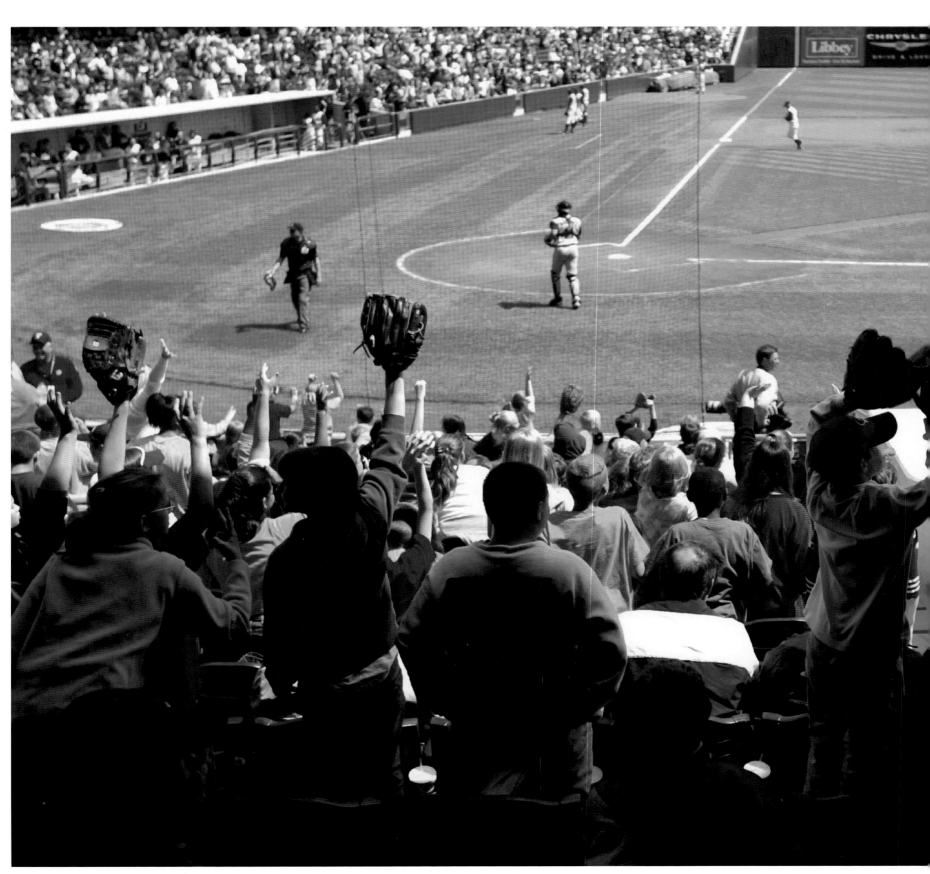

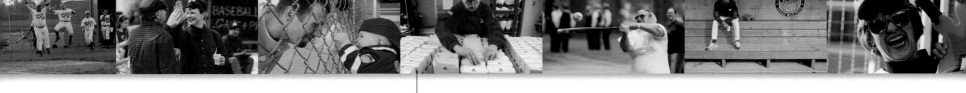

**TOLEDO**

Back in the concession area of the Mud Hens' new Fifth Third Field, Alan St. Arnaud closes boxes of popcorn for the vendors who work the crowd. Completed in 2002, the stadium was named the best minor league ballpark in the country by *Newsweek*.

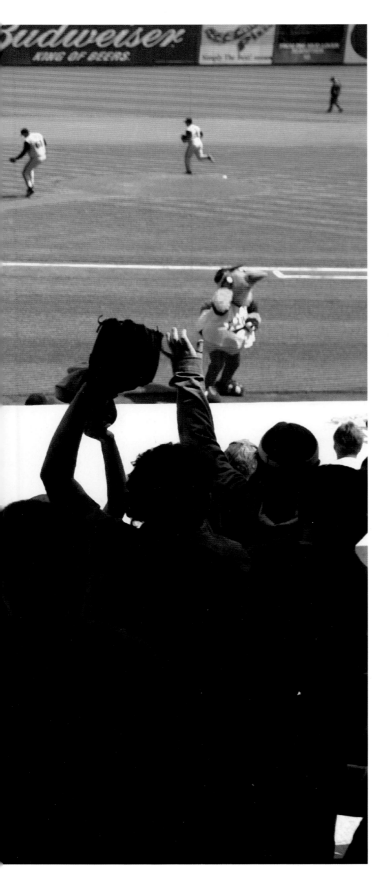

Tracie Hull watches her first monster truck race at the 18th Annual Advance Auto Parts 4-Wheel Jamboree Nationals. Her husband Rick and their kids, on the other hand, have been regulars at the event. The competitions, involving hundreds of trucks from America and Canada, range from mild (the "Show-N-Shine" fest) to wild (the "Tough Trucks" face-off).
*Photo by Bruce Strong, LightChasers*

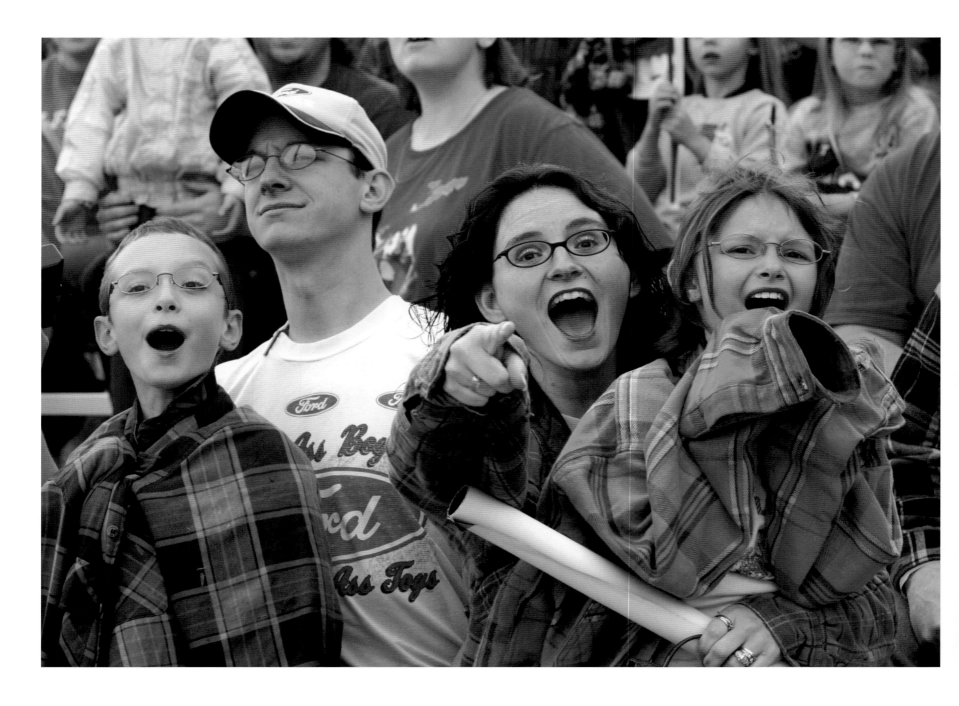

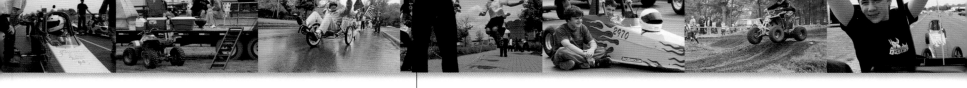

**AKRON**

Scharlawn Hubbard jumps rope during recess at Hope Academy in downtown Akron. The charter school is funded by the state but managed by a private company, White Hat Ventures LLC—named after the CEO's favorite accessory. White Hat runs 25 charter schools in Ohio, using $30 million in taxpayer funds annually.
*Photo by Carolyn Drake*

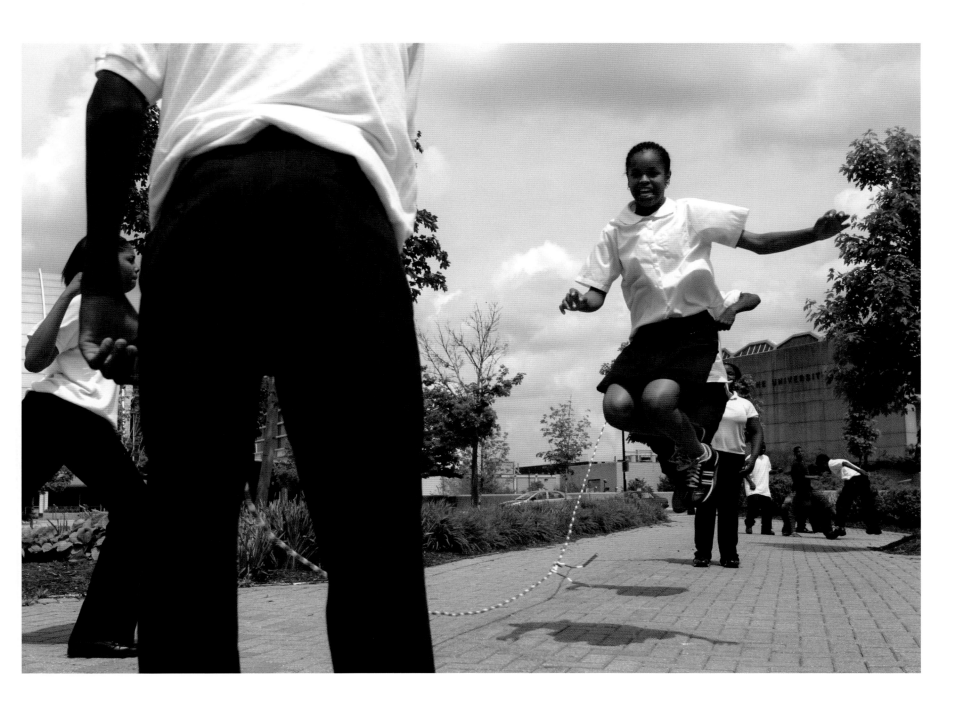

**RICHFIELD**
Vespers at the Serbian Orthodox Marcha
Monastery begin with a candle offering
by Father Steve Seraphim. Marcha was the
Western hemisphere's first Serbian monas-
tery when it opened in 1975.
*Photo by Lawrence Hamel-Lambert*

Reason To Believe

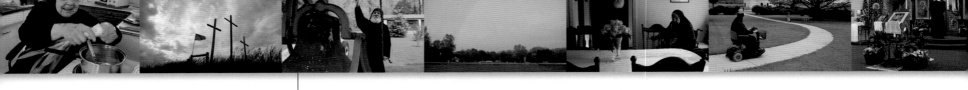

**RICHFIELD**
Father Steve Seraphim rings one of the monastery's four bells before evening service at the chapel. Ohio's 17,000-member Serbian community raised $560,000 to build a new church for the monastery in 2001.
*Photos by Lawrence Hamel-Lambert*

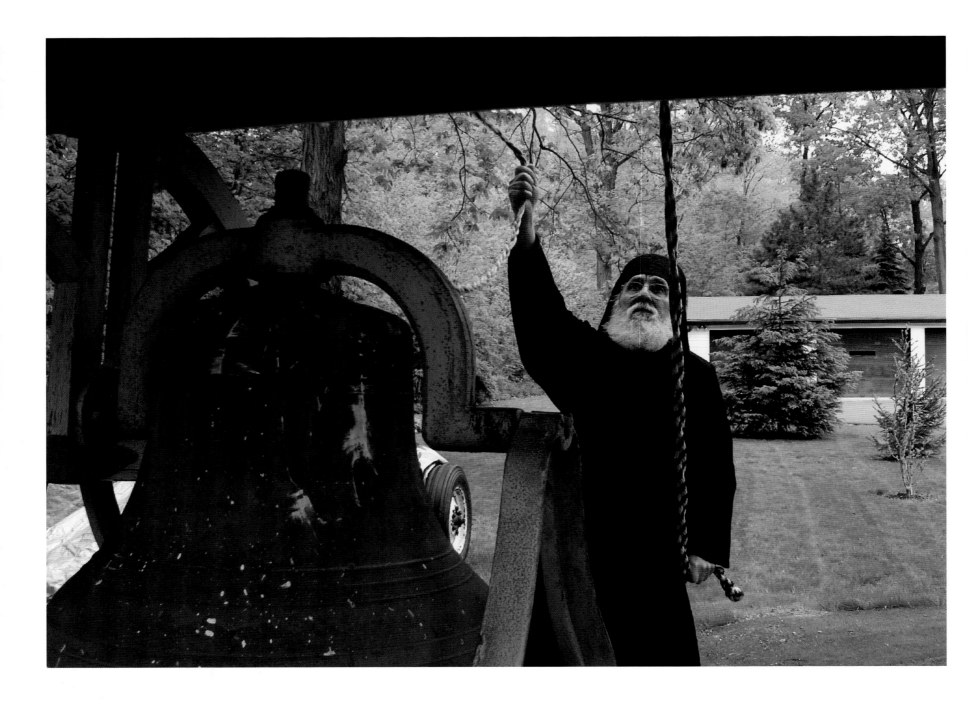

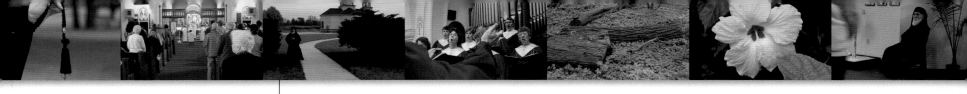

**RICHFIELD**
Living at Marcha affords plenty of time for con-
templation. The 82-acre compound has just two
full-time residents: Father Seraphim and Mother
Ana Radetich, the monastery's abbess.

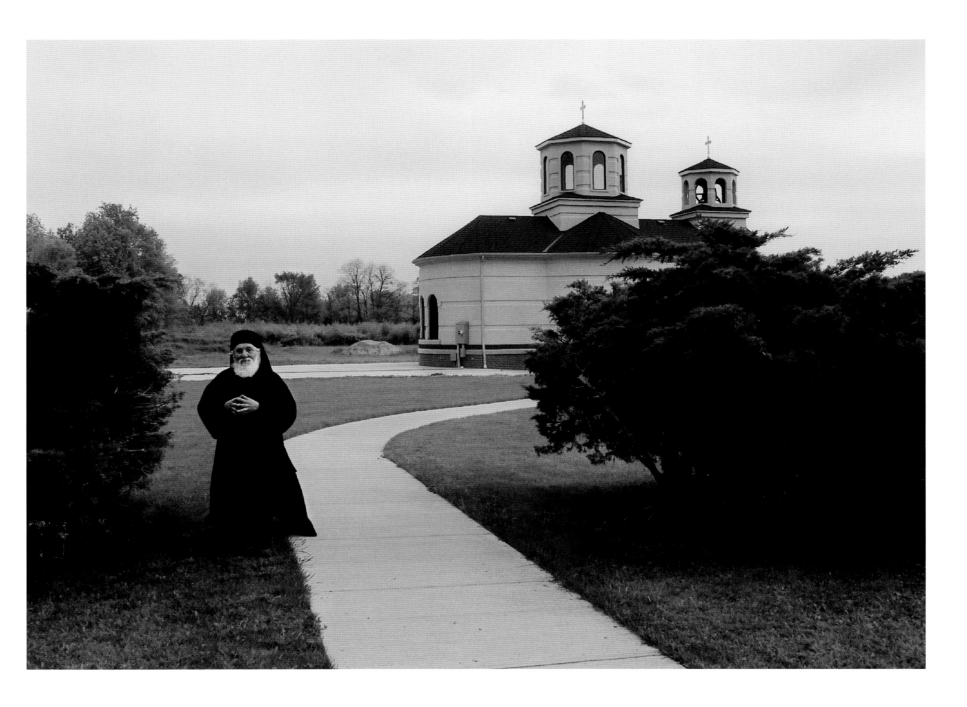

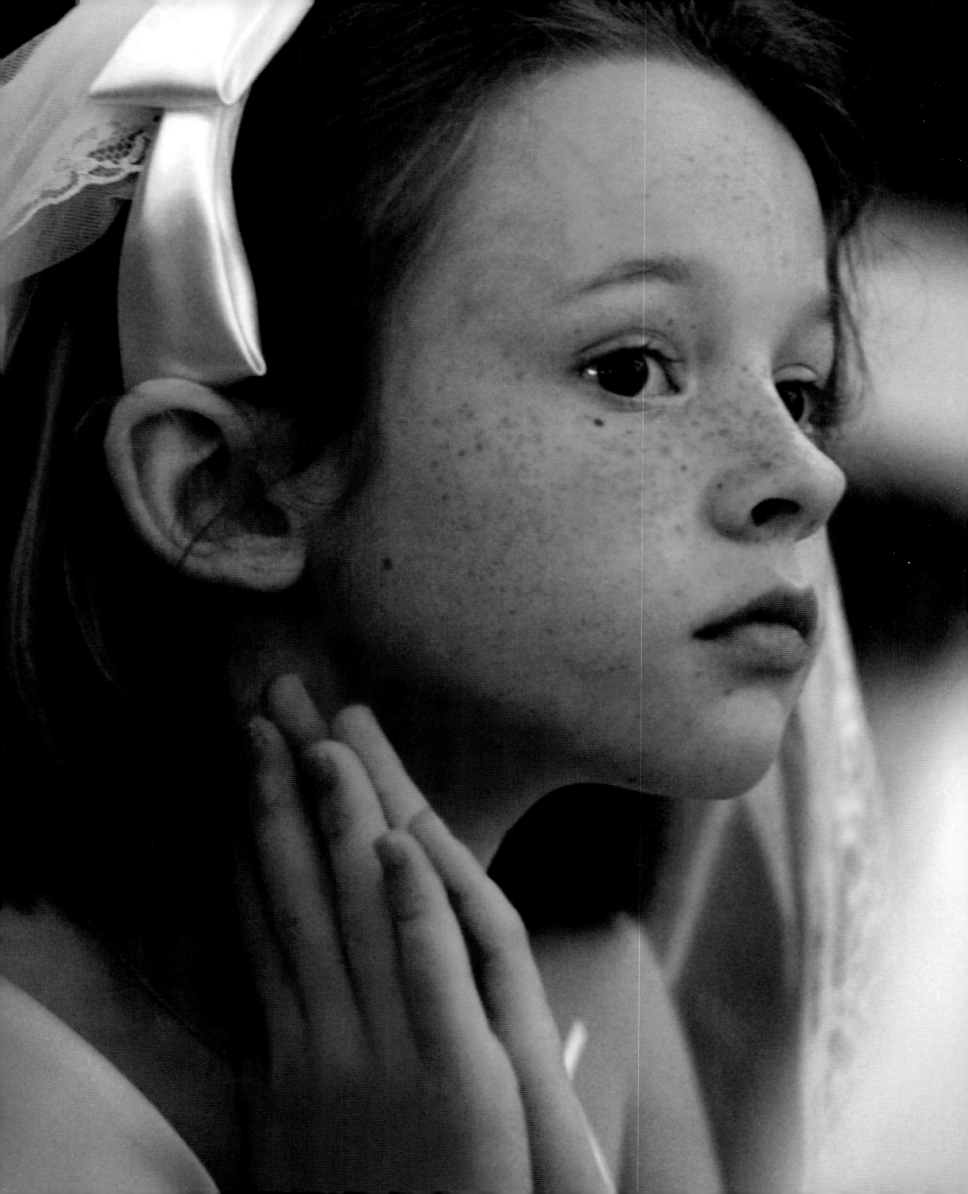

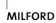

**MILFORD**

Gabriella Sabino kneels as she takes in her First Communion at St. Andrew Parish.
*Photos by Bruce Crippen, The Cincinnati Post*

**MILFORD**

After receiving her First Communion, Kirby Bowman, sitting between her brother Palmer and mom Mary, opens envelopes of money from friends. She got $140, she happily reports, and plans to buy a bike.

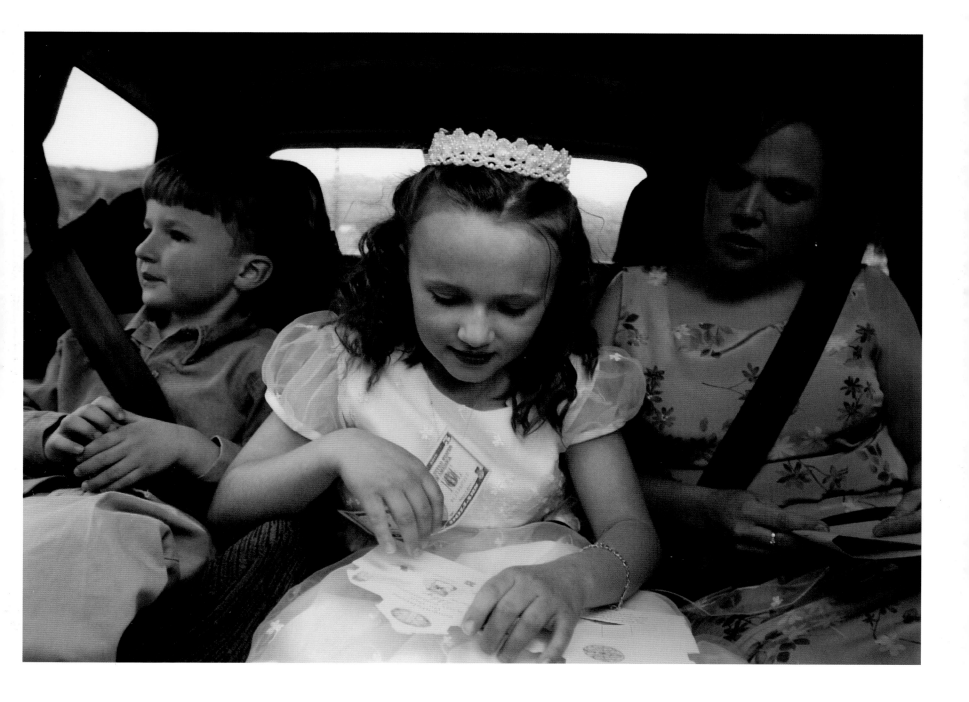

Sarita Cunningham reads sympathy cards at the grave of her daughter Amanda, who was killed in a car accident 10 days earlier. A student leader at Ohio University, Amanda was set to graduate on June 14.
*Photo by Bruce Strong, LightChasers*

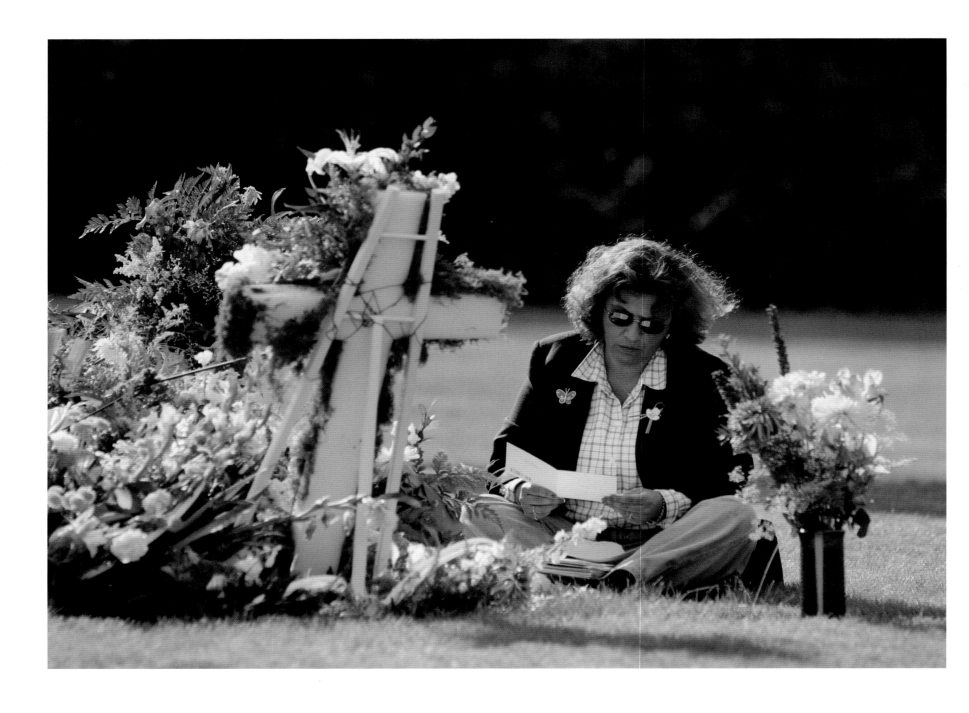

**DAYTON**

Richard Beckett got through the Korean War un-scathed but suffered a crippling spinal injury in a car accident after he returned home. Though he's confined to a wheelchair and lives at the Dayton Veterans Administration Hospital, Beckett makes the three-block trip to the Dayton National Cem-etery every week to spend time with his fallen friends.

*Photo by Bill Reinke, Dayton Daily News*

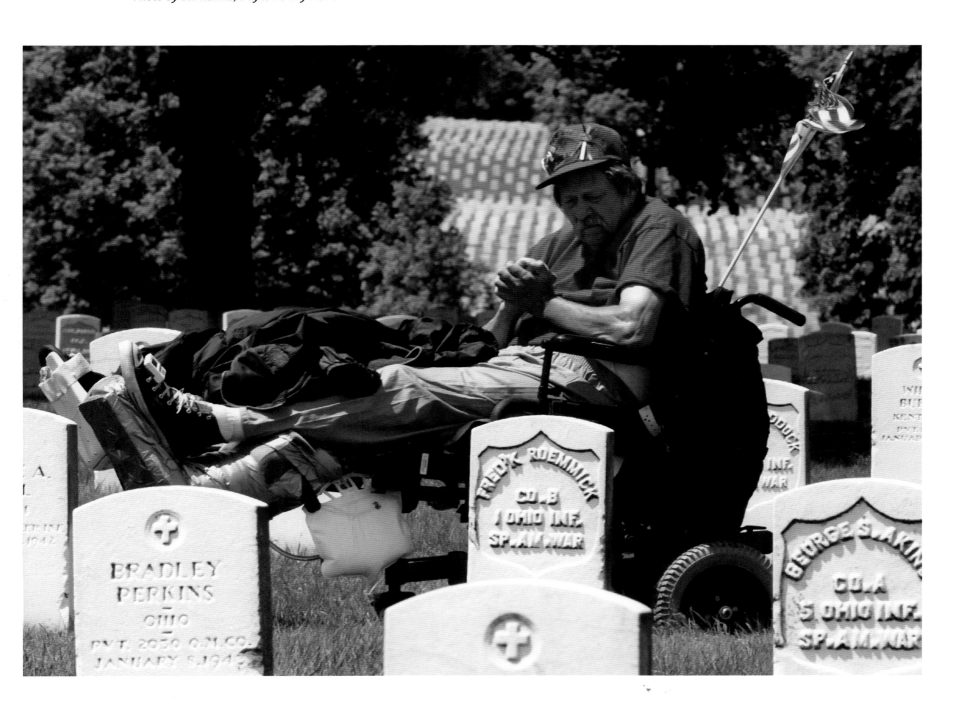

**MILLERSBURG**

The tendency of Amish communities to keep to themselves has fueled the public's curiosity about their lifestyle. In this paradox, Eli Yoder, a former Amish adherent, saw opportunity. The entrepreneur created the Yoder Amish Home outside of Cleveland, where visitors pay a fee to ride in a buggy and watch Amish employees go about their business on the 110-acre farm.

*Photos by Carolyn Drake*

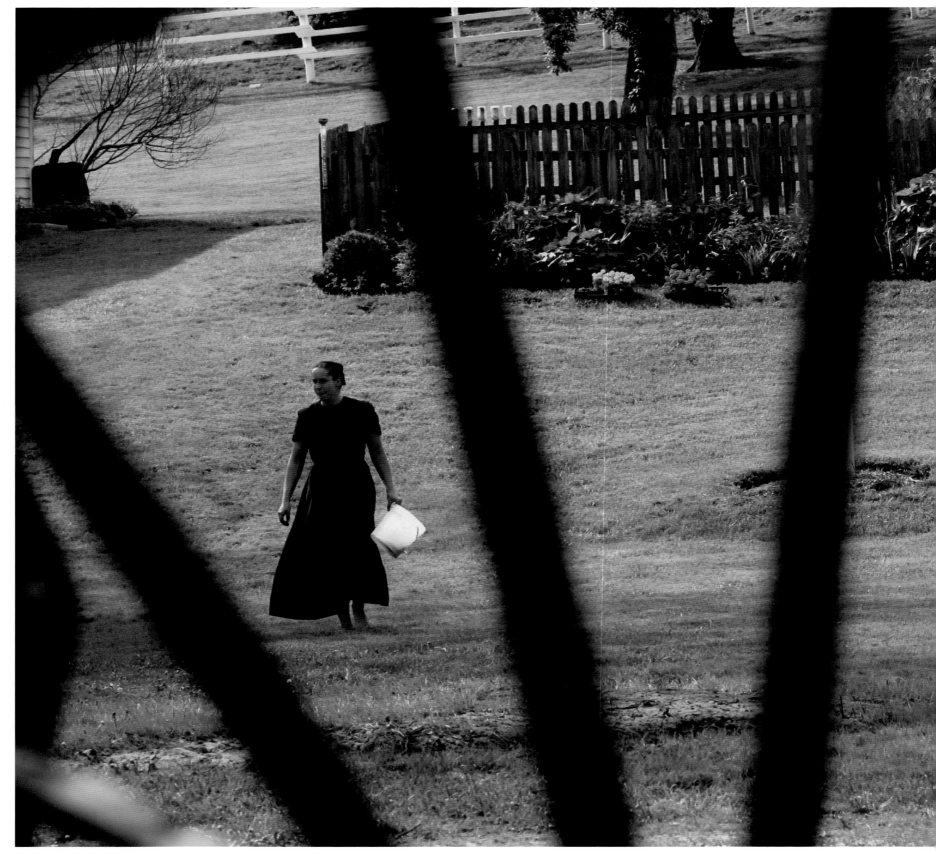

The simple life includes horsing around on a communal trampoline for these Amish boys who live across the street from the Yoder Amish Home.

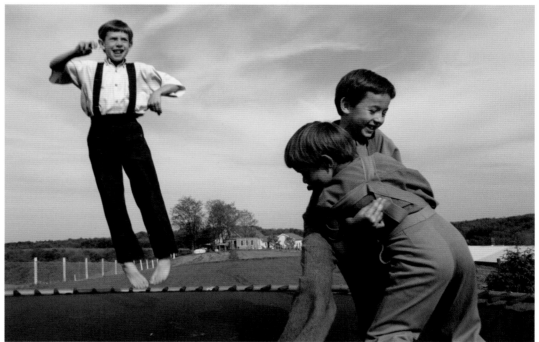

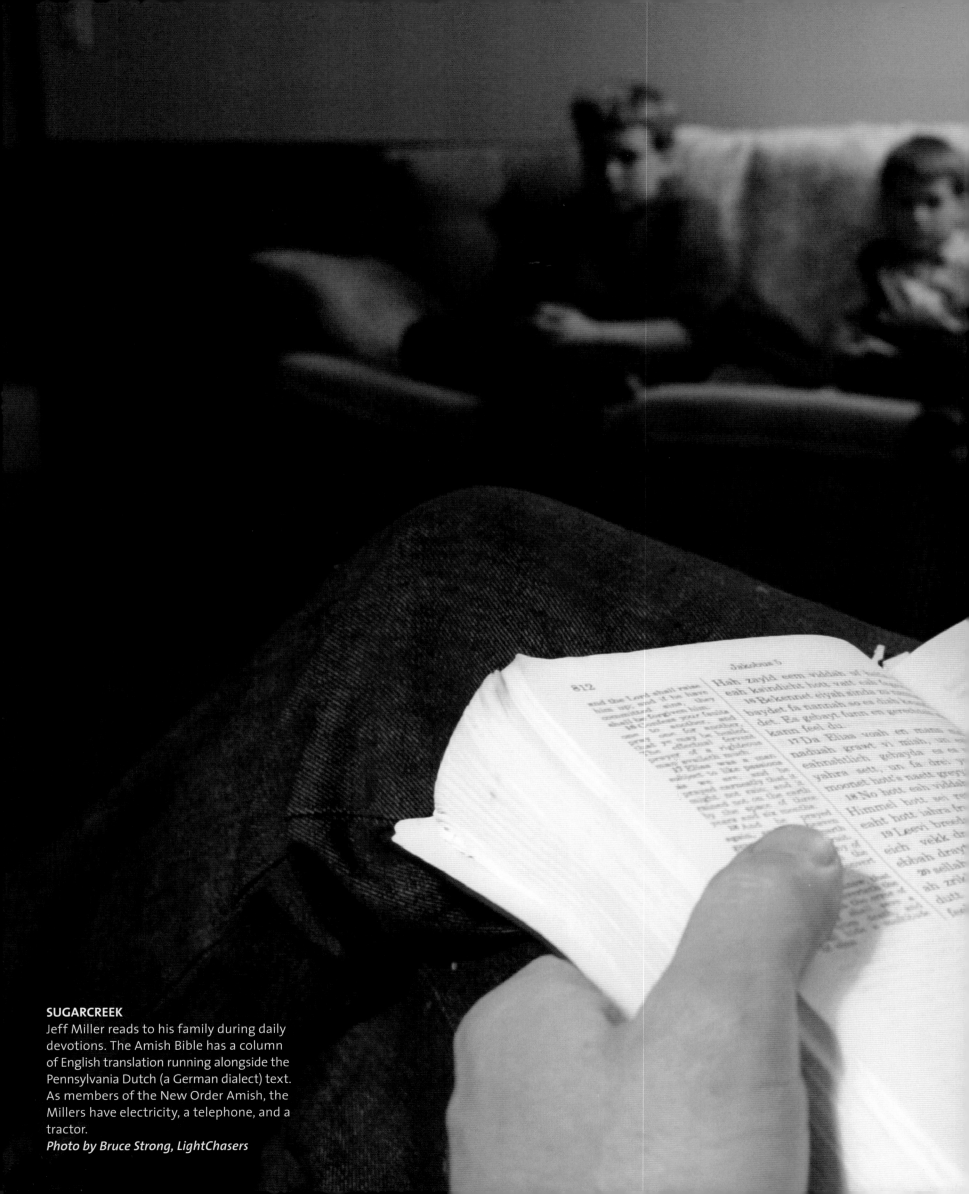

**SUGARCREEK**
Jeff Miller reads to his family during daily devotions. The Amish Bible has a column of English translation running alongside the Pennsylvania Dutch (a German dialect) text. As members of the New Order Amish, the Millers have electricity, a telephone, and a tractor.
*Photo by Bruce Strong, LightChasers*

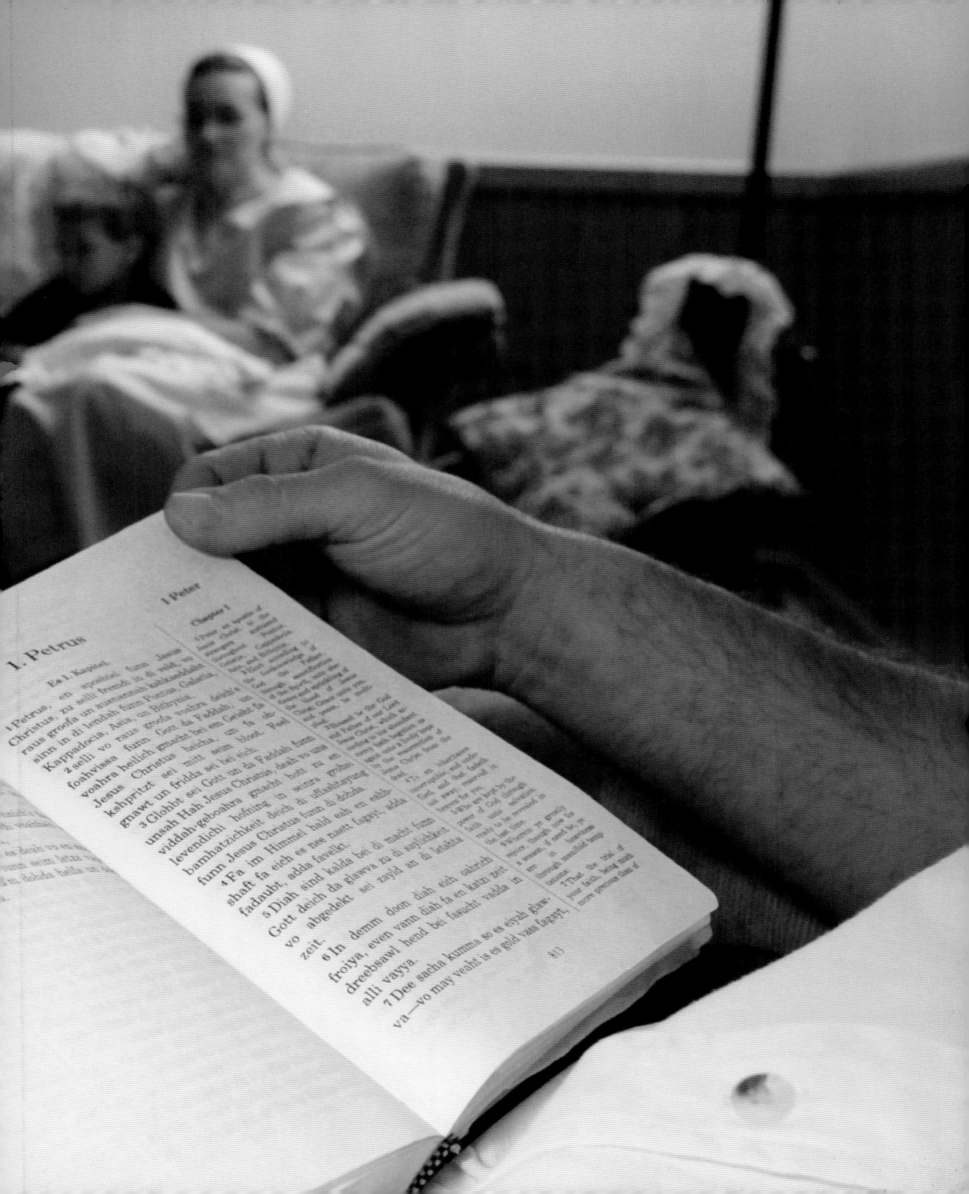

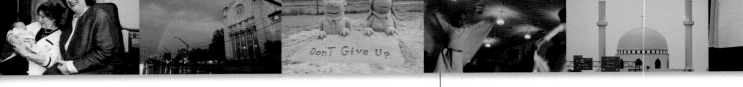

**ALBANY**

At 5 years old, Audrey Namenyi spontaneously began to dance during services at Living Water Worship Center, an independent Pentecostal church. According to her mother Pam, Pastor Jim Stewart encouraged her. Sometimes Audrey, now 7, is joined by her sister, and they wear special costumes. "Dancing to the Lord puts your heart and soul into worship," says Pam.
*Photo by Uma Sanghvi*

**SHAKER HEIGHTS**
In an affluent suburb, an intimate moment: the rabbinical circumcision of infant Peter Maxwell Levin. His grandfather holds him, while four generations of his family witness the ritual.
*Photo by Eric Smith*

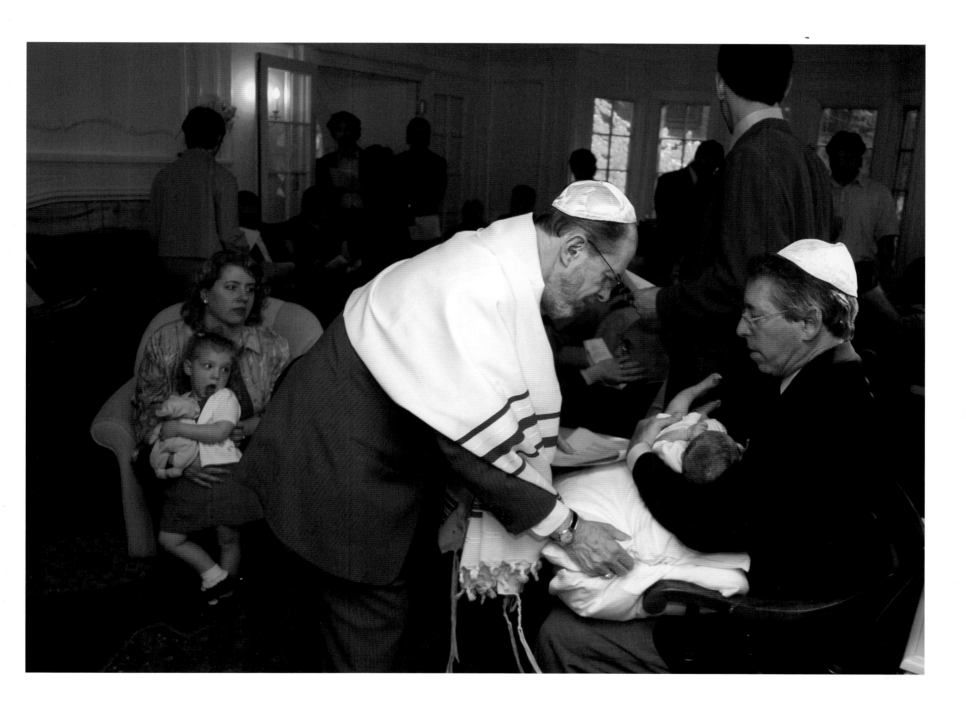

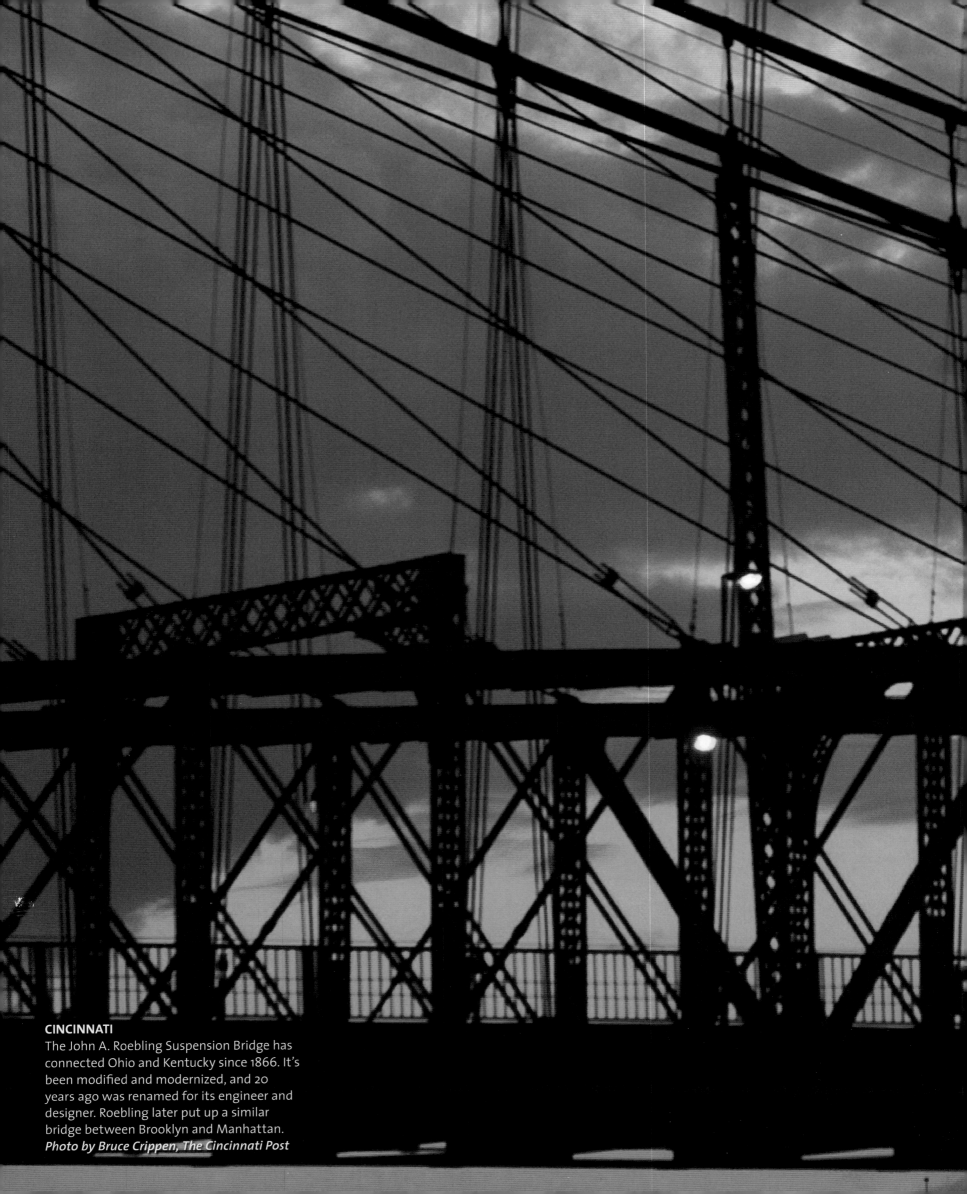

**CINCINNATI**

The John A. Roebling Suspension Bridge has connected Ohio and Kentucky since 1866. It's been modified and modernized, and 20 years ago was renamed for its engineer and designer. Roebling later put up a similar bridge between Brooklyn and Manhattan.
*Photo by Bruce Crippen, The Cincinnati Post*

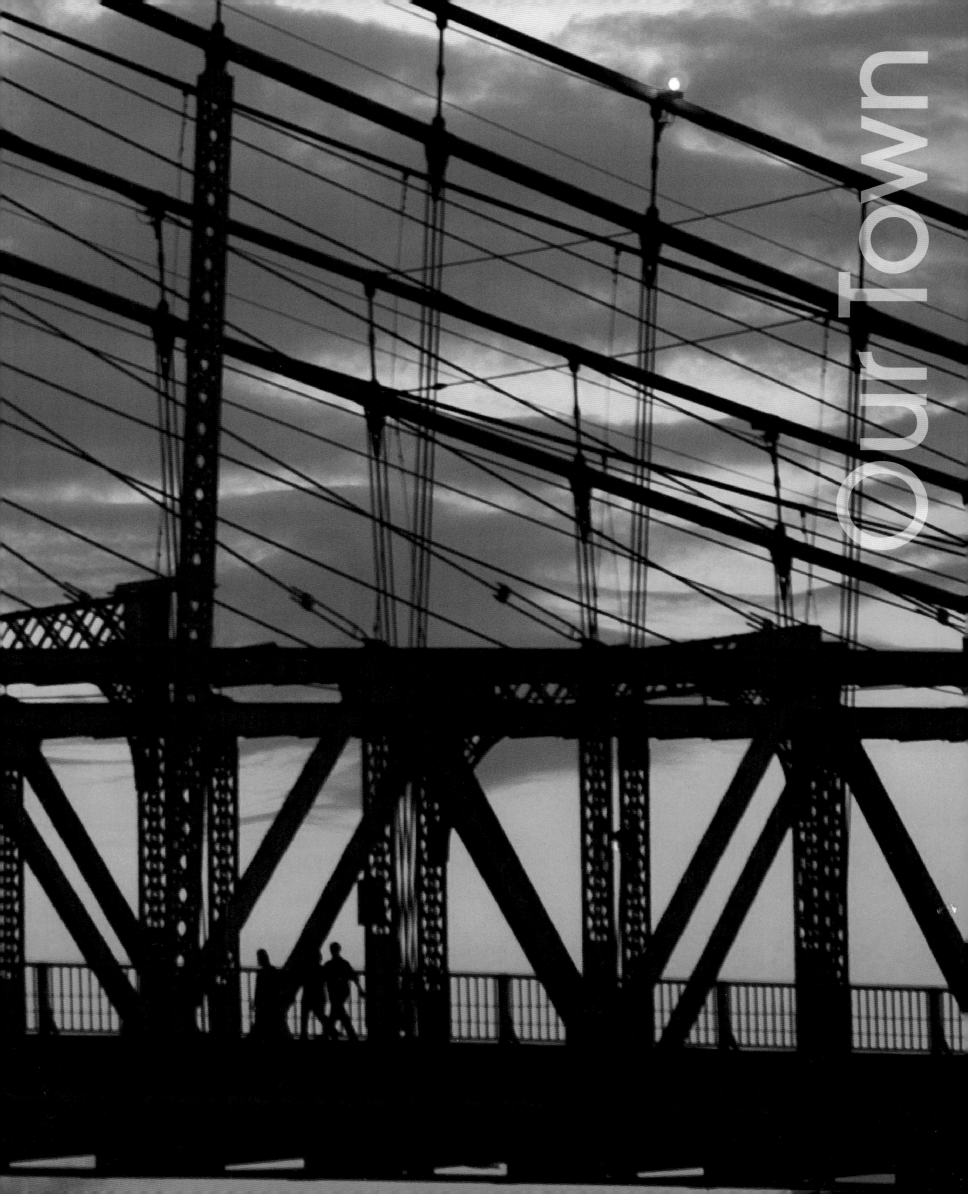

Our Town

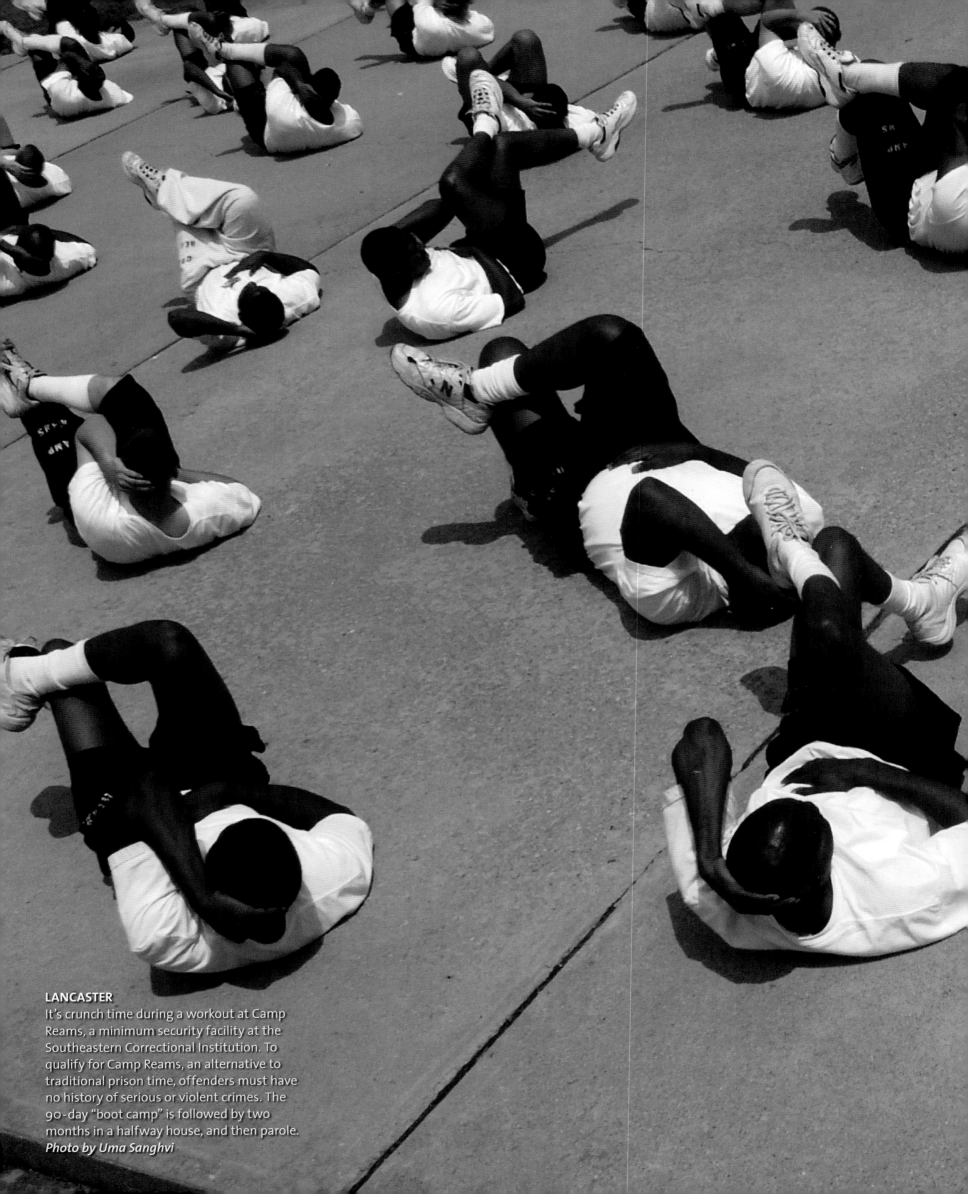

**LANCASTER**
It's crunch time during a workout at Camp Reams, a minimum security facility at the Southeastern Correctional Institution. To qualify for Camp Reams, an alternative to traditional prison time, offenders must have no history of serious or violent crimes. The 90-day "boot camp" is followed by two months in a halfway house, and then parole.
*Photo by Uma Sanghvi*

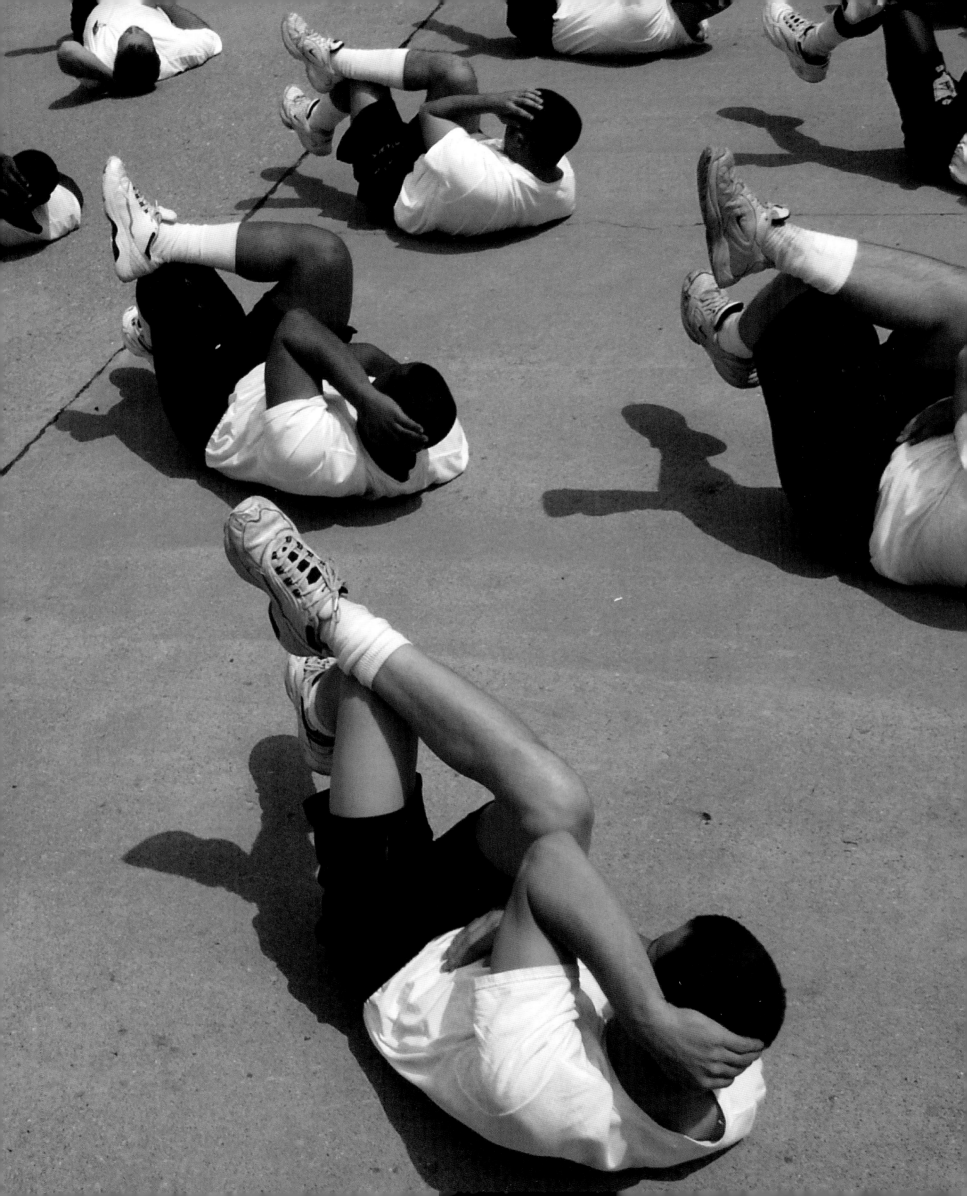

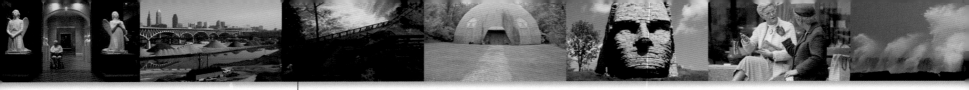

The origin of the name Chagrin Falls depends on whom you ask. Some say "chagrin" derives from a Native American term meaning "clear water." Others tell a story about a surveying party that mistakenly followed a river they thought was the Cuyahoga until they realized, much to their chagrin, that it was not.
*Photo by David Distelhorst*

## DUBLIN

At Sciota Run Park, children play atop the limestone visage of Wyandot chief Shateyaronyah, whose name translates as "Two Equal Clouds." Friendly and influential with white settlers who called him "Leather Lips," the chief aroused the jealousy of rival chief Tecumseh. Charged with witchcraft, Shateyaronyah was executed near this spot in 1810.

***Photo by Eric Albrecht, The Columbus Dispatch***

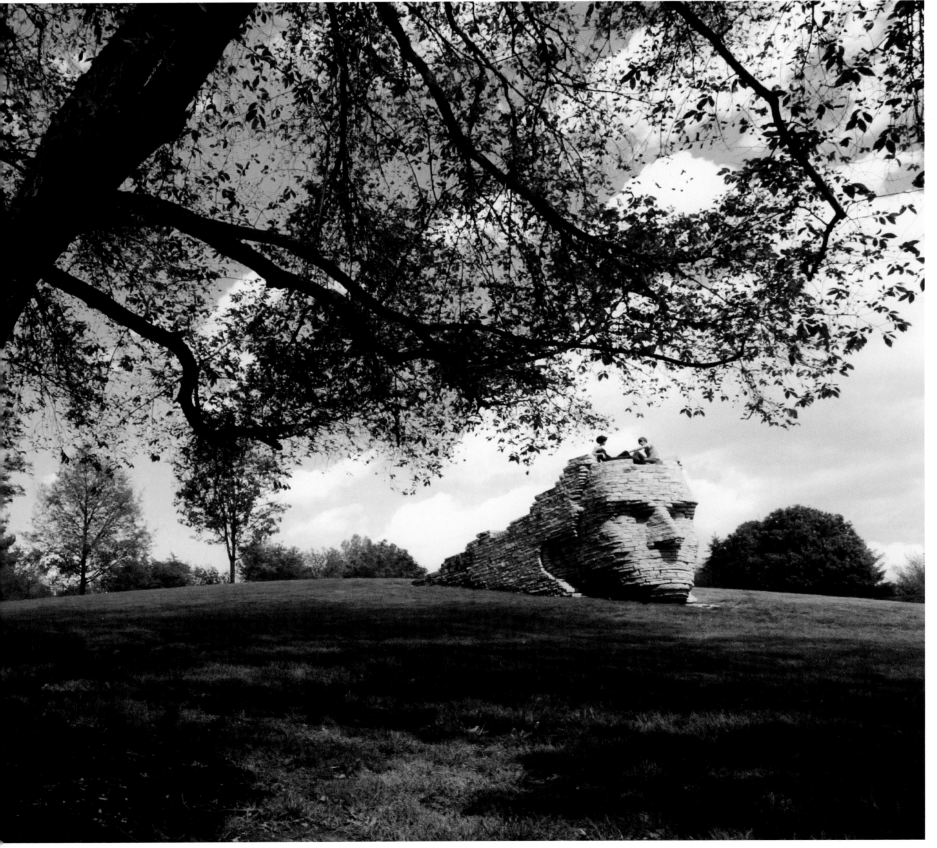

**WELLINGTON**

At the turn of the 20th century, there were 40 cheese factories and numerous carriage makers in the area. Times have changed. Today, the town is home to auto parts manufacturers, tool and die companies, and sheet metal fabricators. This customized ATM harks back to the good old days.
*Photo by Edward Smith*

**NEWARK**

Newark is the home of the Longaberger basket company. At seven stories high, the basket is known as the world's largest.

*Photo by Steve Hoskinson*

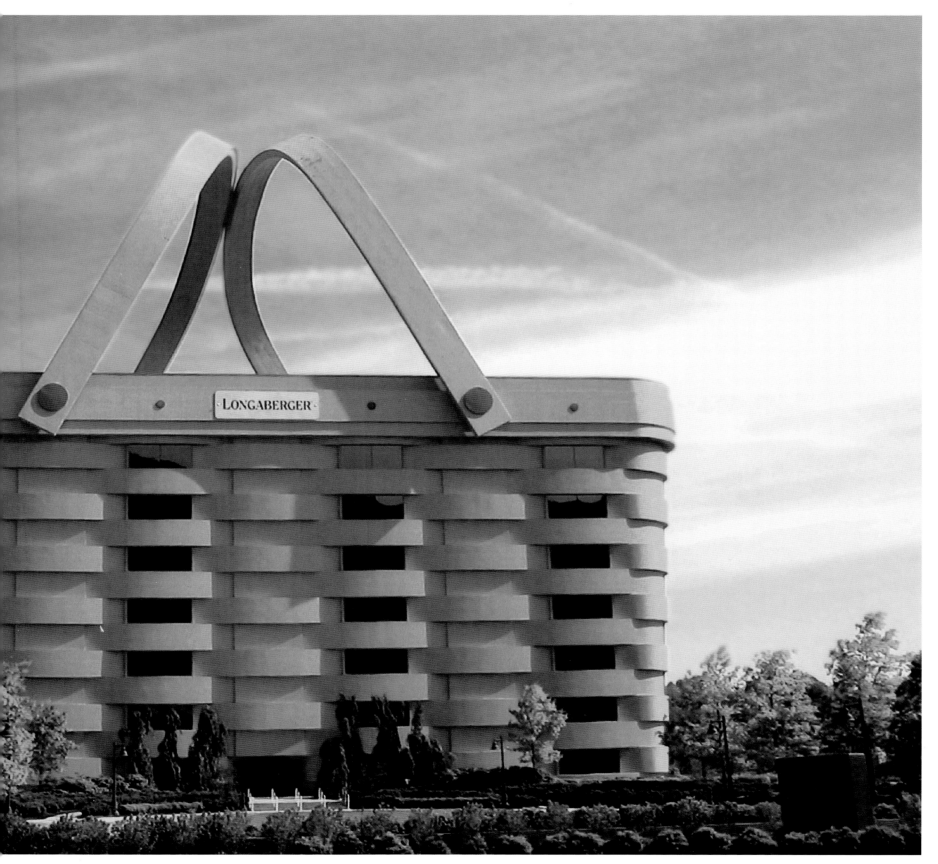

## CINCINNATI

At one time, 216 trains ran through Cincinnati's Union Terminal daily. Constructed in 1933, the magnificent art deco building is now called the Museum Center and houses the Children's Museum, the Cincinnati Museum of Natural History and Science, and the Cincinnati History Museum.

*Photo by Patrick Reddy, Cincinnati Enquirer*

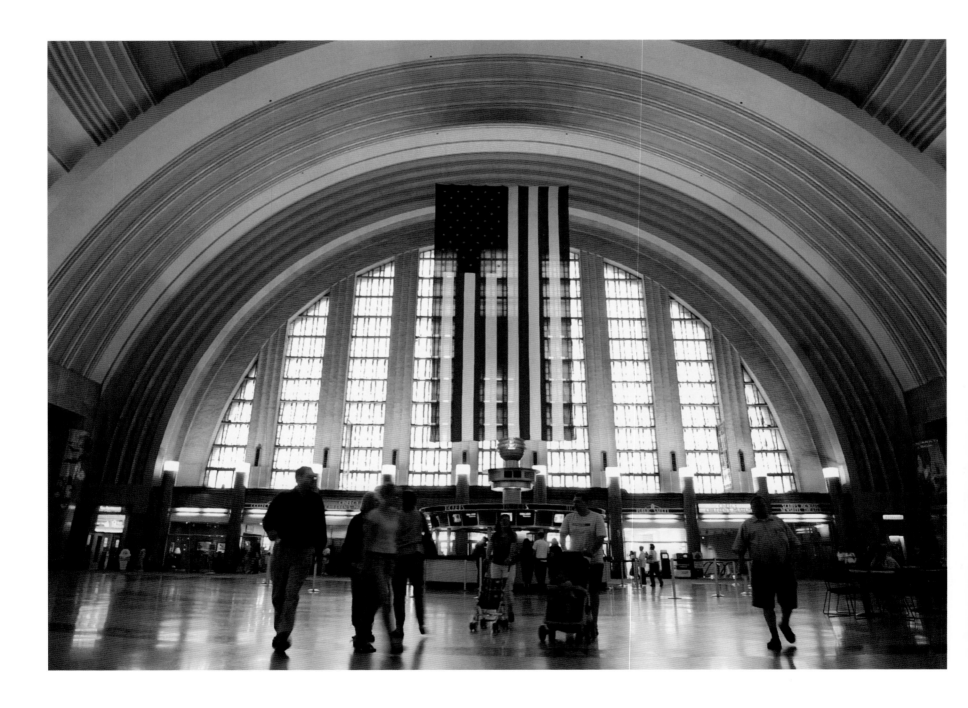

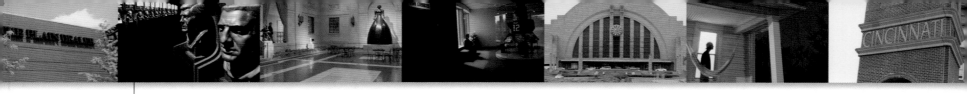

**CANTON**

Since the Pro Football Hall of Fame opened its doors in 1963, 7 million visitors have passed through the turnstiles. The museum honors 221 of the finest players—gridiron greats like All-Pro guard John Hannah of the New England Patriots and Bill George, legendary linebacker for the Chicago Bears and Los Angeles Rams.
*Photo by Bruce Strong, LightChasers*

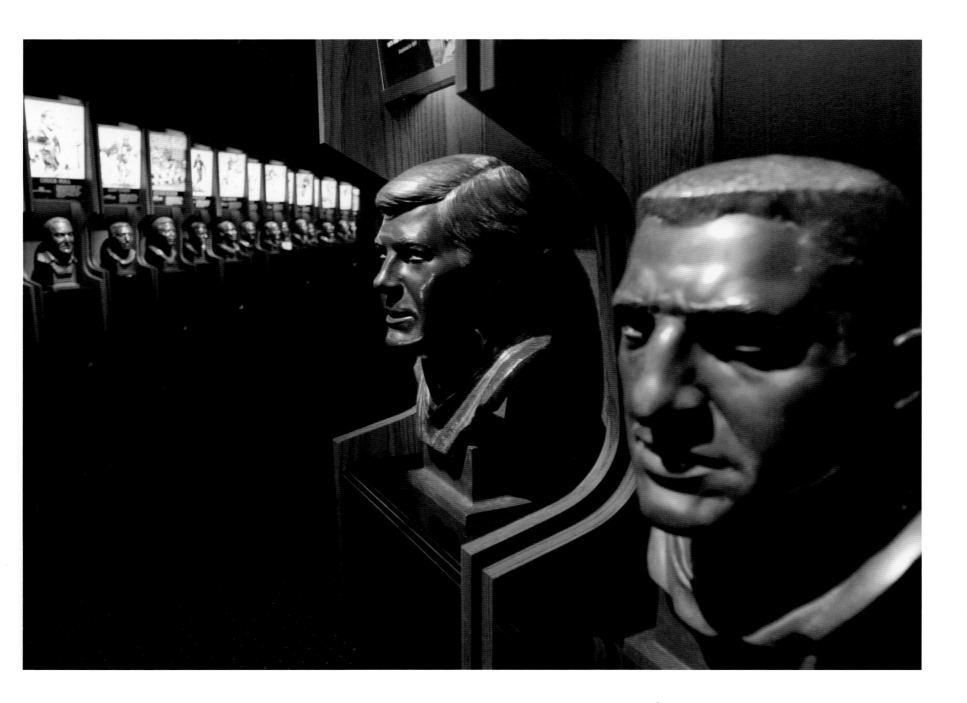

**ATHENS**

Japanese exchange students hit the ATM at the International Street Fair sponsored by Ohio University. During the one-day event, Court Street is transformed into an international pedestrian mall with ethnic cuisine, music, and dance. Ohio University draws students from 100 countries.
*Photo by Uma Sanghvi*

**ATHENS**

Rhythm nations: Students from five continents march through the Ohio University campus during the annual street fair. West African drummers kick off the celebration with percussion and singing; Brazilian samba dancers bring up the rear.
*Photo by Terry E. Eiler, Ohio University*

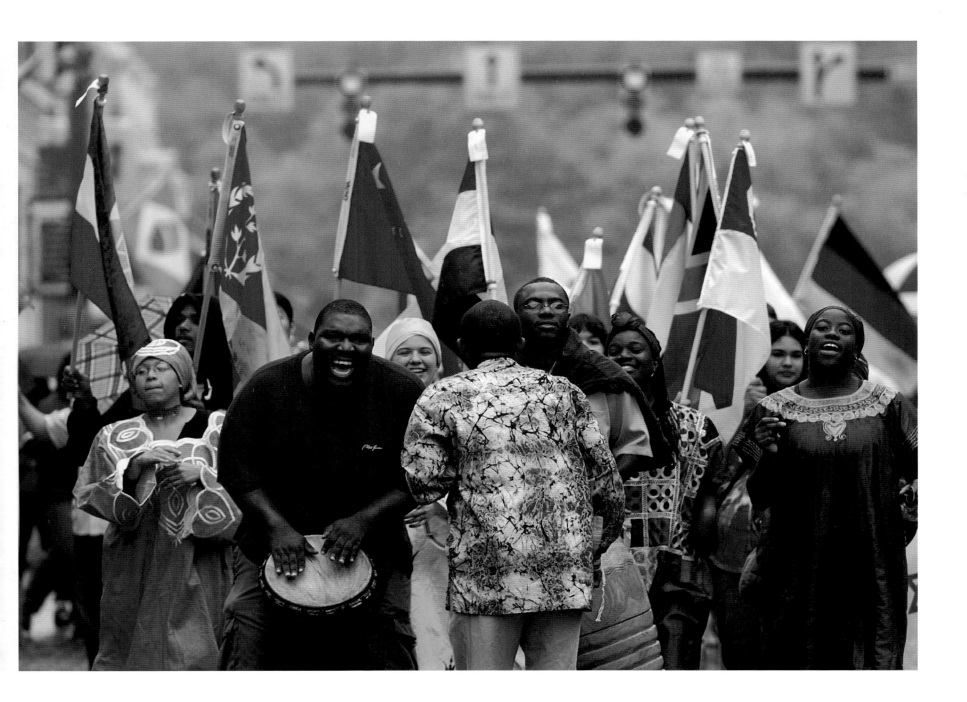

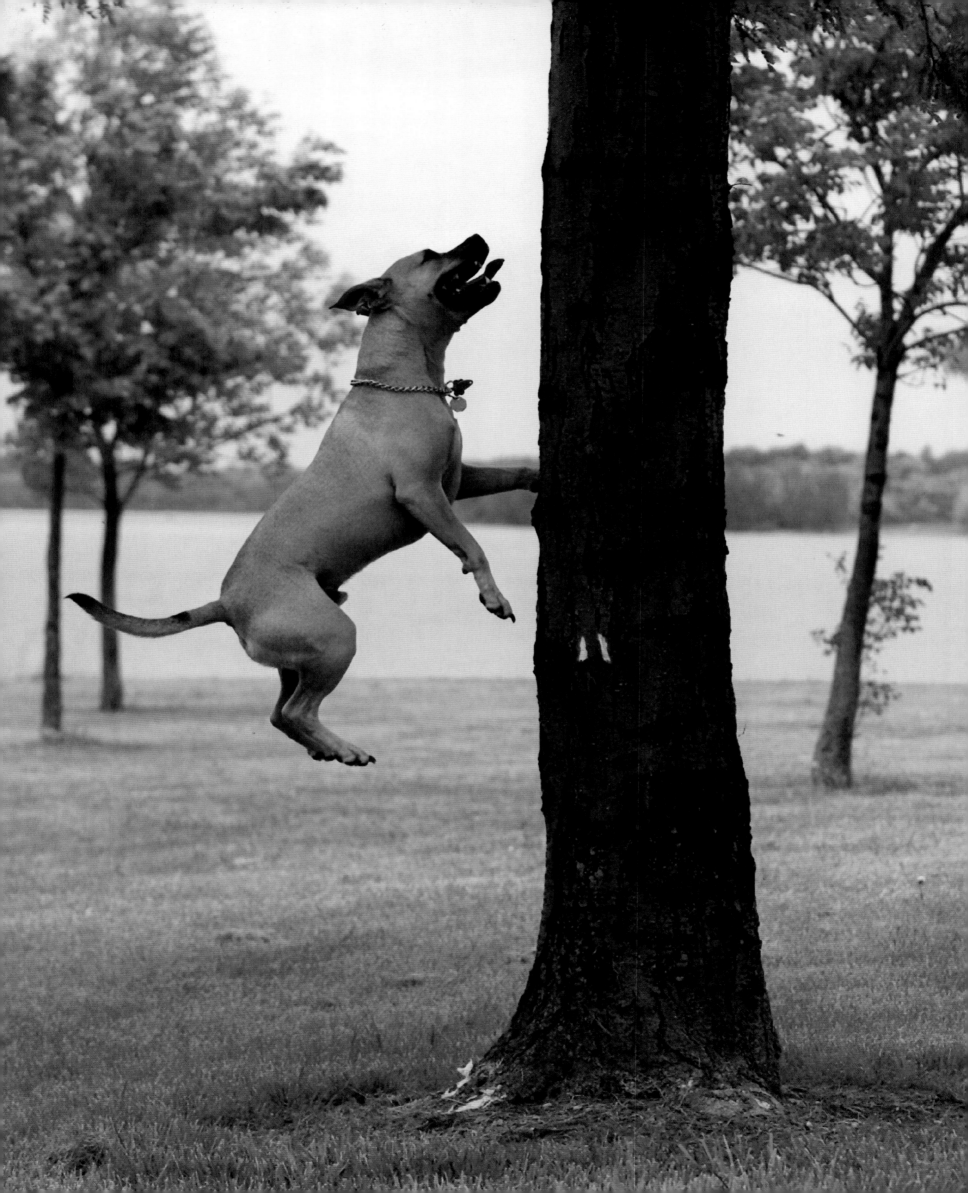

**SPRINGFIELD**

Squirrels torment Chance, a stray mutt found by owner Michael Woods in a machine shop parking lot. Most days are spent chasing the elusive rodents along the backyard fence or up tree trunks like this one at Buck Creek Lake. "He's never caught one," says Woods.

*Photo by Bill Reinke, Dayton Daily News*

**VAN WERT**

Ashley John and Daisy, her 7-year-old spitz mix, took first prize in the Sub Novice B Category at the Van Wert County K-9 4-H Club Dog Show. Daisy had to flawlessly execute commands such as long down, long sit, circle right, and circle left. Ashley's secret to training a winner? "Make her feel special, but be strict."

*Photo by Bruce Strong, LightChasers*

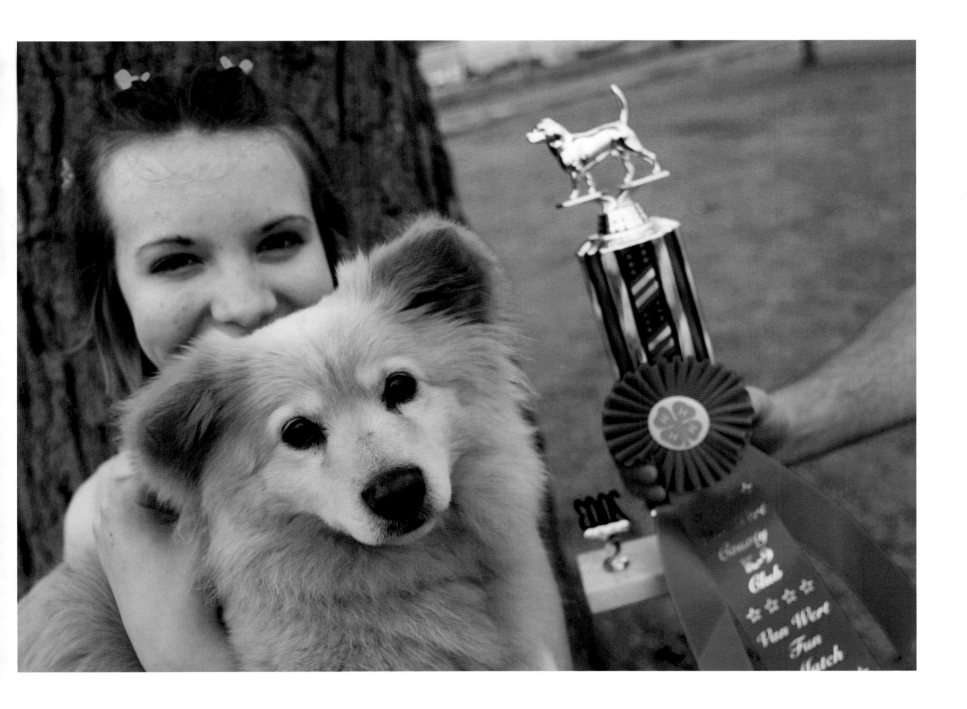

Capital City Hats on the north side of Columbus
has been selling richly colored and trimmed
headgear for 20 years.
*Photo by Eric Albrecht, The Columbus Dispatch*

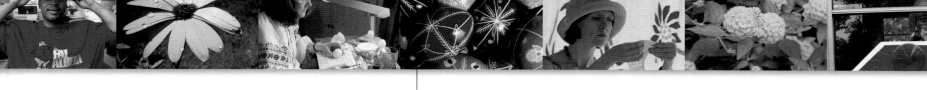

**TIPP CITY**

Ukrainian eggs are meticulously etched in wax and dyed in stages before the paraffin is burned off to reveal delicate patterns and vibrant color schemes. These examples of ovoid art are waiting to be sold at the World Affair in Dayton, a multicultural festival that showcases food, crafts, and music from around the world.

*Photo by Bill Reinke, Dayton Daily News*

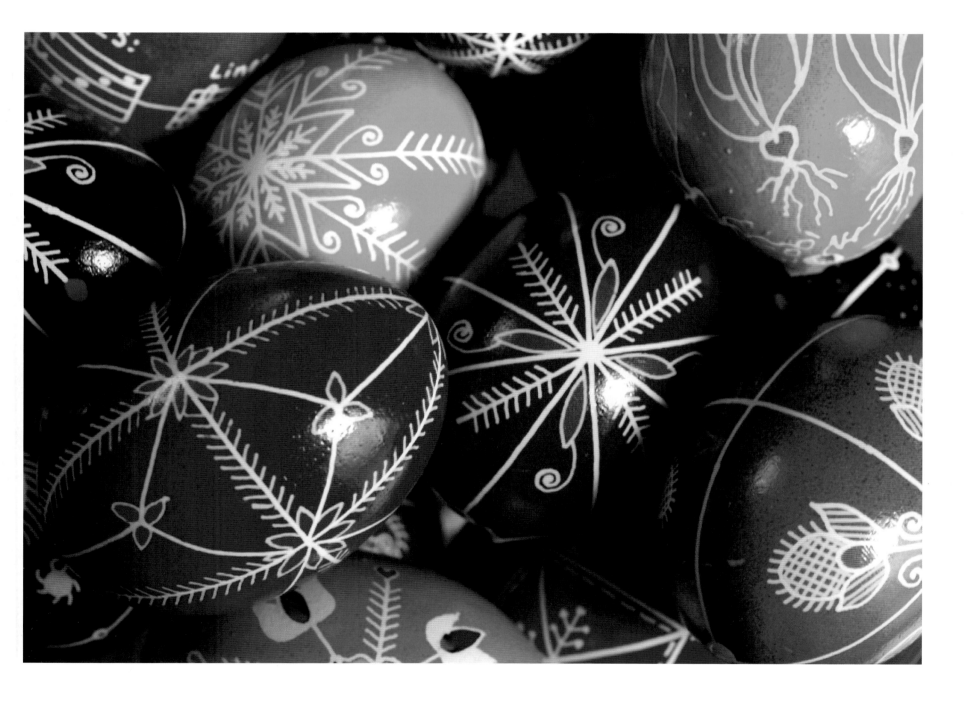

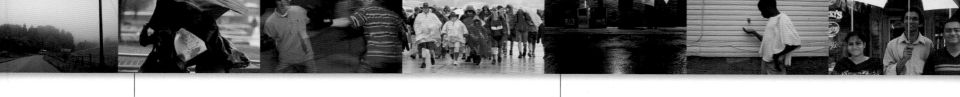

**CLEVELAND**

Pedestrians in downtown Cleveland struggle to keep dry during a windy rainstorm. Although springtime is just plain wet in Cleveland, Lake Erie tends to moderate the town's climate extremes, keeping winters warmer and summers cooler than other Midwestern cities.
*Photo by Albert P. Fuchs,*
*Fuchs & Kasperek Photography*

**MASSILLION**

Just off the old Lincoln Highway, a traveler finds a pay phone. The highway, envisioned in 1913, became the nation's first paved, transcontinental road and ran from New York City to San Francisco. The Ohio leg (US 30) begins in East Liverpool and heads straight west to the Indiana border.
*Photo by Bruce Strong, LightChasers*

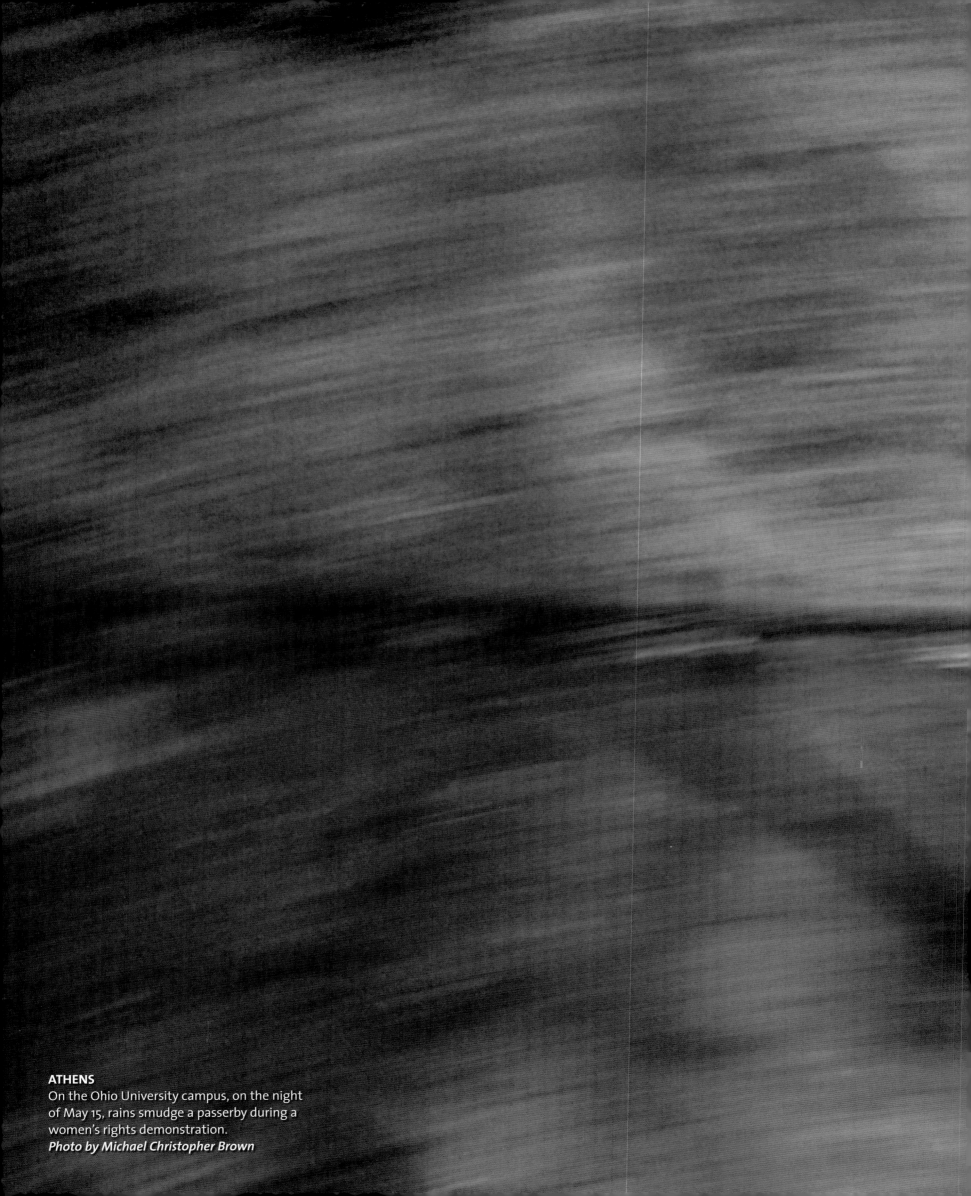

**ATHENS**
On the Ohio University campus, on the night of May 15, rains smudge a passerby during a women's rights demonstration.
*Photo by Michael Christopher Brown*

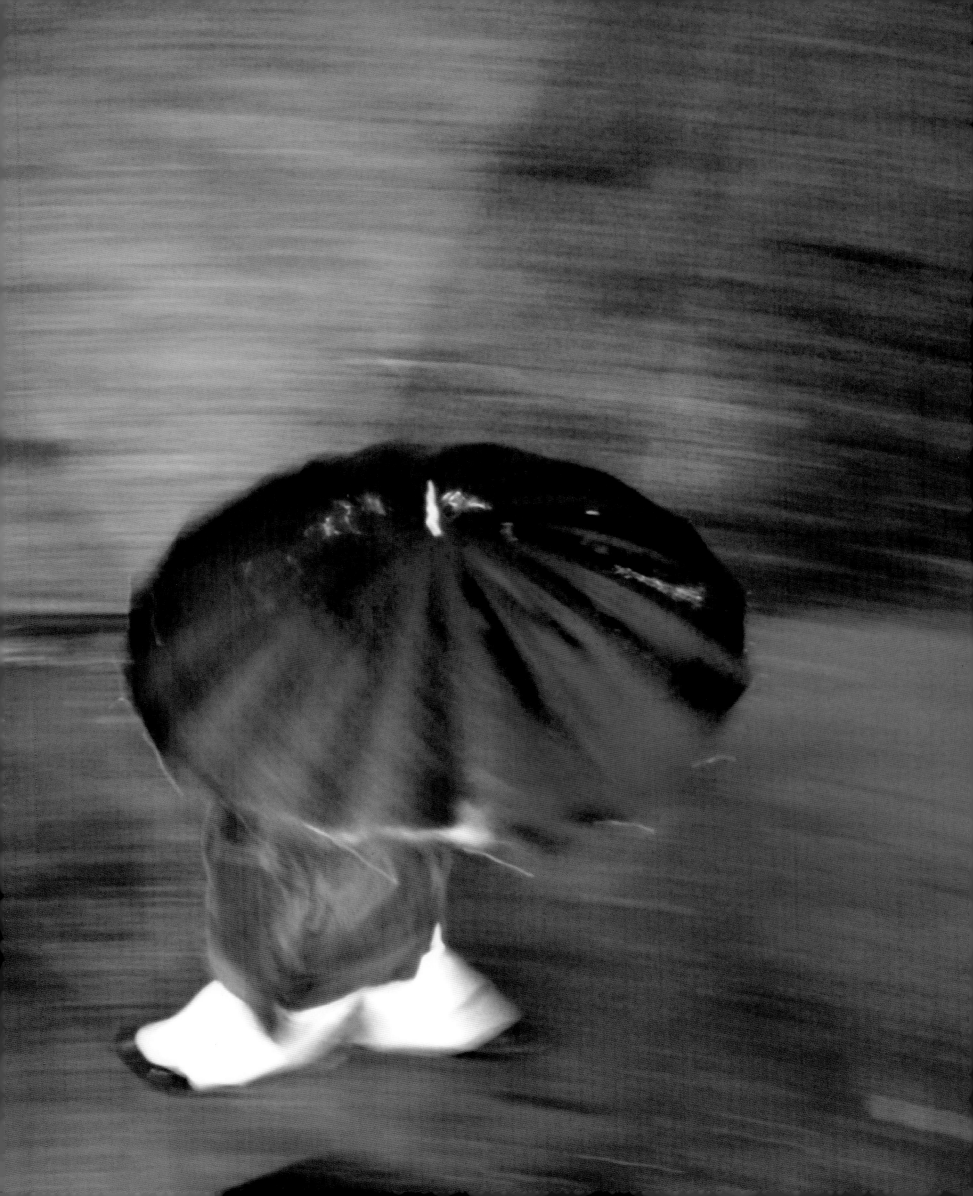

**ATHENS**

Ohio University seniors gorge on buffalo wings during the Red Brick Tavern's annual wing-eating contest. The 2003 champ, Jim Bero (not pictured), was also the 2002 winner. He ate 28 wings in five minutes and earned 50 free wings per month for the next year as his grand prize, antacids not included.

*Photo by Robert Caplin*

## COLUMBUS

Columbusites crowd the dance floor at the Frog Bear & Wild Boar Bar in the Arena District. The once-blighted downtown area lit up in 2000, when the new Nationwide Arena (home to the NHL Blue Jackets) opened and attracted a host of brand-name restaurants, bars, and shops.
*Photo by Andres Gonzalez, Ohio University*

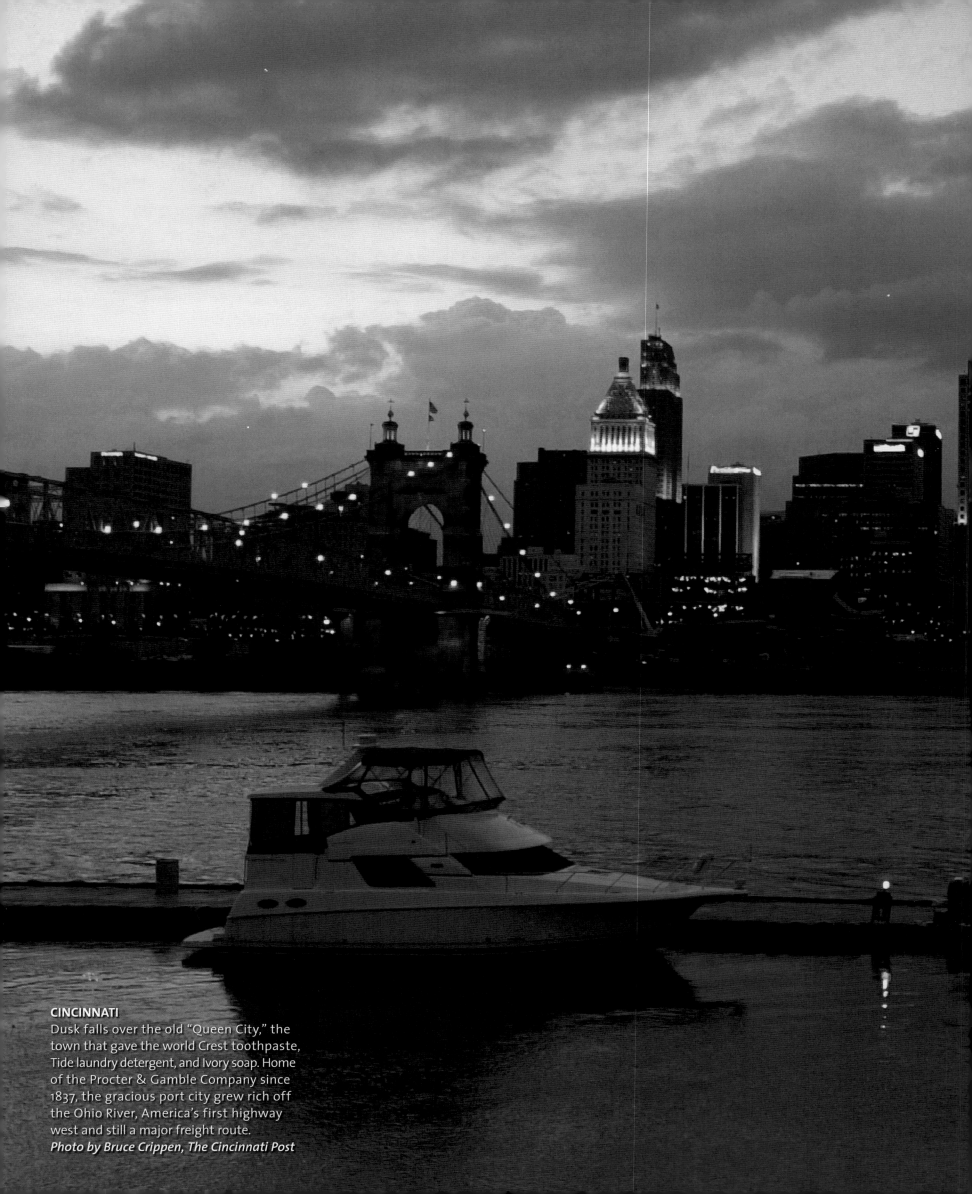

**CINCINNATI**
Dusk falls over the old "Queen City," the town that gave the world Crest toothpaste, Tide laundry detergent, and Ivory soap. Home of the Procter & Gamble Company since 1837, the gracious port city grew rich off the Ohio River, America's first highway west and still a major freight route.
*Photo by Bruce Crippen, The Cincinnati Post*

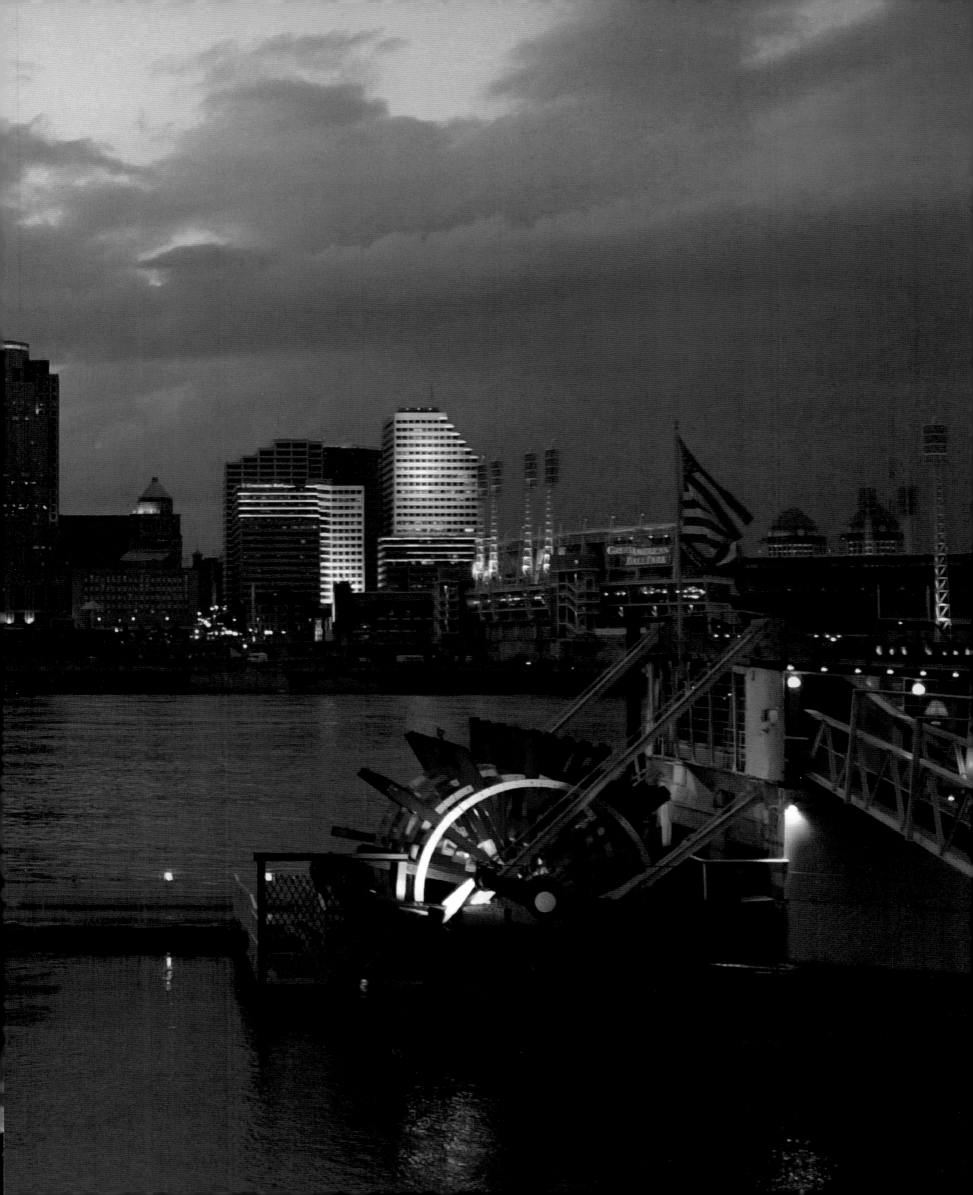

The week of May 12-18, 2003, more than 25,000 professional and amateur photographers spread out across the nation to shoot over a million digital photographs with the goal of capturing the essence of daily life in America.

The professional photographers were equipped with Adobe Photoshop and Adobe Album software, Olympus C-5050 digital cameras, and Lexar Media's high-speed compact flash cards.

The 1,000 professional contract photographers plus another 5,000 stringers and students sent their images via FTP (file transfer protocol) directly to the *America 24/7* website. Meanwhile, thousands of amateur photographers uploaded their images to Snapfish's servers.

At *America 24/7*'s Mission Control headquarters, located at CNET in San Francisco, dozens of picture editors from the nation's most prestigious publications culled the images down to 25,000 of the very best, using Photo Mechanic by Camera Bits. These photos were transferred into Webware's ActiveMedia Digital Asset Management (DAM) system, which served as a central image library and enabled the designers to track, search, distribute, and reformat the images for the creation of the 51 books, foreign language editions, web and magazine syndication, posters, and exhibitions.

Once in the DAM, images were optimized (and in some cases resampled to increase image resolution) using Adobe Photoshop. Adobe InDesign and Adobe InCopy were used to design and produce the 51 books, which were edited and reviewed in multiple locations around the world in the form of Adobe Acrobat PDFs. Epson Stylus printers were used for photo proofing and to produce large-format images for exhibitions. The companies providing support for the *America 24/7* project offer many of the essential components for anyone building a digital darkroom. We encourage you to read more on the following pages about their respective roles in making *America 24/7* possible.

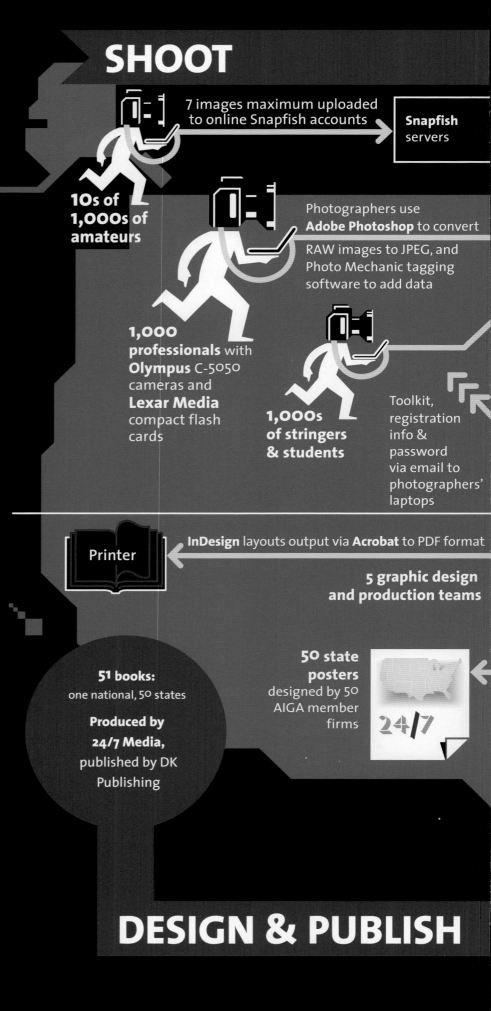

**SHOOT**

7 images maximum uploaded to online Snapfish accounts

**Snapfish** servers

**10s of 1,000s of amateurs**

Photographers use **Adobe Photoshop** to convert RAW images to JPEG, and Photo Mechanic tagging software to add data

**1,000 professionals** with **Olympus** C-5050 cameras and **Lexar Media** compact flash cards

**1,000s of stringers & students**

Toolkit, registration info & password via email to photographers' laptops

InDesign layouts output via **Acrobat** to PDF format

Printer

**5 graphic design and production teams**

**51 books:** one national, 50 states

**Produced by 24/7 Media,** published by DK Publishing

**50 state posters** designed by 50 AIGA member firms

24/7

**DESIGN & PUBLISH**

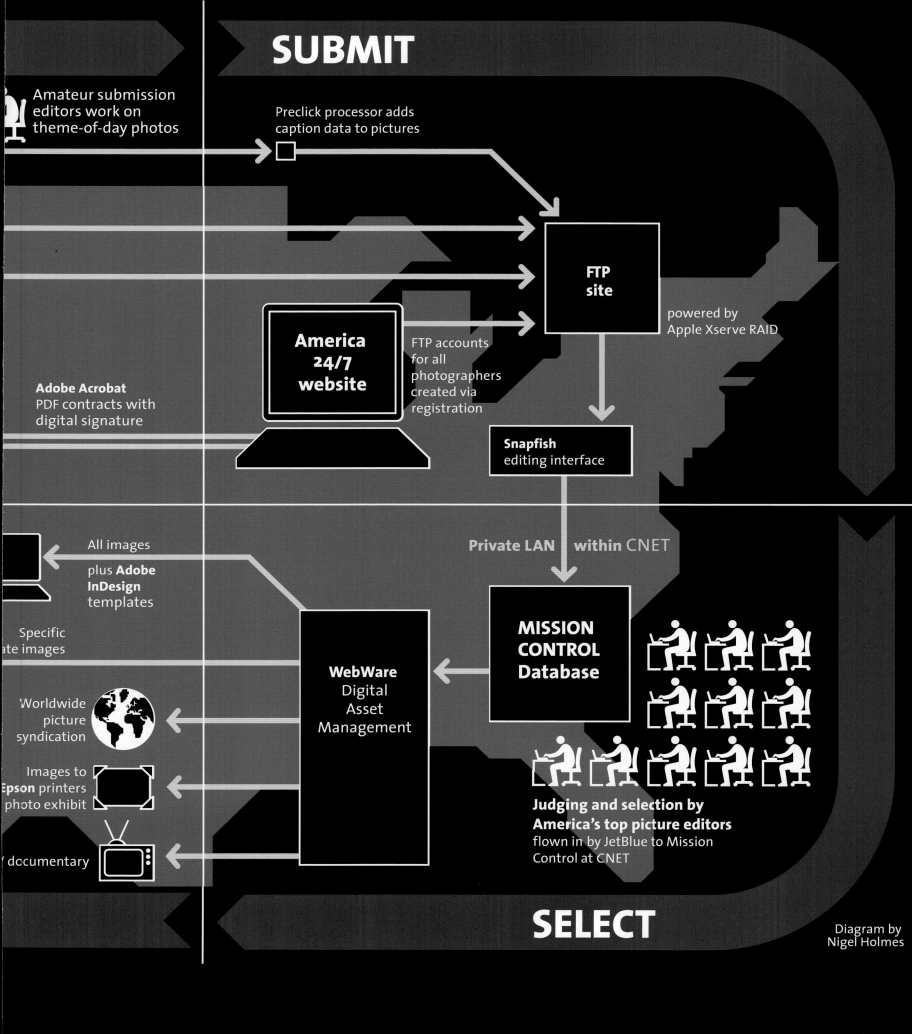

# SUBMIT

Amateur submission editors work on theme-of-day photos

Preclick processor adds caption data to pictures

**FTP site**

powered by Apple Xserve RAID

**America 24/7 website**

FTP accounts for all photographers created via registration

**Adobe Acrobat** PDF contracts with digital signature

**Snapfish** editing interface

All images

plus **Adobe InDesign** templates

**Private LAN within CNET**

Specific ate images

**WebWare** Digital Asset Management

**MISSION CONTROL Database**

Worldwide picture syndication

Images to **Epson** printers photo exhibit

**Judging and selection by America's top picture editors** flown in by JetBlue to Mission Control at CNET

documentary

# SELECT

Diagram by Nigel Holmes

# About Our Sponsors

*America 24/7* gave digital photographers of all levels the opportunity to share their visions of what it means to live in the United States. This project was made possible by a digital photography revolution that is dramatically changing and improving picture-taking for professionals and amateurs alike. And an Adobe product, Photoshop®, has been at the center of this sea change.

Adobe's products reflect our customers' passion for the creative process, be it the photographer, graphic designer, layout artist, or printer. Adobe is the Publishing and Imaging Software Partner for *America 24/7* and products such as Adobe InDesign®, Photoshop, Acrobat®, and Illustrator® were used to produce this stunning book in a matter of weeks. We hope that our software has helped do justice to the mythic images, contributed by well-known photographers and the inspired hobbyist.

Adobe is proud to be a lead sponsor of *America 24/7*, a project that celebrates the vibrancy of the American spirit: the same spirit that helped found Adobe and inspires our employees and customers to deliver the very best.

Bruce Chizen
President and CEO
Adobe Systems Incorporated

Olympus, a global technology leader in designing precision healthcare solutions and innovative consumer electronics, is proud to be the official digital camera sponsor of *America 24/7*. The opportunity to introduce Americans from coast to coast to the thrill, excitement, and possibility of digital photography makes the vision behind this book a perfect fit for Olympus, a leader in digital cameras since 1996.

For most people, the essence of digital photography is best grasped through firsthand experience with the technology, which is precisely what *America 24/7* is about. We understand that direct experience is the pathway to inspiration, and welcome opportunities like this sponsorship to bring the power of the digital experience into the lives of people everywhere. To Olympus, *America 24/7* offers a platform to help realize a core mission: to deliver and make accessible the power of the digital experience to millions of American photographers, amateurs, and professionals alike.

The 1,000 professional photographers contracted to shoot on the America 24/7 project were all equipped with Olympus C-5050 digital cameras. Like all Olympus products, the C-5050 is offered by a company well known for designing, manufacturing, and servicing products used by professionals to perform their work, every day. Olympus is a customer-centric company committed to working one-

to-one with a diverse group of professionals. From biomedical researchers who use our clinical microscopes, to doctors who perform life-saving procedures with our endoscopes, to professional photographers who use cameras in their daily work, Olympus is a trusted brand.

The digital imaging technology involved with *America 24/7* has enabled the soul of America to be visually conveyed, not just by professional observers, but by the American public who participated in this project—the very people who collectively breath life into this country's existence each day.

We are proud to be enabling so many photographers to capture the pictures on these pages that tell the story of who we are as a nation. From sea to shining sea, digital imagery allows us to connect to one another in ways we never dreamed possible.

At Olympus, our ideas have proliferated as rapidly as technology has evolved. We have channeled these visions into breakthrough products and solutions to meet the demands of our changing world-products like microscopes, endoscopes, and digital voice recorders, supported by the highly regarded training, educational, and consulting services we offer our customers.

Today, 83 years after we introduced our first microscope, we remain as young, as curious, and as committed as ever.

Lexar Media has grown from the digital photography revolution, which is why we are proud to have supplied the digital memory cards used in the America 24/7 project. Lexar Media's high-performance memory cards utilize our unique and patented controller coupled with high-speed flash memory from Samsung, the world's largest flash memory supplier. This powerful combination brings out the ultimate performance of any digital camera.

Photographers who demand the most from their equipment choose our products for their advanced features like write speeds up to 40X, Write Acceleration technology for enabled cameras, and Image Rescue, which recovers previously deleted or lost images. Leading camera manufacturers bundle Lexar Media digital memory cards with their cameras because they value its performance and reliability.

Lexar Media is at the forefront of digital photography as it transforms picture-taking worldwide, and we will continue to be a leader with new and innovative solutions for professionals and amateurs alike.

Snapfish, which developed the technology behind the *America 24/7* amateur photo event, is a leading online photo service, with more than 5 million members and 100 million photos posted online. Snapfish enables both film and digital camera owners to share, print, and store their most important photo memories, at prices that cannot be equaled. Digital camera users upload photos into a password-protected online album for free. Users can also order film-quality prints on professional photographic paper for as low as 25¢. Film camera users get a full set of prints, plus online sharing and storage, for just $2.99 per roll.

JetBlue Airways is proud to be *America 24/7's* preferred carrier, flying photographers, photo editors, and organizers across the United States.

Winner of Condé Nast Traveler's Readers' Choice Awards for Best Domestic Airline 2002, JetBlue provides friendly service and low fares for travelers in 22 cities in nine states across America.

On behalf of JetBlue's 5,000 crew members, we're excited to be involved in this remarkable project, and for the opportunity to serve American travelers each and every day, coast to coast, 24/7.

WebWare Corporation is pleased to be a major sponsor of the America 24/7 project. We take pride in being part of a groundbreaking adventure that is stretching the boundaries—and the imagination—in digital photography, digital asset management, publishing, news, and global events.

Our ActiveMedia Enterprise™ digital asset management software is the "nerve center" of *America 24/7*, the central repository for managing, sharing, and collaborating on the project's photographs. From photo editors and book publishers to 24/7's media relations and marketing personnel, ActiveMedia provides the application support that links all facets of the project team to the content worldwide.

WebWare helps Global 2000 firms securely manage, reuse, and distribute media assets locally or globally. Its suite of ActiveMedia software products provide powerful media services platforms for integrating rich media into content management systems marketing and communication portals; web publishing systems; and e-commerce portals.

Google's mission is to organize the world's information and make it universally accessible and useful.

With our focus on plucking just the right answer from an ocean of data, we were naturally drawn to the America 24/7 project. The book you hold is a compendium of images of American life distilled from thousands of photographs and infinite possibilities. Are you looking for emotion? Narrative? Shadows? Light? It's all here, thanks to a multitude of photographers and writers creating links between you, the reader, and a sea of wonderful stories. We celebrate the connections that constitute the human experience and are pleased to help engender them. And we're pleased to have been a small part of this project, which captures the results of that interaction so vividly, so dynamically, and so dramatically.

Founded in 1995, eBay created a powerful platform for the sale of goods and services by a passionate community of individuals and businesses. On any given day, there are millions of items across thousands of categories for sale on eBay. eBay enables trade on a local, national and international basis with customized sites in markets around the world.

Through an array of services, such as its payment solution provider PayPal, eBay is enabling global e-commerce for an ever-growing online community.

Digital Pond has been a leading creator of large graphic displays for museums, corporations, trade shows, retail environments and fine art since 1992.

We were proud to bring together our creative, print and display capabilities to produce signage and displays for mission control, critical retouching for numerous key images for the book, and art galleries for the New York Public Library and Bryant Park.

The Pond's team and SplashPic® Online service enabled us to nimbly design, produce and install over 200 large graphic panels in two NYC locations within the truly "24/7" production schedule of less than ten days.

**Special thanks to additional contributors:** FileMaker, Apple, Camera Bits, LaCie, Now Software, Preclick, Outpost Digital, Xerox, Microsoft, WoodWing Software, net-linx Publishing Solutions, and Radical Media. The Savoy Hotel, San Francisco; The Pan Pacific, San Francisco; Four Seasons Hotel, San Francisco; and The Queen Anne Hotel. Photography editing facilities were generously hosted by CNET Networks, Inc.

# Participating Photographers

**Coordinator:** Larry Nighswander, School of Visual Communication, Ohio University

Eric Albrecht, *The Columbus Dispatch*
Stan Alost, Ohio University
Ron Alvey
Jim Barrett
Lisa Bohman
Michael Christopher Brown
Robert Caplin
Doral Chenoweth, *The Columbus Dispatch*
Bruce Crippen, *The Cincinnati Post*
John DeMarco
Allan E. Detrich
Brady Dindia
David Distelhorst
Carolyn Drake
Terry E. Eiler, Ohio University
Albert P. Fuchs, Fuchs & Kasperek Photography
Monique Ganucheau
Andres Gonzalez, Ohio University
Lawrence Hamel-Lambert
Dave Hoffman
Steve Hoskinson
Eustacio Humphrey

Larry Kasperek, Fuchs & Kasperek Photography
Carl Keller
Jason Kossman
David G. Massey
Denise McGill, www.denisemcgill.com
Larry Nighswander, Ohio University
Marcy Nighswander
Dale Omori
Skip Peterson, *Dayton Daily News*
Chris Pezzutti
Patrick Reddy, *Cincinnati Enquirer*
Bill Reinke, *Dayton Daily News*
Tim Revell, *The Columbus Dispatch*
David Richard
Dana Romanoff, Ohio University
Uma Sanghvi
Eric Smith
Edward Smith
Bruce Strong, LightChasers
Shirley Ware, *Medina Gazette*
Jim Witmer, *Dayton Daily News*
Bonson Yee

# Thumbnail Picture Credits

Credits for thumbnail photographs are listed by the page number and are in order from left to right.

**20** Anna Rhae Smith, New York Institute of Photography
Anna Rhae Smith, New York Institute of Photography
Bruce Strong, LightChasers
Bruce Strong, LightChasers
Bruce Strong, LightChasers
Jim Barrett
Eric Albrecht, *The Columbus Dispatch*

**21** Monique Ganucheau
Jim Witmer, *Dayton Daily News*
Tim Revell, *The Columbus Dispatch*
J. Pruden, AmericanWeblog.com
Larry Kasperek, Fuchs & Kasperek Photography
Patrick Reddy, *Cincinnati Enquirer*
Tim Revell, *The Columbus Dispatch*

**22** Michael A. Ciu
Carolyn Drake
Carolyn Drake
Jim Witmer, *Dayton Daily News*
Dale Omori
Bruce Strong, LightChasers
Carolyn Drake

**23** Eric Albrecht, *The Columbus Dispatch*
Eric Albrecht, *The Columbus Dispatch*
Eric Albrecht, *The Columbus Dispatch*
Josh Dague
Larry Nighswander, Ohio University
Lawrence Hamel-Lambert
Eric Albrecht, *The Columbus Dispatch*

**24** Lawrence Hamel-Lambert
Allan E. Detrich
Anna Rhae Smith, New York Institute of Photography
Bruce Strong, LightChasers
Bruce Crippen, *The Cincinnati Post*
Bruce Crippen, *The Cincinnati Post*
Patrick Reddy, *Cincinnati Enquirer*

**25** Lawrence Hamel-Lambert
Jim Barrett
Meghan June Brown, University of Dayton
K.L.M.N. Williams
Albert P. Fuchs, Fuchs & Kasperek Photography
Bruce Crippen, *The Cincinnati Post*
Dale Omori

**26** Bruce Strong, LightChasers
Bruce Strong, LightChasers
Eric Albrecht, *The Columbus Dispatch*
Jim Witmer, *Dayton Daily News*
Bruce Strong, LightChasers
Bruce Strong, LightChasers
Christine K. McCune

**27** Bruce Strong, LightChasers
Bruce Strong, LightChasers
Larry Kasperek, Fuchs & Kasperek Photography
Monique Ganucheau
Bruce Strong, LightChasers
Monique Ganucheau
Bruce Strong, LightChasers

**28** Allan E. Detrich
Anna Rhae Smith, New York Institute of Photography
Jim Witmer, *Dayton Daily News*
J. Pruden, AmericanWeblog.com
Eric Albrecht, *The Columbus Dispatch*
Anna Rhae Smith, New York Institute of Photography
Larry Kasperek, Fuchs & Kasperek Photography

**29** Eric Smith
Jim Witmer, *Dayton Daily News*
Jim Witmer, *Dayton Daily News*
Jim Witmer, *Dayton Daily News*
Shirley Ware, *Medina Gazette*
Bill Reinke, *Dayton Daily News*
Christine K. McCune

**30** Lawrence Hamel-Lambert
Robert Caplin
Eric Albrecht, *The Columbus Dispatch*
Shirley Ware, *Medina Gazette*
Jim Witmer, *Dayton Daily News*
Allan E. Detrich
Bruce Strong, LightChasers

**34** Carolyn Drake
Albert P. Fuchs, Fuchs & Kasperek Photography
Anna Rhae Smith, New York Institute of Photography
Denise McGill, www.denisemcgill.com
Carolyn Drake

Anna Rhae Smith, New York Institute of Photography
Denise McGill, www.denisemcgill.com

**35** Larry Kasperek, Fuchs & Kasperek Photography
John E. Rees
Terry E. Eiler, Ohio University
Anna Rhae Smith, New York Institute of Photography
Jim Witmer, *Dayton Daily News*
Carolyn Drake

**37** Eric Albrecht, *The Columbus Dispatch*
Eric Albrecht, *The Columbus Dispatch*
Eric Albrecht, *The Columbus Dispatch*
Jim Witmer, *Dayton Daily News*
Jim Witmer, *Dayton Daily News*
Eric Albrecht, *The Columbus Dispatch*
Jim Witmer, *Dayton Daily News*

**38** Allan E. Detrich
Patrick Reddy, *Cincinnati Enquirer*
Bruce Strong, LightChasers
Bruce Crippen, *The Cincinnati Post*
Bruce Strong, LightChasers
Bruce Strong, LightChasers
Skip Peterson, *Dayton Daily News*

**39** Carolyn Drake
Bruce Strong, LightChasers
Mike Stump
Monique Ganucheau
Anna Rhae Smith, New York Institute of Photography
Tom Mullins
Bruce Crippen, *The Cincinnati Post*

**41** Meghan June Brown, University of Dayton
Patrick Reddy, *Cincinnati Enquirer*
Patrick Reddy, *Cincinnati Enquirer*
Monique Ganucheau
Patrick Reddy, *Cincinnati Enquirer*
Monique Ganucheau
Monique Ganucheau

**42** Doral Chenoweth, *The Columbus Dispatch*
Larry Kasperek, Fuchs & Kasperek Photography
Uma Sanghvi
Bruce Crippen, *The Cincinnati Post*
Larry Kasperek, Fuchs & Kasperek Photography
Doral Chenoweth, *The Columbus Dispatch*
Bruce Crippen, *The Cincinnati Post*

**43** Bruce Crippen, *The Cincinnati Post*
Doral Chenoweth, *The Columbus Dispatch*
Doral Chenoweth, *The Columbus Dispatch*
Bruce Crippen, *The Cincinnati Post*
Bruce Crippen, *The Cincinnati Post*
Bruce Crippen, *The Cincinnati Post*
Shirley Ware, *Medina Gazette*

**45** Shirley Ware, *Medina Gazette*
Dana Romanoff, Ohio University
Christine K. McCune
Christine K. McCune
Shirley Ware, *Medina Gazette*
Doral Chenoweth, *The Columbus Dispatch*
Christine K. McCune

**52** Patrick Reddy, *Cincinnati Enquirer*
Allan E. Detrich
Lawrence Hamel-Lambert
Christine K. McCune
Bruce Strong, LightChasers
Lawrence Hamel-Lambert
Anna Rhae Smith, New York Institute of Photography

**53** Lawrence Hamel-Lambert
Patrick Reddy, *Cincinnati Enquirer*
Lawrence Hamel-Lambert
Shirley Ware, *Medina Gazette*
Bruce Strong, LightChasers
Skip Peterson, *Dayton Daily News*
Patrick Reddy, *Cincinnati Enquirer*

**54** Skip Peterson, *Dayton Daily News*
Bruce Crippen, *The Cincinnati Post*
Skip Peterson, *Dayton Daily News*
Robert Caplin
John E. Rees
Lara Neel
Patrick Reddy, *Cincinnati Enquirer*

**55** Robert A. Makley
Robert Caplin
Robert Caplin
Skip Peterson, *Dayton Daily News*

Robert Caplin
Larry Kasperek, Fuchs & Kasperek Photography
Albert P. Fuchs, Fuchs & Kasperek Photography

**56** Bruce Strong, LightChasers
Albert P. Fuchs, Fuchs & Kasperek Photography
Dale Omori
Allan E. Detrich
Bruce Strong, LightChasers
Albert P. Fuchs, Fuchs & Kasperek Photography
Bruce Strong, LightChasers

**57** Bruce Strong, LightChasers
Bruce Strong, LightChasers
Allan E. Detrich
Bruce Strong, LightChasers
Dale Omori
Bruce Strong, LightChasers
Dale Omori

**58** Bruce Strong, LightChasers
Bruce Crippen, *The Cincinnati Post*
Carolyn Drake
Lawrence Hamel-Lambert
Bruce Crippen, *The Cincinnati Post*
Lawrence Hamel-Lambert
Lawrence Hamel-Lambert

**59** Carolyn Drake
Bruce Strong, LightChasers
Jim Witmer, *Dayton Daily News*
Lawrence Hamel-Lambert
Larry Kasperek, Fuchs & Kasperek Photography
Bruce Crippen, *The Cincinnati Post*
Lawrence Hamel-Lambert

**60** Bruce Strong, LightChasers
Allan E. Detrich
Jim Witmer, *Dayton Daily News*
Skip Peterson, *Dayton Daily News*
Bruce Strong, LightChasers
Dale Omori
Skip Peterson, *Dayton Daily News*

**61** Bruce Strong, LightChasers
Skip Peterson, *Dayton Daily News*
Skip Peterson, *Dayton Daily News*
Bill Reinke, *Dayton Daily News*
Skip Peterson, *Dayton Daily News*
Tom Mullins
Bill Reinke, *Dayton Daily News*

**62** Bruce Strong, LightChasers
Robert Caplin
Bruce Strong, LightChasers
Eric Albrecht, *The Columbus Dispatch*
John E. Rees
Andres Gonzalez, Ohio University
Larry Kasperek, Fuchs & Kasperek Photography

**63** Lawrence Hamel-Lambert
Andres Gonzalez, Ohio University
Bruce Strong, LightChasers
Lawrence Hamel-Lambert
Larry Kasperek, Fuchs & Kasperek Photography
Lawrence Hamel-Lambert
Albert P. Fuchs, Fuchs & Kasperek Photography

**66** Albert P. Fuchs, Fuchs & Kasperek Photography
Bruce Crippen, *The Cincinnati Post*
Uma Sanghvi
Lawrence Hamel-Lambert
Uma Sanghvi
Larry Nighswander, Ohio University
Bill Reinke, *Dayton Daily News*

**67** Uma Sanghvi
Larry Kasperek, Fuchs & Kasperek Photography
Uma Sanghvi
Uma Sanghvi
Bill Reinke, *Dayton Daily News*
Patrick Reddy, *Cincinnati Enquirer*
Bruce Crippen, *The Cincinnati Post*

**69** Bruce Strong, LightChasers
David G. Massey
David G. Massey
Bill Reinke, *Dayton Daily News*
Bruce Strong, LightChasers
David G. Massey
Patrick Reddy, *Cincinnati Enquirer*

**70** Larry Kasperek,
Fuchs & Kasperek Photography
Michael C. Andrews
Terry E. Eiler, Ohio University
J. Pruden, AmericanWeblog.com
Andres Gonzalez, Ohio University
Bruce Crippen, *The Cincinnati Post*
Bruce Crippen, *The Cincinnati Post*

**71** Larry Kasperek,
Fuchs & Kasperek Photography
Michael C. Andrews
Michael C. Andrews
Bruce Crippen, *The Cincinnati Post*
Skip Peterson, *Dayton Daily News*
Bruce Crippen, *The Cincinnati Post*
Bill Reinke, *Dayton Daily News*

**72** Anna Rhae Smith,
New York Institute of Photography
Albert P. Fuchs,
Fuchs & Kasperek Photography
Michael A. Ciu
Albert P. Fuchs,
Fuchs & Kasperek Photography
Patrick Reddy, *Cincinnati Enquirer*
Angela Hunter
Patrick Reddy, *Cincinnati Enquirer*

**74** Patrick Reddy, *Cincinnati Enquirer*
David G. Massey
Eric Albrecht, *The Columbus Dispatch*
Allan E. Detrich
Jim Witmer, *Dayton Daily News*
Allan E. Detrich
Bruce Crippen, *The Cincinnati Post*

**75** Bruce Crippen, *The Cincinnati Post*
Jim Witmer, *Dayton Daily News*
Eric Albrecht, *The Columbus Dispatch*
Patrick Reddy, *Cincinnati Enquirer*
Skip Peterson, *Dayton Daily News*
Patrick Reddy, *Cincinnati Enquirer*
Bruce Crippen, *The Cincinnati Post*

**76** Patrick Reddy, *Cincinnati Enquirer*
Allan E. Detrich
Eric Albrecht, *The Columbus Dispatch*
Bill Reinke, *Dayton Daily News*
Patrick Reddy, *Cincinnati Enquirer*
Bruce Strong, LightChasers
Bruce Crippen, *The Cincinnati Post*

**77** Bruce Crippen, *The Cincinnati Post*
Bill Reinke, *Dayton Daily News*
Patrick Reddy, *Cincinnati Enquirer*
Skip Peterson, *Dayton Daily News*
Eric Albrecht, *The Columbus Dispatch*
Bill Reinke, *Dayton Daily News*
Bruce Crippen, *The Cincinnati Post*

**80** Allan E. Detrich
Lawrence Hamel-Lambert
Eric Albrecht, *The Columbus Dispatch*
Bill Reinke, *Dayton Daily News*
Skip Peterson, *Dayton Daily News*
Allan E. Detrich
Bill Reinke, *Dayton Daily News*

**81** Bill Reinke, *Dayton Daily News*
Eric Albrecht, *The Columbus Dispatch*
Tim G. Zechar,
New York Institute of Photography
Bruce Strong, LightChasers
Tim G. Zechar,
New York Institute of Photography
Lawrence Hamel-Lambert
Patrick Reddy, *Cincinnati Enquirer*

**82** Bruce Strong, LightChasers
Bruce Strong, LightChasers
David Richard
Carolyn Drake
Uma Sanghvi
Bruce Strong, LightChasers
Bruce Strong, LightChasers

**83** Larry Kasperek,
Fuchs & Kasperek Photography
Bill Reinke, *Dayton Daily News*
Bruce Strong, LightChasers
Stan Alost, Ohio University
Robert Caplin
Bruce Strong, LightChasers
Carolyn Drake

**86** Albert P. Fuchs,
Fuchs & Kasperek Photography
David G. Massey
Bruce Crippen, *The Cincinnati Post*
Bruce Crippen, *The Cincinnati Post*
David G. Massey
Uma Sanghvi
Monique Ganucheau

**87** Larry Kasperek,
Fuchs & Kasperek Photography
Larry Kasperek,
Fuchs & Kasperek Photography
Albert P. Fuchs,
Fuchs & Kasperek Photography
Monique Ganucheau
Albert P. Fuchs,
Fuchs & Kasperek Photography
Uma Sanghvi
Bruce Crippen, *The Cincinnati Post*

**88** Lara Neel
Bruce Strong, LightChasers
Lara Neel
Albert P. Fuchs,
Fuchs & Kasperek Photography
Lara Neel
Albert P. Fuchs,
Fuchs & Kasperek Photography
Albert P. Fuchs,
Fuchs & Kasperek Photography

**89** William D. Taylor, Sr.
Lara Neel
Patrick Reddy, *Cincinnati Enquirer*
William D. Taylor, Sr.
William D. Taylor, Sr.
Lawrence Hamel-Lambert
Lara Neel

**92** Dana Romanoff, Ohio University
Albert P. Fuchs,
Fuchs & Kasperek Photography
Dale Omori
David Distelhorst
Terry E. Eiler, Ohio University
David Richard
Larry Kasperek,
Fuchs & Kasperek Photography

**93** Larry Kasperek,
Fuchs & Kasperek Photography
Larry Kasperek,
Fuchs & Kasperek Photography
Marcy Nighswander
Carolyn Drake
Marcy Nighswander
Larry Kasperek,
Fuchs & Kasperek Photography
Bill Reinke, *Dayton Daily News*

**94** Eric Albrecht, *The Columbus Dispatch*
Eric Albrecht, *The Columbus Dispatch*
Eric Albrecht, *The Columbus Dispatch*
Bruce Crippen, *The Cincinnati Post*
Eric Albrecht, *The Columbus Dispatch*
Eric Albrecht, *The Columbus Dispatch*
Christine K. McCune

**95** Eric Albrecht, *The Columbus Dispatch*
Larry Kasperek,
Fuchs & Kasperek Photography
Eric Albrecht, *The Columbus Dispatch*
Eric Albrecht, *The Columbus Dispatch*
Ron Alvey
Larry Kasperek,
Fuchs & Kasperek Photography
Eric Albrecht, *The Columbus Dispatch*

**96** Robert Caplin
Allan E. Detrich
Allan E. Detrich
Allan E. Detrich
Skip Peterson, *Dayton Daily News*
David Richard
Allan E. Detrich

**97** David Richard
David Richard
Bill Reinke, *Dayton Daily News*
Allan E. Detrich
Jim Witmer, *Dayton Daily News*
Allan E. Detrich
Skip Peterson, *Dayton Daily News*

**98** Bruce Strong, LightChasers
Bruce Strong, LightChasers
Eric Albrecht, *The Columbus Dispatch*
Bruce Strong, LightChasers
Lawrence Hamel-Lambert
Eric Albrecht, *The Columbus Dispatch*
Eric Albrecht, *The Columbus Dispatch*

**99** Lawrence Hamel-Lambert
Bruce Strong, LightChasers
Skip Peterson, *Dayton Daily News*
Carolyn Drake
Lawrence Hamel-Lambert
John E. Rees
Lawrence Hamel-Lambert

**102** Lawrence Hamel-Lambert
Bruce Strong, LightChasers
Lawrence Hamel-Lambert
Larry Kasperek,
Fuchs & Kasperek Photography
Lawrence Hamel-Lambert
Lawrence Hamel-Lambert
Lawrence Hamel-Lambert

**103** Lawrence Hamel-Lambert
Hunt Sidway
Lawrence Hamel-Lambert
Terry E. Eiler, Ohio University
Albert P. Fuchs,
Fuchs & Kasperek Photography
Angela Hunter
Lawrence Hamel-Lambert

**105** Michael A. Ciu
Bruce Crippen, *The Cincinnati Post*
Shirley Ware, *Medina Gazette*
Bruce Crippen, *The Cincinnati Post*
Bruce Crippen, *The Cincinnati Post*
Hunt Sidway
Bruce Crippen, *The Cincinnati Post*

**106** Bill Reinke, *Dayton Daily News*
Angela Hunter
Bruce Strong, LightChasers
Terry E. Eiler, Ohio University
Eric Albrecht, *The Columbus Dispatch*
Stan Alost, Ohio University
Eric Albrecht, *The Columbus Dispatch*

**107** Anna Rhae Smith,
New York Institute of Photography
Bill Reinke, *Dayton Daily News*
Anna Rhae Smith,
New York Institute of Photography
Bruce Crippen, *The Cincinnati Post*
Anna Rhae Smith,
New York Institute of Photography
Josh Dague
Bruce Strong, LightChasers

**108** Carolyn Drake
Bruce Crippen, *The Cincinnati Post*
Bruce Crippen, *The Cincinnati Post*
Bruce Crippen, *The Cincinnati Post*
Carolyn Drake
Carolyn Drake
Bruce Crippen, *The Cincinnati Post*

**109** David Distelhorst
Carolyn Drake
Bruce Crippen, *The Cincinnati Post*
Carolyn Drake
Bruce Crippen, *The Cincinnati Post*
Monique Ganucheau
Bruce Crippen, *The Cincinnati Post*

**112** Eric Smith
David G. Massey
Christine K. McCune
Uma Sanghvi
David Distelhorst
Eric Albrecht, *The Columbus Dispatch*
Uma Sanghvi

**113** Eric Albrecht, *The Columbus Dispatch*
Eric Smith
Terry E. Eiler, Ohio University
Terry E. Eiler, Ohio University
Eric Albrecht, *The Columbus Dispatch*
Eric Smith
Uma Sanghvi

**118** Bruce Crippen, *The Cincinnati Post*
Albert P. Fuchs,
Fuchs & Kasperek Photography
David Distelhorst
Christine K. McCune
Eric Albrecht, *The Columbus Dispatch*
Jim Witmer, *Dayton Daily News*
Dale Omori

**119** Eric Albrecht, *The Columbus Dispatch*
Eric Albrecht, *The Columbus Dispatch*
Eric Albrecht, *The Columbus Dispatch*
Lawrence Hamel-Lambert
Bruce Strong, LightChasers
Tim G. Zechar,
New York Institute of Photography
Lawrence Hamel-Lambert

**120** Allan E. Detrich
Anna Rhae Smith,
New York Institute of Photography
Edward Smith
Patrick Reddy, *Cincinnati Enquirer*
Bruce Strong, LightChasers
Patrick Reddy, *Cincinnati Enquirer*
Lara Neel

**121** Michael C. Andrews
Larry Kasperek,
Fuchs & Kasperek Photography
Patrick Reddy, *Cincinnati Enquirer*
Steve Hoskinson
Bruce Strong, LightChasers
Terry E. Eiler, Ohio University
Larry Kasperek,
Fuchs & Kasperek Photography

**122** Bruce Strong, LightChasers
Anna Rhae Smith,
New York Institute of Photography
Patrick Reddy, *Cincinnati Enquirer*
Eric Albrecht, *The Columbus Dispatch*
Michael A. Ciu
Carolyn Drake
Josh Dague

**123** K.L.M.N. Williams
Bruce Strong, LightChasers
Eric Albrecht, *The Columbus Dispatch*
Carolyn Drake
Michael C. Andrews
Dana Romanoff, Ohio University
Michael C. Andrews

**125** Christine K. McCune
Uma Sanghvi
Larry Kasperek,
Fuchs & Kasperek Photography
Larry Kasperek,
Fuchs & Kasperek Photography
Terry E. Eiler, Ohio University
Anna Rhae Smith,
New York Institute of Photography
Bill Reinke, *Dayton Daily News*

**127** Andres Gonzalez, Ohio University
Bill Reinke, *Dayton Daily News*
Brian K. Wellman
Bill Reinke, *Dayton Daily News*
Bruce Strong, LightChasers
Bruce Strong, LightChasers
Bill Reinke, *Dayton Daily News*

**128** Anna Rhae Smith,
New York Institute of Photography
Tim G. Zechar,
New York Institute of Photography
Bill Reinke, *Dayton Daily News*
Eric Albrecht, *The Columbus Dispatch*
Angela Hunter
David G. Massey
Larry Nighswander, Ohio University

**129** Eric Albrecht, *The Columbus Dispatch*
Anna Rhae Smith,
New York Institute of Photography
Bill Reinke, *Dayton Daily News*
Bill Reinke, *Dayton Daily News*
Carolyn Drake
Angela Hunter
Lara Neel

**131** Larry Nighswander, Ohio University
Albert P. Fuchs,
Fuchs & Kasperek Photography
Robert Caplin
Skip Peterson, *Dayton Daily News*
Bruce Strong, LightChasers
Lara Neel
Terry E. Eiler, Ohio University

**134** John Gerard Quinn
Jim Witmer, *Dayton Daily News*
Carolyn Drake
Robert Caplin
Bill Reinke, *Dayton Daily News*
Andres Gonzalez, Ohio University
Eric Albrecht, *The Columbus Dispatch*

**135** Larry Kasperek,
Fuchs & Kasperek Photography
Andres Gonzalez, Ohio University
Michael Christopher Brown
Robert Caplin
Michael Christopher Brown
Terry E. Eiler, Ohio University
Lara Neel

# Staff

The *America 24/7* series was imagined years ago by our friend Oscar Dystel, a publishing legend whose vision and enthusiasm have been a source of great inspiration.

We also wish to express our gratitude to our truly visionary publisher, DK.

Rick Smolan, Project Director
David Elliot Cohen, Project Director

## Administrative
Katya Able, Operations Director
Gina Privitere, Communications Director
Chuck Gathard, Technology Director
Kim Shannon, Photographer Relations Director
Erin O'Connor, Photographer Relations Intern
Leslie Hunter, Partnership Director
Annie Polk, Publicity Manager
John McAlester, Website Manager
Alex Notides, Office Manager
C. Thomas Hardin, State Photography Coordinator

## Design
Brad Zucroff, Creative Director
Karen Mullarkey, Photography Director
Judy Zimola, Production Manager
David Simoni, Production Designer
Mary Dias, Production Designer
Heidi Madison, Associate Picture Editor
Don McCartney, Production Designer
Diane Dempsey Murray, Production Designer
Jan Rogers, Associate Picture Editor
Bill Shore, Production Designer and Image Artist
Larry Nighswander, Senior Picture Editor
Bill Marr, Sarah Leen, Senior Picture Editors
Peter Truskier, Workflow Consultant
Jim Birkenseer, Workflow Consultant

## Editorial
Maggie Canon, Managing Editor
Curt Sanburn, Senior Editor
Teresa L. Trego, Production Editor
Lea Aschkenas, Writer
Olivia Boler, Writer
Korey Capozza, Writer
Beverly Hanly, Writer
Bridgett Novak, Writer
Alison Owings, Writer
Fred Raker, Writer
Joe Wolff, Writer
Elise O'Keefe, Copy Chief
Daisy Hernández, Copy Editor
Jennifer Wolfe, Copy Editor

## Infographic Design
Nigel Holmes

## Literary Agent
Carol Mann, The Carol Mann Agency

## Legal Counsel
Barry Reder, Coblentz, Patch, Duffy & Bass, LLP
Phil Feldman, Coblentz, Patch, Duffy & Bass, LLP
Gabe Perle, Ohlandt, Greeley, Ruggiero & Perle, LLP
Jon Hart, Dow, Lohnes & Albertson, PLLC
Mike Hays, Dow, Lohnes & Albertson, PLLC
Stephen Pollen, Warshaw Burstein, Cohen, Schlesinger & Kuh, LLP
Rick Pappas

## Accounting and Finance
Rita Dulebohn, Accountant
Robert Powers, Calegari, Morris & Co. Accountants
Eugene Blumberg, Blumberg & Associates
Arthur Langhaus, KLS Professional Advisors Group, Inc.

## Picture Editors
J. David Ake, Associated Press
Caren Alpert, formerly *Health* magazine
Simon Barnett, *Newsweek*
Caroline Couig, *San Jose Mercury News*
Mike Davis, formerly *National Geographic*
Michel duCille, *Washington Post*
Deborah Dragon, *Rolling Stone*
Victor Fisher, formerly Associated Press
Frank Folwell, *USA Today*
MaryAnne Golon, *Time*
Liz Grady, formerly *National Geographic*
Randall Greenwell, *San Francisco Chronicle*
C. Thomas Hardin, formerly *Louisville Courier-Journal*
Kathleen Hennessy, *San Francisco Chronicle*
Scot Jahn, *U.S. News & World Report*
Steve Jessmore, *Flint Journal*
John Kaplan, University of Florida
Kim Komenich, *San Francisco Chronicle*
Eliane Laffont, *Hachette Filipacchi Media*
Jean-Pierre Laffont, *Hachette Filipacchi Media*
Andrew Locke, MSNBC
Jose Lopez, *The New York Times*
Maria Mann, formerly AFP
Bill Marr, formerly *National Geographic*
Michele McNally, *Fortune*
James Merithew, *San Francisco Chronicle*
Eric Meskauskas, *New York Daily News*
Maddy Miller, *People* magazine
Michelle Molloy, *Newsweek*
Dolores Morrison, *New York Daily News*
Karen Mullarkey, formerly *Newsweek, Rolling Stone, Sports Illustrated*
Larry Nighswander, Ohio University School of Visual Communication
Jim Preston, *Baltimore Sun*
Sarah Rozen, formerly *Entertainment Weekly*
Mike Smith, *The New York Times*
Neal Ulevich, formerly Associated Press

## Website and Digital Systems
Jeff Burchell, Applications Engineer

## Television Documentary
Sandy Smolan, Producer/Director
Rick King, Producer/Director
Bill Medsker, Producer

## Video News Release
Mike Cerre, Producer/Director

## Digital Pond
Peter Hogg
Kris Knight
Roger Graham
Philip Bond
Frank De Pace
Lisa Li

## Senior Advisors
Jennifer Erwitt, Strategic Advisor
Tom Walker, Creative Advisor
Megan Smith, Technology Advisor
Jon Kamen, Media and Partnership Advisor
Mark Greenberg, Partnership Advisor
Patti Richards, Publicity Advisor
Cotton Coulson, Mission Control Advisor

## Executive Advisors
Sonia Land
George Craig
Carole Bidnick

## Advisors
Chris Anderson
Samir Arora
Russell Brown
Craig Cline
Gayle Cline
Harlan Felt
George Fisher
Phillip Moffitt
Clement Mok
Laureen Seeger
Richard Saul Wurman

## DK Publishing
Bill Barry
Joanna Bull
Therese Burke
Sarah Coltman
Christopher Davis
Todd Fries
Dick Heffernan
Jay Henry
Stuart Jackman
Stephanie Jackson
Chuck Lang
Sharon Lucas
Cathy Melnicki
Nicola Munro
Eunice Paterson
Andrew Welham

## Colourscan
Jimmy Tsao
Eddie Chia
Richard Law
Josephine Yam
Paul Koh
Chee Cheng Yeong
Dan Kang

## Chief Morale Officer
Goose, the dog

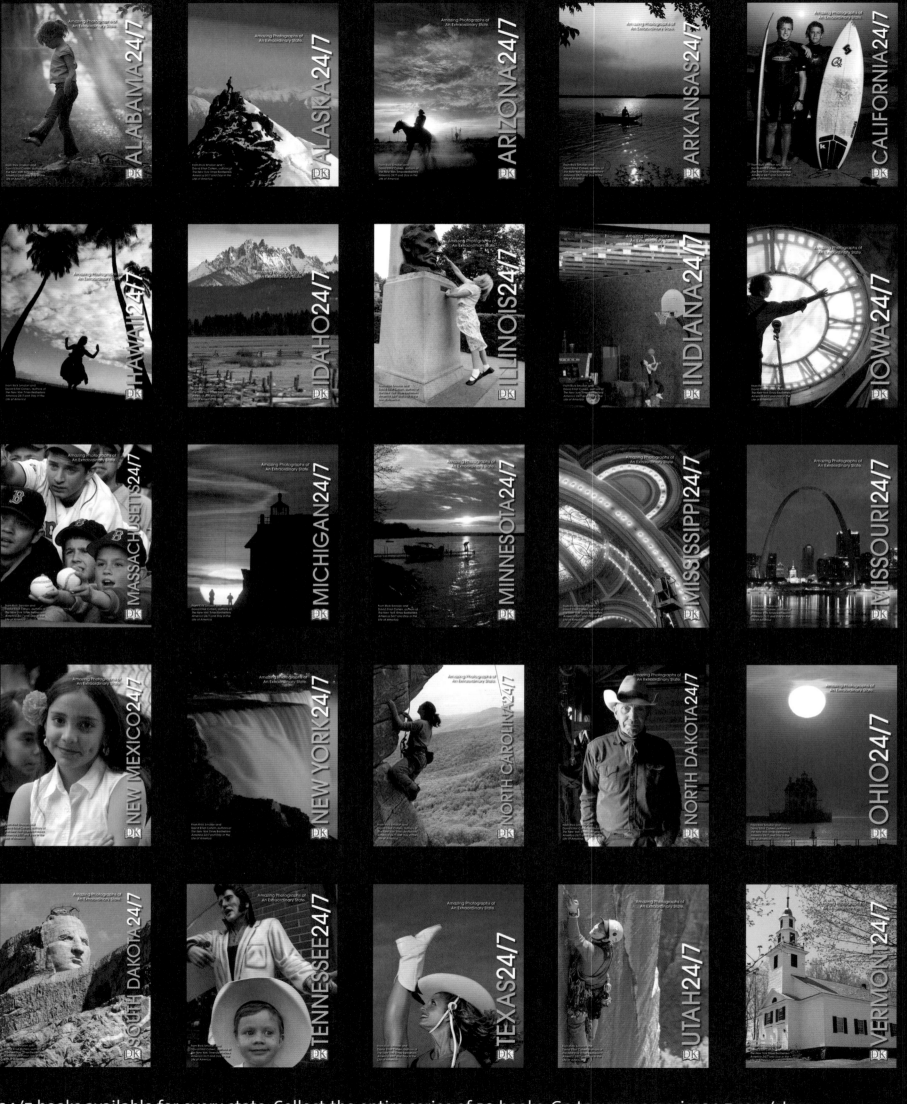